One was Whistler in public—the fop,

the cynic, the brilliant, flippant, vain,

and careless idler; the other was Whistler

 of the studio—the earnest, tireless,

 somber worker, a very slave to his art,

 a bitter foe to all pretense and sham, an

 embodiment of simplicity almost to the

 point of diffidence, an incarnation of

 earnestness and sincerity of purpose.

 —William Merritt Chase

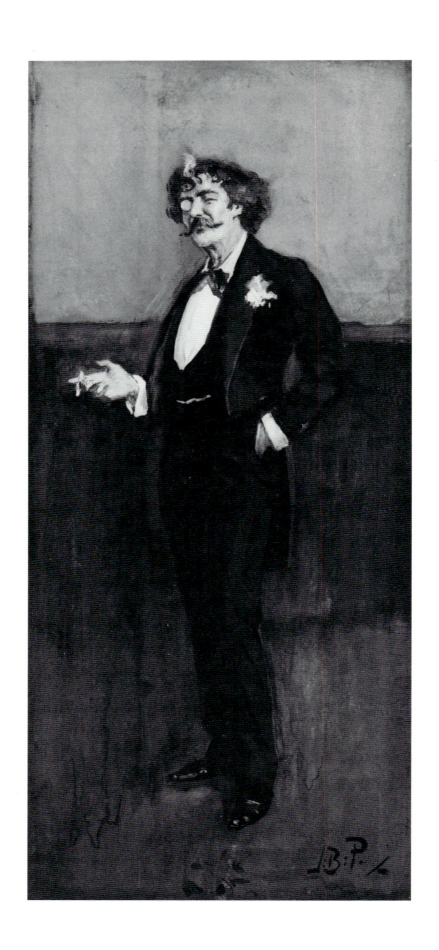

In Pursuit of the Butterfly

PORTRAITS OF

JAMES MCNEILL

WHISTLER

Eric Denker

Published by the
National Portrait Gallery
Washington, D.C.
in association with the
University of Washington Press
Seattle and London

1995

This publication and the exhibition have been made possible in part by grants from The Clark Charitable Foundation and the Smithsonian Institution Special Exhibition Fund. In-kind support was provided for the exhibition by British Airways.

An exhibition at the National Portrait Gallery
April 7 to August 13, 1995

Dedication
For Wendy and my parents and grandmother.

Library of Congress Cataloging-in-Publication data

Denker, Eric.
 In pursuit of the butterfly : portraits of James McNeill Whistler
/ Eric Denker.
 p. cm.
 Catalog of an exhibition held at the National Portrait Gallery,
Apr. 7–Aug. 13, 1995.
 Includes bibliographical references and index.
 ISBN 0-295-97463-X
 1. Whistler, James McNeill, 1834–1903—Portraits—Exhibitions.
2. Artists—United States—Portraits—Exhibitions. I. National
Portrait Gallery (Smithsonian Institution) II. Title.
N7628.W48D45 1995
760' . 092—dc20 95-931
 CIP

The butterfly images appearing throughout this book are reproduced from *The Gentle Art of Making Enemies* by James McNeill Whistler. Courtesy of the Freer Gallery of Art, Smithsonian Institution, Washington, D.C.

Cover
James McNeill Whistler (detail) by Giovanni Boldini (1844–1931).
Oil on canvas, 170.4 x 95.2 cm. (67 1/8 x 37 1/8 in.), 1897.
The Brooklyn Museum, New York; gift of A. Augustus Healy.
Illustrated in full on page 139.

Frontispiece
James McNeill Whistler by J. Bernard Partridge (1861–1945).
Watercolor, 28.6 x 13 cm. (11 1/4 x 5 1/8 in.), not dated.
National Portrait Gallery, London; gift of Mrs. L. M. Lamont

Contents

Foreword

Although the National Portrait Gallery has studied the development of the work of a single artist in publications and exhibitions over the years, this is the first time the portrayal of a notable artist has taken center stage. Until now, this distinction has been reserved for Presidents of uncommon popularity, like Washington, Jackson, Grant, or Franklin Roosevelt, for folk heroes like Davy Crockett, or for political and social leaders of exceptional prominence, like Daniel Webster or Frederick Douglass. Yet few sitters are as frequently depicted as artists, who are often challenged to create self-portraits and always seem ready to oblige their colleagues by posing for them.

Indeed, the artist has long captured the public imagination. Artists of exceptional skill are mentioned by ancient Greek and Roman writers, often virtually as magicians, possessed of uncanny skill in handling tools and in capturing the likeness of an object in nature. Giorgio Vasari published the lives of the principal painters and sculptors of the Renaissance, who had become public personalities, sometimes given to rash or unconventional behavior, but accorded a place above that of the normal citizen, thanks to patronage by the rich and powerful. By the eighteenth and early nineteenth centuries, many artists led comfortable lives as prominent and successful citizens in their own communities.

But beginning in the mid-nineteenth century, the public perception of the artist took a new form, which found its way into literature and music (for example, in the opera *La Bohème*, based on a popular novel by Henri Murger). During this period a younger group of independent artists marked out an individual ground for themselves, freeing themselves from the conventions observed by polite society. Instead of occupying a secure place in the professional middle class, the artist began to think of himself as a free spirit, unconstrained by the normal rules of society and tending to unconventional—even daring—behavior. For Americans, this was easier to do in Paris (or even Rome or London) than in New York or Boston, where moral and religious strictures seemed to be universally heeded, and where, anyhow, there was little market for art created according to unconventional principles. Any emerging artist with an independent streak, then, found himself a studio abroad, enrolled in classes in one of the academies or schools affording space to work and models to work from, and began to dress and behave according to the most modern models.

One may wonder whether a great many artists contributed to the creation of this new spirit, or whether the most independent emerging artists thought

they ought to follow the behavior of their fictional models to underscore their commitment to innovation and freedom. Probably there is a bit of truth on both sides of the question. Suffice it to say that of all the young artists working in Paris in the late 1850s, none fit more perfectly into the Bohemian mold than James Abbott McNeill Whistler.

Whistler had a flair for the outrageous. He dressed to be noticed, spoke his mind without constraint, and had a wicked sense of satire. In his art, he was comparably original. The highly individual style he evolved, based on his observation of Japanese woodblock prints and paintings, on the explorations into new subjects from everyday life of contemporary artists like Courbet and Degas, and on the freely brushed painting styles of Pissarro, Monet, and the others who would soon be called "impressionists," assured him a leading role among his fellow artists.

The insouciant and even arrogant facade Whistler presented to the world masked the insecurity he felt as he struggled to refine his personal style. No one else had dared to combine colors and forms precisely as he did, and as his style became more individual, he found himself virtually creating a new "school" of painting. He attracted students as well as imitators. Whistler also discovered in himself a didactic streak; he found that he enjoyed teaching, and when not directly working with his students and

colleagues, he wrote a series of provocative, highly original essays that furthered his public image. Always pleased to be the center of attention, he welcomed his followers into his circle, enjoying the camaraderie of artists and writers even while working.

Others were less than captivated by Whistler. The influential critic John Ruskin wrote so often and so condescendingly about Whistler's work and flamboyant personality that the artist took him to court in a notorious lawsuit; Whistler won the case, but the cost of the proceedings contributed to his bankruptcy.

None of this is new to the considerable audience familiar with Whistler's work, for it has been the subject of many exhibitions and books from the moment he became a public figure. The most recent exhibition opened in London in 1994, has recently opened in Paris, and is soon to be seen in Washington, D.C. Yet as far as I know, there has never been an exhibition devoted entirely to portraiture of him, and the last publication was more than eighty years ago.

With his highly personal style of dress, his unmistakable posture and hairstyle, and his public notoriety, it was inevitable that Whistler should be the subject of innumerable portrayals by both his friends and his opponents. Some are serious paintings and sculptures, others are informal drawings—cartoons, caricatures, and lampoons—both

affectionate and vitriolic. Moreover, Whistler was a talented and inventive portraitist who often used himself as a subject, searching his features with a depth not often applied to his other sitters. These portraits and self-portraits, taken together, constitute a visual biography of exceptional breadth and interest.

Eric Denker has done a remarkable job in gathering these portraits and in assessing their meaning and significance, and he has done so at a splendid juncture in the history of Whistler studies. Soon after this book is published and the exhibition of portraits of Whistler opens at the National Portrait Gallery, the exhibition of Whistler's work will be on view just a few streets away at the National Gallery of Art, and a special installation of Whistler prints and paintings will be on display at the Freer Gallery of Art, along with the magnificently restored Peacock Room. Taken together, these will provide visitors to Washington with the most comprehensive exploration yet undertaken of one of the most striking and original artists America has yet produced—a man simultaneously celebrated and reviled on both sides of the Atlantic, a celebrity in his own time and a legend today.

Alan Fern
Director
National Portrait Gallery

Acknowledgments

I am very grateful to all of the owners of portraits of Whistler, including museums, dealers, and private collectors, for their generosity in sharing their works and knowledge with me during the course of the exhibition and the writing of this book.

I would like to express my deep appreciation to the many people who assisted me with the research and writing of the text, most importantly my adviser, Dr. Roger Stein at the University of Virginia, without whom this could never have been done. His thoughtful guidance and advice were crucial to every part of the project. I would also like to thank Donald Vogler for his many insights and suggestions that became part of the fabric of the book.

At the National Gallery of Art in Washington, D.C., I would like to thank the curator of American painting, Nicolai Cikovsky, Jr.; Frances Lederer, George Dalziel, and Tom McGill in the library; Greg Most and the staff of the slide library; Dick Amt, Ira Bartfield, Barbara Bernard, Lorene Emerson, and the staff of the Department of Imaging and Visual Services; Virginia Clayton, Carlotta Owens, and Greg Jecmen in the Department of Prints, Drawings, and Sculpture; Linda Davis, head of the Education Division; Lynn P. Russell and Wilford Scott for their wisdom and advice, and the entire staff of the Department of Adult Programs, who generously gave their energy to allow me the necessary time to research and write this catalogue. A special note of thanks to Charles Brock, exhibition assistant in the Department of American and British Paintings, for his many suggestions on the material and for his help in finding and identifying numerous obscure images.

At the National Portrait Gallery in Washington, D.C., I want to give special thanks to the director, Alan Fern, who showed confidence in approving the project while it was still a twinkle in my eyes, and also to Carolyn Kinder Carr for her suggestions on my text. Beverly Cox, the head of the Office of Exhibitions, also deserves special thanks for her tireless shepherding of the book and the show, for her readings of the multiple drafts of the text, and for her care and precision in dealing with the immense number of details that are integral to the success of any exhibition. My thanks also to Liza Karvellas, Claire Kelly, Deborah Berman, Vandy Cook, and the rest of the exhibition staff who have also worked so hard to make the show a reality. Among the many people at the National Portrait Gallery who have assisted me during the last three years I would like to express my gratitude to Frances Stevenson, publications officer, Dru Dowdy, managing editor, and Katherine Gibney, editorial intern; Cecilia Chin and the staff of the library; Wendy Wick Reaves, curator of prints, and Ann Wagner and the staff of the Department of Prints; Nello Marconi,

chief of Design and Production, and the rest of the Design and Production staff; and Linda Thrift, keeper of the Catalog of American Portraits, Patricia Svoboda, and the staff of the CAP.

I would like to express my appreciation for the help of the many Whistler scholars who enthusiastically assisted me with many thorny issues and obscure details. As with other writers in the field, I can never sufficiently thank Nigel Thorp, director of the Centre for Whistler Studies, and Margaret Mac-Donald, research fellow at the Centre, for their encouragement and timely assistance with information on the master. They are eternally available, seemingly day and night, to provide information and direction on Whistler problems. Additional thanks goes to Katherine Lochnan at the Art Gallery of Ontario; Linda Merrill, curator of American Art at the Freer Gallery of Art, and the staff of their library; Ronald Anderson; Richard Dorment; Michael Parkin; Michael Bryan, Diana Bryan, and Francesca Bryan; Tom Pocock; and Peyton Skipworth and Gordon Cooke at the Fine Art Gallery in London.

At the University of Glasgow, I would like to thank Martin Hopkinson, curator at the Hunterian Art Gallery; research assistants Margaret Fox and Katherine Mooney; Timothy Riggs, keeper of the Special Collections in the university library, and staff members Peter Asplen, David Weston, Elizabeth Watson, Niki Russell, Sue Macallan, and James Downs. At the National Portrait Gallery in London, I want to thank John Cooper, head of the Education Department; Kai Kin Yung, registrar; and Jayne Shrimpton, Terence Pepper, and Jonathan Franklin of the Archive and Library.

I would also like to acknowledge the assistance of the many others in the United Kingdom who have helped me with the book and the exhibition, including Hilary Williams and the staff of the British Museum Print Room; Catherine Bindman and the staff of the Victoria and Albert Museum Print Room; Curator Richard Humphries, and Andrew Brighton and Sylvia Lahav in the Department of Education at the Tate Gallery; Susanna Kerr at the Scottish National Portrait Gallery; William Darby of Browse and Darby; Raffe Whistler; Wendy Baron; Julia Findlater; Miranda Taylor and Amanda Jane Doran at the *Punch* Archives; Paul Gravette; and Debbie Ireland at the Royal Photographic Society.

I would also like to thank the many others in the United States who have offered their time and assistance, including Martha Tedeschi and Anselmo Carini, associate curators of prints and drawings at the Art Institute of Chicago; Jay Fisher, curator of Prints, Drawings, and Photographs at the Baltimore Museum of Art; Sinclair Hitchings, keeper of prints, and Karen Shafts at the Boston Public Library; Ann Havinga and Eunice

Gomez in the print room at the Museum of Fine Arts in Boston; curatorial assistant Sabine Kretzschmar at the Cleveland Museum of Art; Barbara Krieger, Phyllis Tedreault, and the Special Collections Department, Dartmouth College Library; Miriam Stewart and Abigail Smith at the Fogg Art Museum; Jane Van Nimmen in the Print Division of the Library of Congress; Roberta Waddell and the staff of the New York Public Library Print Room; Ann Percy, curator, and the staff of the Print Room at the Philadelphia Museum of Art; Paul Barolsky and Rosemary Smith at the University of Virginia; Kris Stakenborg; Martha Richler Wise; Bill Tomlinson; Mark Lasner; Robert Mayo; and E. Adina Gordon.

Finally, I would like to express my appreciation to my family and friends. My thanks goes to my parents for their years of support and encouragement, and to Jack Barrett, Richard Wright, Elizabeth O'Leary, and Bill Wallace for their tireless patience in discussions of Whistler that often went on long into the night. My special thanks goes to my wife Wendy for her unfailing support, particularly during those substantial periods when I had to be away on research.

Eric Denker

Lenders to the Exhibition

The Art Institute of Chicago, *Illinois*

Birmingham Museums and Art Gallery, *England*

Boston Public Library, *Massachusetts*

The British Museum, *London, England*

The Brooklyn Museum, *New York*

Cincinnati Art Museum, *Ohio*

The Cleveland Museum of Art, *Ohio*

The Fine Art Society, *London, England*

Fogg Art Museum, Harvard University Art Museums, *Cambridge, Massachusetts*

Freer Gallery of Art Archives, Smithsonian Institution, *Washington, D.C.*

Glasgow University Library, University of Glasgow, *Scotland*

Charles Goldsmith, Inc., *New York City*

Hugh Lane Municipal Gallery of Modern Art, *Dublin, Ireland*

Hunterian Art Gallery, University of Glasgow, *Scotland*

Mark Samuels Lasner

Library of Congress, *Washington, D.C.*

The Metropolitan Museum of Art, *New York City*

Museum of Fine Arts, *Boston, Massachusetts*

National Gallery of Art, *Washington, D.C.*

National Museum of American Art, Smithsonian Institution, *Washington, D.C.*

National Portrait Gallery, *London, England*

National Portrait Gallery, Smithsonian Institution, *Washington, D.C.*

The New York Public Library, *New York City*

Michael Palmer, Esq.

Michael Parkin Fine Art, *London, England*

The Parrish Art Museum, *Southampton, New York*

Philadelphia Museum of Art, *Pennsylvania*

Tom Pocock

Princeton University Libraries, *New Jersey*

Private collections

Tate Gallery, *London, England*

The Board of Trustees of the Victoria and Albert Museum, *London, England*

Introduction

*Whistler was a diamond with many facets, and being also a poseur,
he presented himself at different angles to different people.*

— G. S. LAYARD [1]

James McNeill Whistler (1834–1903) was the single most depicted artist prior to the twentieth century. More than four hundred portraits by approximately one hundred artists represent this American expatriate from the age of ten to his death at the age of sixty-eight. Painters, photographers, caricaturists, and printmakers captured Whistler's striking appearance, beginning in his early years as a flamboyant student. Fashionable illustrators represented the public side of Whistler in the guise of the society dandy or intellectual aesthete. While some of these works are casual sketches, others are life-size canvases. Though caricaturists generally lampooned the artist's carefully devised public persona, fellow artists recorded his personal life—at work in the studio, at home in the garden, or among friends in cafés. In addition to these depictions by his contemporaries, Whistler executed many self-portraits, particularly during certain periods of his life. As a whole, these portraits offer a richer, more complex, and truer picture of the artist than the popular one-dimensional image of Whistler as a dandy.

Whistler's appearance changed considerably over the fifty-nine years delineated in this study. He is first seen as an attractive youth, carefully posed for the camera and the portraitist; his familiar features are crowned by a prominent shock of dark, curly hair, and he has small, delicate hands. Other characteristics gained prominence during his student years—a slim build, the mustache, the monocle, and the straw hat. The length of the mustache changed over the years. Whistler adopted various fashions of dress distinctive to specific periods, sometimes adding a cane or gloves. A white lock of hair appeared around 1870 and became a reliable part of the Whistler image. Photographs betrayed signs of his aging beginning in the 1880s, despite Whistler's vain attempts to disguise the passage of time. White hair and an overcoat were added to the ensemble in the later years.

A compilation of portraits records more than changes in Whistler's physical appearance and the style of his costume, and any analysis of his portraits must take certain variables into account. His appearance at a specific moment in his life is one relevant concern; the way he wished to appear at that moment is another, as Richard Brilliant has discussed in his examination of the dynamics of portraiture.[2] Other considerations include the way an artist wished to show Whistler at a given moment, the intended audience, and what predisposition the viewer brought to the image.

Beyond providing a record of Whistler's appearance, the works also reveal how nineteenth-century artists

constructed images of their contemporaries. A study of these representations and their context reveals how audiences perceived and understood the role of the artist. The portraits and descriptions of Whistler in the popular press helped define "the artist" for Victorian England —as a celebrity and as an independent intellectual, free from conventional criticism and unfettered by the mores of traditional upper-class society. Whistler worked consciously to create and promote this persona. He acknowledged as much during his preparation for the Ruskin trial. The artist instructed his attorney, Anderson Rose, to represent him as "the well-known Whistler," since "sticking to this character," he felt, would be to their advantage.[3]

The artist received assistance constructing this icon from contemporary English writers and illustrators. Popular weekly journals, focusing largely on the great personalities of the day, dominated the Victorian era. Whistler's distinctive appearance and his notable wit were displayed throughout this period in galleries, clubs, cafés, and most conspicuously in the law courts. Caricaturists and journalists were attracted to his idiosyncratic dress and behavior, as the artist no doubt intended. Whistler maintained a high public profile, even if the results of that visibility were not always flattering. He played a part in the much broader shift toward a celebration of individualism that underlay the cult of personality in Europe in the latter half of the nineteenth century. Part of this phenomenon emphasized notoriety and its

attendant publicity. Whistler's sense of the importance of publicity anticipates its significance for twentieth-century artists, ranging from Pablo Picasso to Andy Warhol.

The eminent historian Daniel Boorstin, formerly the Librarian of Congress, has written on the conscious creation of notoriety and its attendant function in this century.[4] His distinction between the illusion of importance—notoriety—and the actual recognition accorded to achievement—fame—is useful in appreciating Whistler's accomplishments in the promotion of his own image. An analysis of the existing images of Whistler, their development, and their use exposes the crucial role that he played in constructing the popular notion of the nineteenth-century painter as a prominent and independent personality.

Albert E. Gallatin compiled the first list of representations of Whistler in 1913 in his *Portraits and Caricatures of James McNeill Whistler, an Iconography.* His fuller study, *Portraits of Whistler: A Critical Study and an Iconography*, appeared five years later.[5] The latter contains a short introduction and a checklist of works, with their location at the time of writing. This essay is indebted to Gallatin's pioneering studies. While acknowledging the importance of Gallatin's work, however, we also need to address its flaws. The divisions of his catalogue are obsolete by today's standards. Gallatin begins with a listing of "Portraits by Himself," which he organizes into chronological sections divided

by media. The next section, "Portraits by Various Artists," is broken down in a similar manner. A listing of "Plastic Portraits" precedes a section on "Caricatures," and another on "Photographs." Descriptions of Whistler by a few authors occupy the end of the volume. Illustrations are sparse and of poor quality. The introduction contains only brief remarks, which offer little commentary on individual works. Gallatin attempts no analysis of the images chronologically, or across various media. Each image exists in an art-historical vacuum, independent of other Whistler portraits and depictions. Finally, Gallatin omitted many images and missed many portraits by those artists he did include.

The present essay, while building on Gallatin's pioneering work, refocuses the discussion by treating the works chronologically in both the context of Whistler's art and the period in which they were created. The portraits are then considered with regard to the artist's career and placed within their specific historical situation. All of the works discussed were done either during Whistler's lifetime or after his death by artists he had known; portraits based on photographs and posthumous likenesses have been excluded from consideration, except where relevant.

Beginning in the late 1860s, Whistler started to sign his paintings and prints with a new signature comprised of his initials, JMW. The letters were combined into the form of an insect that at first resembled a dragonfly but soon developed into a butterfly. At about the same time, Whistler adopted the motif as his signature in his correspondence, and later often referred to himself as "the butterfly." The design of the butterfly evolved as time passed; eventually, it became a versatile symbol representing the artist. Writers and caricaturists readily embraced it and used it to refer to Whistler. A number of the portrayals discussed make reference to the butterfly, or utilize a combination of the creature and a likeness of Whistler. For the purpose of this study, the butterflies that abound in Whistler's prints, drawings, and letters are not considered self-portraits.

This inquiry into Whistler portraits is divided into five chapters. The first discusses images dating from 1844 through Whistler's years of Parisian art study, while the second covers the 1860s. The third chapter explores Whistler's representation in the popular press, beginning with the Ruskin trial. The fourth presents portraits of Whistler done by his circle of students and friends, and the fifth chapter concludes the book, focusing on the image of the artist in his final years. Each chapter is arranged chronologically, with sections subdivided into related themes. Also included in each chapter is a summary of the relevant events in Whistler's life, followed by a discussion of the images of Whistler from the period covered. Whistler's life has been written about many times in the ninety years since his death, and this is not the appropriate place for a new biography. Rather, the emphasis is upon the visual evidence of his life,

and its impact during and after Whistler's lifetime.[6]

An examination of Whistler portraits illuminates a number of critical issues in art and the art world in Europe in the nineteenth century. The very existence of an unusually large number of images of Whistler is significant in art-historical terms. An analysis of their development and function yields additional information about the reception of the artist and his circle. A new understanding of the dynamics of contemporary society results from applying this information to the broader context of celebrity and publicity in the latter part of the century. Whistler's crucial role in these changes, as both artist and subject, is integral to an understanding of the era.

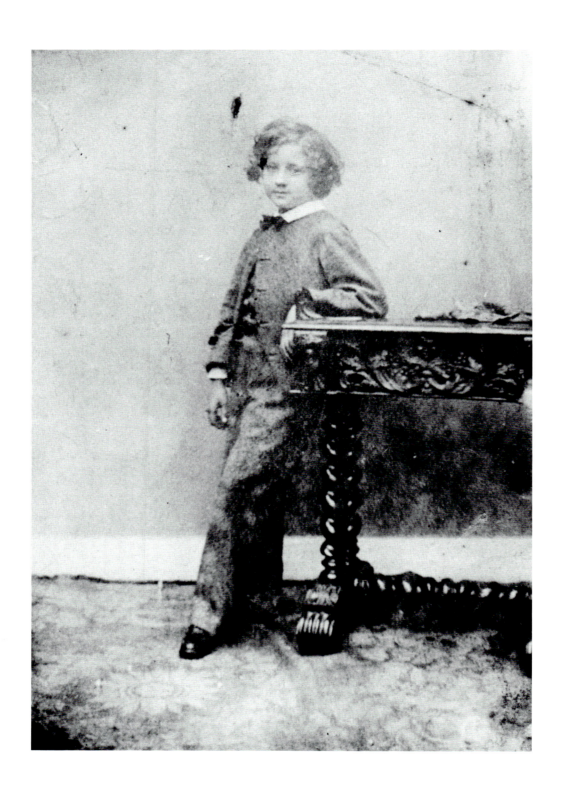

1

Youthful Images and Student Years

Despite his repeated attempts to relocate his birthplace in some more exotic locale, James Abbott McNeill Whistler was born in Lowell, Massachusetts, on July 10, 1834.[1] He lived with his family in Connecticut and Massachusetts until he was nine. In September 1843 James accompanied his mother and brothers to St. Petersburg, Russia, where his father had been employed as a civil engineer since the previous year. They remained in Russia, with occasional trips to Western Europe, until Major Whistler's death in the spring of 1849. In 1844 Whistler had his first exposure to art with visits to the Russian royal collections, and with private drawing instruction. The first portraits date from this time.

An albumen photograph after a daguerreotype from these years may be the earliest record of Whistler's appearance [Fig. 1:1].[2] The photograph shows Whistler standing, dressed in a suit with prominent buttonholes. He is leaning with his left elbow on the side of a table, a typical studio prop of the era. A dark bow tie contrasts with his stiff white shirt collar, which in turn sets off his face and curly hair. An unidentified photographer created a convincing space by posing his model in a three-quarter view with one leg forward, and positioning the table at an acute angle. Whistler looks out toward the camera, creating the impression that he has turned to look at the viewer, a device first used pictorially by Renaissance painters. The position of the table and the pose are conventions characteristic of early photographic portraits.

A recently discovered watercolor derives from about the same time [Fig. 1:2]. In this portrait Whistler holds a paintbrush and a palette. He wears a painting smock, and stands by a wooden drafting table that has a drawing of a woman upon it. The facial features match the early photograph, although Whistler appears heavier. As in the early photograph, he is shown in a three-quarter view with his face turned toward the viewer. An otherwise-unrecorded artist, C. A. F. Fiessler, signed the work. The oversized head and hand, and the unconvincing sense of space, are consistent for an artist with limited

Fig. 1:1.*
Whistler at about age ten by an unidentified photographer. Albumen silver print, 11 x 7.8 cm. (4 5/16 x 3 1/16 in.), image size, circa 1844. Department of Special Collections, University of Glasgow, Glasgow University Library, Scotland (PH 1/93)

* Asterisks indicate objects in the exhibition.

Fig. 1:2.*
Whistler with a Paintbrush and Palette by C. A. F. Fiessler (lifedates unknown). Watercolor, 28.1 x 23.3 cm. (11 1/16 x 9 3/8 in.), circa 1844. Private collection

training. The drawing remains interesting nevertheless, not only as an early representation of the youthful American, but as the first depiction of Whistler as an artist.

Other portraits survive from this period. The Freer Gallery of Art's drawing of the youthful Whistler is inscribed "1845 or 1846" and has been regarded as his earliest self-portrait [Fig. 1:3]. However, as David Curry states in his 1984 catalogue of the Freer's collection of Whistler, "There is no particularly compelling evidence that Whistler did more than sit for this portrait."[3] The head is rendered with a skill that appears beyond Whistler's early talent. The hair and face are delicately drawn and shaded, with a sophisticated sense of modeling. The expression is carefully delineated, again casting doubts on an attribution to an eleven-year-old.

Margaret MacDonald has suggested that the drawing could have been done by one of Whistler's Russian teachers.[4]

The Freer Gallery has an additional portrayal of Whistler from this same time, a pastel signed and dated by the French artist Émile François Dessain [Fig. 1:4]. This large double portrait depicts James standing with his arm around his seated younger brother, William Gibbs McNeill Whistler (1836–1900). The standing figure of James dominates the composition, by both his size and his placement. Dessain sensitively represented the faces of both brothers; their overemphasized eyes are a common sentimental touch of the era. The artist did not handle the details of the pose very persuasively, however, as an examination of the older brother's hip reveals. Elizabeth and Joseph Pennell, friends of the artist from the mid-1880s who wrote the seminal early Whistler biography, knew the work only in reproduction and labeled it "from a daguerreotype," for which there is no documented evidence.[5] Daguerreotypes of the brothers from this time are known and are reproduced in the Pennells' biography, *The Life of James McNeill Whistler* [Fig. 1:5].[6] The figures are seen reversed, in a mirror image of their actual appearance, a characteristic of many early photographic processes. None of the other early portraits of Whistler, including the Dessain pastel, show this reversal, making it improbable that they were based on early photographs.

Whistler's appearance in these portraits parallels contemporary descriptions. Emma W. Palmer, the artist's cousin, told the Pennells that at this time he was "tall and slight with a pensive, delicate face, shaded by soft brown curls, one lock of

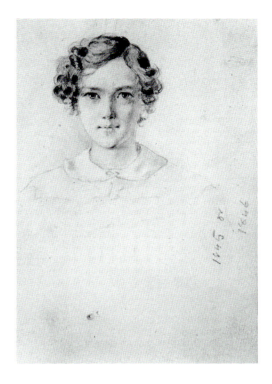

Fig. 1:3.
James McNeill Whistler by an unidentified artist. Pencil and watercolor, 11.8 x 7.9 cm. (4 5/8 x 3 1/8 in.), circa 1845–1846. Freer Gallery of Art, Smithsonian Institution, Washington, D.C.

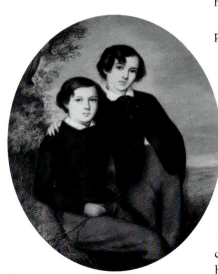

Fig. 1:4.
William Gibbs McNeill Whistler and James McNeill Whistler by Émile-François Dessain (1808–1882). Pastel, 52.7 x 41.3 cm. (20 3/4 x 16 1/4 in.) oval, 1847. Freer Gallery of Art, Smithsonian Institution, Washington, D.C.

which fell over his forehead. . . . He had a somewhat foreign appearance and manner, which, aided by his natural abilities, made him very charming, even at that age."[7]

The final portrait from Whistler's preadolescence is a painting by Sir William Boxall executed in 1849 [Fig. 1:6].

Boxall was a popular portraitist of the Victorian age, a prominent member of the Royal Academy, and the director of England's National Gallery of Art from 1866 to 1874. His portrait of Whistler dates from the winter of 1848–1849, when the teenager had been sent to London to recuperate from rheumatic fever. Boxall portrayed the American in a conservative, academic style, seated in a conventional pose. Whistler is represented half-length, emerging from a dark background in a then-popular Rembrandtesque manner. The painting was exhibited in the annual Royal Academy exhibition in June 1849, where it was seen by Whistler's mother and her children, who were returning from Russia after the death of Major Whistler. By August the family had come back to America to begin a new phase of their lives.

For the next two years, Whistler attended school at Christ Church Hall in Pomfret, Connecticut. In July 1851 he entered the service academy at West Point. His years at the academy were marked by bad study habits, a mercurial temperament, and a notable lack of discipline. Drawing class was one area where he excelled, instructed by Robert W. Weir. Whistler's first self-portraits date from his West Point years. These drawings are quick sketches used to illustrate letters to his family. Even as juvenilia, however, they contain the seeds of many attributes of later portraits. The visual cues identifying the figure are the great shock of curly dark hair, as depicted in *Whistler with Uncombed Hair* [Fig. 1:7], and the early introduction of an eyepiece, in *Whistler Examining His Foot* [Fig. 1:8]. These terse sketches match the accounts of Whistler's appearance by his contemporaries at the academy.

Fig. 1:5.
William Gibbs McNeill Whistler and James McNeill Whistler by an unidentified photographer. Daguerreotypes, circa 1847. Published in Joseph Pennell and Elizabeth Robbins Pennell, *The Life of James McNeill Whistler*, 1908

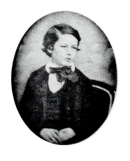 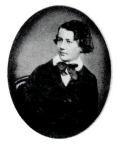

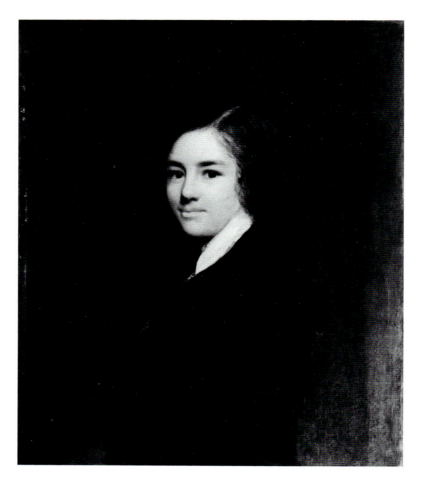

Fig. 1:6.
Whistler at Age Fourteen by
Sir William Boxall
(1800–1879). Oil on canvas,
74.9 x 61 cm.
(29 1/2 x 24 in.), 1849.
Hunterian Art Gallery,
University of Glasgow,
Scotland; Birnie Philip gift

Fig. 1:7.
Whistler with Uncombed Hair
by James McNeill Whistler.
Pen and ink on paper, 1850s.
Pennell Collection, Manuscript
Division, Library of Congress,
Washington, D.C.

He was *"a vivacious and likeable little fellow,"* as General C. B. Comstock describes him, and we get a picture of him, short and slight, *not overmilitary in his bearing, somewhat foreign in appearance, near-sighted, and with thick black curls that won him the name of "Curly" among the cadets.*[8] Whistler was proud of his profuse curls, and paid great attention to his appearance, particularly his hair, throughout his life. In spite of his later assertions, the notorious white lock did not appear for another fifteen years.

In June 1854 he was dismissed from West Point after accumulating a record number of demerits, crowned by his deficiencies in chemistry. Whistler did not take his dismissal from the academy personally, however, often referring to himself as a West Point man in later life. After briefly working as an apprentice draftsman in Baltimore, Whistler moved to Washington, D.C., where he was

Fig. 1:8.
Whistler Examining His Foot by James McNeill Whistler. Pen and ink on paper, 1850s. Pennell Collection, Manuscript Division, Library of Congress, Washington, D.C.

employed by the United States Coast and Geodetic Survey. There he learned to etch in the few hours per week when he managed to attend work during the three months he was employed by the Geodetic Survey. In 1855 Whistler decided to study art in Paris. He arrived in France in November, never to return to the United States.

Whistler studied in Paris from 1855 until his move to London in May 1859. He was enrolled in the studio of the academic Swiss artist Charles Gleyre for most of this period, but his education extended beyond the traditional boundaries of the studio class. He spent time copying in the Louvre, sketching on the street, and living

a thoroughly Bohemian existence in the cafés and dance halls of Paris. The Pennells relate that before leaving America, Whistler read Henri Murger's *Scènes de la vie bohème,* a virtual manual of undisciplined student life in Paris.[9] All of the early biographies and memoirs agree on the uninhibited nature of Whistler's life during this time, though there is some disagreement about his diligence in studying to be an artist. In general, the artist's English contemporaries in Paris regarded him as indolent and undisciplined, a view that set the tone for later British criticism of the artist. His French acquaintances, on the other hand, recalled him as industrious and imaginative.[10] Whistler's dedication to developing his skills as an artist, and the beginnings of his construction of an artistic persona, are evident in the self-portraits dating from this time.

The Freer Gallery contains several self-portraits from the student years. *An Artist in His Studio* [Fig. 1:9] is probably the earliest, a drawing dated about 1856.[11] A young man sits at a table, surrounded by the typical decorations of an art student's room: small model figurines on the table, an easel with a canvas, prints or sketches on the walls, laundry, bookshelves, and a small stove. Other realistic details include a small lamp and drawing tools on the table; on the floor in the foreground is a book titled *Fuseli,* a reference to the eighteenth-century Swiss artist Henry Fuseli. Some elements of the scene relate specifically to Whistler. The hat on the wall beyond the table matches the type that Whistler wore—a straw hat with a stiff brim, which was uncommon in Paris at that time. A portfolio leaning against the chair is inscribed "J. Whistler Au 5me No. 7 Rue Galeres, Quartier

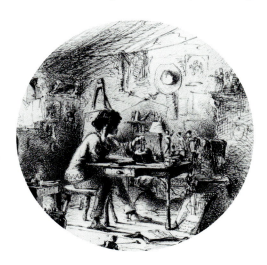

Fig. 1:9.
An Artist in His Studio by James McNeill Whistler. Pen, ink, and pencil, 23.4 cm. (9 3/16 in.) diameter, circa 1856. Freer Gallery of Art, Smithsonian Institution, Washington, D.C.

Latin." The artist seated at the table has a big mop of curly dark hair and a thin mustache. The combination of these elements makes it probable that this is, in fact, a self-portrait. The figure leans on his right elbow, a traditional pose associated with artistic temperament at least since Albrecht Dürer's engraving *Melancolia* of 1513. The object in Whistler's left hand is difficult to perceive, but it may be an artist's compass or other artist's tool. Whistler rendered this view of a room in Paris in the sketchy style characteristic of his earliest student years, deriving from the style of period illustrators such as Paul Gavarni.[12]

Whistler's admiration for Gustave Courbet during this period is well documented. It is instructive to contrast Whistler's modest view of his own poor surroundings with Courbet's *The Artist's Studio: A Real Allegory Summing Up Seven Years of My Artistic Life,* the work that dominated Courbet's special exhibition accompanying the 1855 Universal Exhibition, shown just a few months before the American's arrival in Paris. Reviews and notices continued to appear throughout the year, and the controversial masterpiece cannot have escaped Whistler's notice.[13] However, the younger artist's depiction of a studio is intended to be a direct and realistic view of the actual circumstances of an artist's environment, in contrast to Courbet's painting, with its grandiose allusions to the various orbits of the artist's life. Despite the differences in their representations of the artist's working environment, the youthful Whistler demonstrated his early adherence to a realist aesthetic

in his modest circular drawing. Courbet's influence on him remained significant during the next ten years, as may be seen in Whistler's *The White Girl* of 1862 and in numerous paintings of the period.

The sketchiness of *An Artist in His Studio* relates the work to another self-portrait, an etching entitled *Early Portrait of Whistler* [Fig. 1:10], dating to 1857–1858. This print shows the artist half-length, a cigarette in his left hand. The head is carefully rendered to emphasize the luxuriant curls and attentive gaze.[14] In contrast to the face and arm, the costume and background are rendered with substantial freedom. Rembrandt's stylistic influence is evident in the sketchy quality of the drawing and the sense of direct observation. The Dutch master was among Whistler's earliest and most enduring artistic idols, and the first of his etched self-portraits is reminiscent of several of Rembrandt's youthful self-portrait prints.[15]

French artists of the Second Empire admired Dutch painting as a model of a popular democratic art, because it concentrated on the history and fashions of its own time. The realist impulses of the nineteenth century provided a sympathetic environment for the homely subjects of Dutch art. Rembrandt was particularly esteemed both for his dramatic use of light and shadow and for his unidealized depictions of the burghers and merchants of Amsterdam. Whistler had access to Rembrandt's work in his brother-in-law Seymour Haden's print collection, in sales shops, in contemporary reproductions, and in the Louvre.[16] Accounts by Whistler's contemporaries confirm his admiration for Rembrandt.[17] Two surviv-

Fig. 1:10.*
Early Portrait of Whistler by James McNeill Whistler. Etching, 11.4 x 7.6 cm. (4 1/2 x 3 in.), 1857–1858. S. P. Avery Collection, The Miriam and Ira D. Wallach Division of Art, Prints and Photographs, The New York Public Library, New York City, Astor, Lenox and Tilden Foundations

Fig. 1:11.*
Whistler Smoking by James McNeill Whistler. Oil on wood, 26 x 18.4 cm. (10 1/4 x 7 1/4 in.), circa 1855–1860. Private collection

ing painted self-portraits of the Paris years reveal the same affection: *Whistler Smoking* and *Whistler in a Beret*.

Whistler Smoking [Fig. 1:11] shows the artist wearing his familiar straw hat. He used chiaroscuro to emphasize the brighter areas of the face and hat and, to a lesser extent, the hand. The hat, set at a rakish angle, establishes Whistler's Bohemian attitude. Luke Ionides, a friend of the artist during his student days, later related: "He was just twenty-one years old, full of life and 'go,' always ready for fun, good-natured and good-tempered—he wore a peculiar straw hat slightly on the side of his head—it had a low crown and a broad brim."[18]

The hat was only one component of the conspicuous outfit that Whistler wore at this time. Thomas Armstrong, another of his friends, remembered his *first sight of Whistler . . . for his appearance, at all times remarkable, was on that occasion most startling. . . . It was in the warm weather of August or September, and he was clothed entirely in white duck (quite clean too!), and on his head he wore a straw hat of an American shape not yet well known in Europe, very low in the crown and stiff in the brim, bound with a black ribbon with long ends hanging down behind.*[19] Several of Whistler's con-

temporaries also related the importance of cleanliness for the American artist, despite the reports of his dissolute life.[20]

The other oil of the period, *Portrait of Whistler in a Beret* [Fig. 1:12], is an even more transparent reference to the art of Rembrandt. The painting resonates with Whistler's acknowledgment of the Dutch master, from the way in which the beret frames the head to the way the face emerges from the shadows. Théodore Duret, writing in 1904, stated that Whistler had admired the beret and wavy hair of Rembrandt's *Portrait of a Young Man* in the Louvre.[21] Duret was the first to connect the Freer self-portrait painting with the Louvre's Rembrandt, and the Pennells' later analysis crystallized the connection: *The portraits "smell of the Louvre." The method is acquired from close knowledge of the Old Masters. "Rembrandtish" is the usual criticism passed on these early canvases, with their paint laid thickly on and their heavy shadows. Indeed, it is evident that the portrait of himself must have been done after long and careful study of Rembrandt's Young Man in the Louvre.*[22] Rembrandt's impact on the young Whistler is connected to the influence of Dutch art on Courbet and the realists of mid-nineteenth-century France. Courbet's

Fig. 1:12.
Portrait of Whistler in a Beret
by James McNeill Whistler.
Oil, 46.3 x 38.1 cm.
(18 1/4 x 15 in.), 1857–1858.
Freer Gallery of Art,
Smithsonian Institution,
Washington, D.C.

Fig. 1:13.
Succès d'Ernest à Cologne
by James McNeill Whistler.
Pencil, 9.8 x 15.1 cm.
(3 7/8 x 5 15/16 in.), 1858.
Freer Gallery of Art,
Smithsonian Institution,
Washington, D.C.

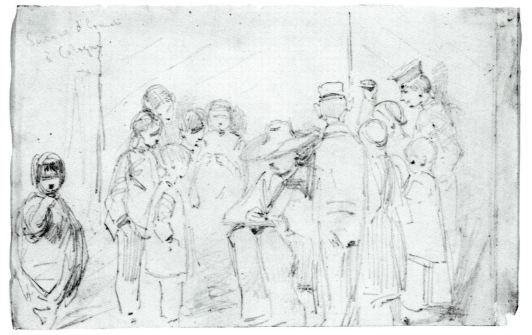

Fig. 1:14.*
The Title to "The French Set"
by James McNeill Whistler.
Etching, 11.4 x 14.6 cm.
(4 1/2 x 5 3/4 in.), 1858.
Rosenwald Collection,
National Gallery of Art.
© 1994, Board of Trustees,
National Gallery of Art,
Washington, D.C.

self-portraits of 1846–1847 provide another possible source for Whistler's early self-conscious imagery.

During the summer and early autumn of 1858, Whistler and the artist Ernest Delannoy made a trip through northern France, Luxembourg, and the Rhineland, visiting Nancy, Strasbourg, and Cologne. The tour resulted in several etchings for Whistler's first print series, *The French Set,* in addition to a group of self-portrait drawings and prints. The identity of the artist depicted in these graphics is problematic, since Whistler and Delannoy wore similar outfits.[23] Recognition is further obscured by an almost complete lack of knowledge about Delannoy and his work. An examination of the surviving visual material contributes to a fuller comprehension of Whistler's role in these

works, and how they served his artistic intentions.

The Freer Gallery's drawing *Succès d'Ernest à Cologne* [Fig. 1:13] provides useful clues to Whistler's other self-portrait drawings and prints. The artist's inscription identifies his friend Ernest, depicted wearing a large hat with the brim turned up. He is drawing, surrounded by children and adolescents. Though Delannoy is seated, the length of his legs indicates that he was at least of average height, probably taller than his diminutive American friend. Whistler used this drawing as the preparatory sketch for *The Title to "The French Set"* [Fig. 1:14].[24]

Whistler modified the etched image, changing the central figure into a self-portrait. The head has been redrawn with a crop of dark curls, while the hat has been altered, becoming Whistler's straw hat with its characteristic ribbon. Other changes have been made to the figure's hands and legs, and feet have been added. The inscription along the top of the print states, "Douze Eaux Fortes d'après Nature par James Whistler," followed by the name of the printer and the date, "Imp. Delâtre. Rue St. Jacques 171. Paris. Nov. 1858." The artist's name is darker than the other text, and is located directly above the self-portrait. It serves both as a means of identifying the central figure and as an act of artistic self-assertion.

The Title to "The French Set" is one of the key images in Whistler's early development as an artist. The image defines his artistic goals, placing him firmly in the movement toward naturalism and toward the realist style. Whistler represents

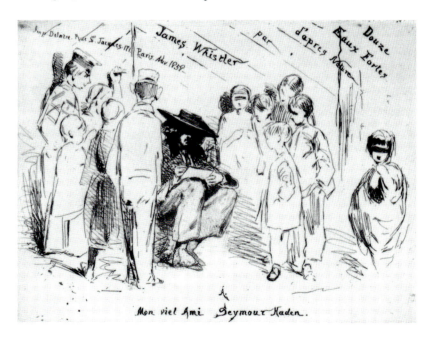

himself seated in the midst of contemporary life. His figures are drawn from the palpable, material world around him, not from the classical past or from a literary narrative. Surrounding the artist are working-class children. The academic narratives of Charles Gleyre's studio are set aside in favor of depictions of working-class women and humble street scenes. Views of interiors show the unadorned homes of the poor, not the familiar middle-class atmosphere of Whistler's family in London. On the cover of the set is Whistler, the youthful realist pursuing the dictum of Courbet, "To be in a position to translate the customs, the ideas, the appearance of my epoch according to my own estimation; to be not only a painter, but a man as well, in short, to create living art—this is my goal."[25] *The Title to "The French Set"* represents Whistler picking up the gauntlet that Courbet had tossed at the feet of the younger generation, defining himself not just as an artist, but as an artist at the center of the contemporary movement. When the first edition of twenty-five sets was published in Paris in November, *The Title to "The French Set"* was printed on *chine collé* along with the other prints, and included as a thirteenth etching. Later, in London, an additional fifty sets were issued with the *Title* printed on a dark blue cover for the series, which enclosed the other twelve etchings. The *Title* served as the announcement both of the subjects and of the style of the prints enclosed in the package.

Whistler Drawing [Fig. 1:15] is a related sketch in the Freer Gallery. Again an artist is portrayed drawing, with several rustic figures standing and watching his progress. The seated person also seems to be Ernest Delannoy, judging from his appearance and hat. A seated artist and three similar rustic figures also appear in a rare Whistler etching of 1858, *Whistler Sketching* [Fig. 1:16]. The artist again substituted his own image—identifiable by the straw hat and the curly hair—for that of Ernest.[26] The inscription reveals that the etching was originally intended as the cover print for *The French Set*. Whistler mistakenly failed to reverse certain letters on the copperplate, a common error among inexperienced printmakers. The opening "E" and "F" of "Eaux Fortes" and the "d" of "d'après" appear backwards on the printed impressions, the reason that Whistler executed a replacement title page. As in *The Title to "The French Set,"* his printed name is directly below the figure shown sketching, identifying Whistler as both sitter and artist. These early self-portraits return repeatedly to the theme of the artist at work, in order to emphasize his self-definition as an artist and to promote this image to others.

Blanchissage à Cologne [Fig. 1:17] relates in terms of both subject and style to the etched self-portraits. Whistler appears full-length in this sketch, in profile to the left. Dressed in his white linen suit with a bow tie, he extends his arm to inspect his shirt. A washbasin and pitcher are added props. The Pennells relate Whistler's story of how he "was reduced to washing his own shirt" during a period when he had run out of money.[27] The drawing remarks upon Whistler's sense of cleanliness and the importance of his appearance, even during his student years.

While Whistler was in Gleyre's atelier in Paris, he met several English artists, including Thomas Lamont, George Du Maurier, Edward Poynter, Joseph Rowley,

Fig. 1:15.
Whistler Drawing by James McNeill Whistler. Pencil on paper, 20.8 x 15.4 cm. (8 3/16 x 6 1/16 in.), 1858. Freer Gallery of Art, Smithsonian Institution, Washington, D.C.

Fig. 1:16.*
Whistler Sketching by James McNeill Whistler. Etching, 15.9 x 10.6 cm. (6 1/4 x 4 3/16 in.), 1858. The British Museum, London

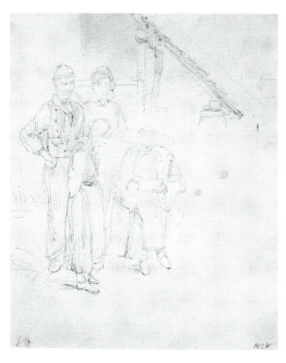

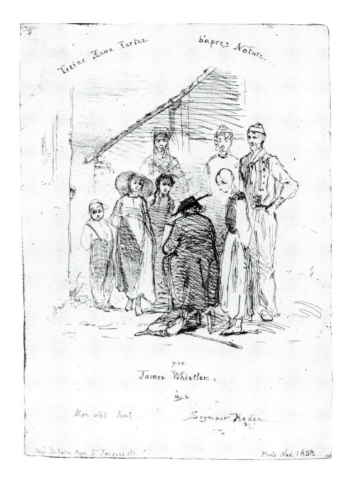

Fig. 1:17.
Blanchissage à Cologne by James McNeill Whistler. Pencil, 15.1 x 9.8 cm. (5 15/16 x 3 7/8 in.), 1858. Freer Gallery of Art, Smithsonian Institution, Washington, D.C.

and Thomas Armstrong. Whistler spent time studying and relaxing with the close-knit group but never became an integral part of the company. Although they shared a common language and a familiarity with British art, the English students had different artistic interests from the American expatriate.[28] Whistler was attracted to Courbet and the progressive French realists who were questioning the basic function and role of art. The British were more concerned with absorbing the conventional academic technique of Ingres and its application to traditional narrative painting. They were in Paris because the atelier system offered a more serious academic training than the Royal Academy in London. They constituted an insular group that was neither rebellious nor avant-garde. Most came from the upper class, and they led orderly lives far removed from the poverty and Bohemian existence of the young French artists.

Du Maurier, for example, lived with his mother and sister in comfortable circumstances throughout his year in Paris.[29]

Among the British students, Whistler was closest to Armstrong and Du Maurier.[30] Armstrong was enrolled at the atelier of Ary Scheffer but shared studio space with Poynter, Lamont, and Du Maurier. Later, he had moderate success as a painter and as the director of art at South Kensington, where he was responsible for museum acquisitions and the curriculum of the art school.[31] Armstrong's and Du Maurier's recollections, along with the latter's early correspondence, are the basis of much of what is known of Whistler's Paris days and first years in London.[32] A half-century later, Armstrong recalled, "Whistler was never wholly one of us."[33]

While the English group attended the atelier regularly, Whistler's attendance at Gleyre's studio was so erratic that "his

very appearance caused surprise."[34] The artist seldom worked alongside his English friends but sometimes frequented their studio in search of camaraderie and recreation. The studio, on the rue Notre Dame des Champs, had a few pieces of furniture, including a piano, and was decorated with plaster casts, copies of old-master paintings, and a series of drawings of Whistler on the wall. A letter from Joseph Rowley to the Pennells described Whistler and the studio: *It was in 1857–1858 that I knew Whistler, and a most amusing and eccentric fellow he was, with his long, black, thick, curly hair, and large felt hat with a broad black ribbon around it. I remember on the wall of the atelier was a representation of him, I believe by Du Maurier, a sketch of him, then a fainter one, and then merely a note of interrogation—very clever it was and very like the original. In those days he did not work hard, and I have a faint recollection of seeing a head painted by him in deep Rembrandtish tones which was thought very good indeed. He was always smoking cigarettes, which he made himself, and his droll sayings caused us no end of fun.*[35] The sketch on the wall was among the first of Du Maurier's many depictions of Whistler. The illustrator portrayed his friend repeatedly in his early published caricatures and later in the 1894 novel *Trilby*. The earliest surviving sketch by Du Maurier that includes a depiction of the American artist is *Ye Society of Our Ladye in the Fieldes* (1857). This sketch includes vignettes of seven of Du Maurier's friends, including Poynter, Lamont, and Armstrong.[36] Whistler appears in a position reminiscent of the early thumbnail self-portrait [see Fig. 1:8]. He is

identified by his shock of curly hair and by the inscription under the figure, which reads, "Ye singere of nigger melodies." The sketch represents a regular diversion of the English group. Occasionally, Whistler went to his friends' studio after four o'clock, when they had finished their afternoon work. Du Maurier would relax by playing the piano, and he, Lamont, and Poynter enjoyed singing. Whistler joined in with songs "of slavery and plantations. He would take a stick or umbrella, hold it in his left hand like a banjo, twiddle on it with the finger and thumb of his right hand, and patter grotesque rhymes founded on supposed adventures of scriptural characters."[37] The songs expose a racist streak in Whistler, shared by many of his upper-class American and British friends, that later resurfaces several times.

Whistler and Poynter, who was two years younger, lived together for a short time during Whistler's first year in Paris. Poynter was a hard-working student who regularly attended classes at Gleyre's studio. His attitude toward learning his craft was therefore very different from his American friend's, and he expressed his views of Whistler in a 1904 memorial speech: *Thrown very intimately in Whistler's company in early days, I knew him well when he was a student in Paris—that is, if he could be called a student, who, to my knowledge, during the two or three years I associated with him, devoted hardly as many weeks to study. His genius, however, found its way in spite of an excess of the natural indolence of disposition and love of pleasure of which a certain share has been the hereditary attribute of the art student.*[38]

Whistler attended the atelier sporadically, preferring to spend time copying in the Louvre or debating the artistic issues of the day in the cafés. Fluent in French since his early days in St. Petersburg, he entered readily into close relations with many youthful French artists, including Alphonse Legros, Delannoy, Félix Bracquemond, the sculptor Charles Drouet, and Henri Fantin-Latour.

Poynter did four portrait drawings of Whistler during the late 1850s. The earliest was a precisely rendered study that is initialed and dated September 27, 1856, Paris.[39] Poynter depicted the twenty-two-year-old Whistler with his eyes closed, perhaps napping, a hand-rolled cigarette in his mouth. All of the familiar attributes are included, with the curly hair crowned by a soft felt hat that is possibly the beret of the self-portrait oil of the same period [see Fig. 1:12]. *Whistler Napping* [Fig. 1:18] was the first of several images of the artist asleep. A portrait of an artist sleeping is sufficiently uncommon that its occasional occurrence with Whistler deserves some conjecture. Whistler's boisterous behavior and outgoing character are well documented. His distinctive features and attributes must have seemed particularly attractive to artists while he was in repose, in contrast to his aggressiveness while awake.

Poynter may have been inspired by Courbet, who exhibited a similar image the previous year in his private display across from the Universal Exhibition of 1855. *The Portrait of the Artist Called the Wounded Man* [Fig. 1:19] is a depiction of Courbet lying propped against a tree with his eyes closed. The addition of blood streaming across his shirt adds a symbolic element and has been associated with Courbet's romantic difficulties.[40] Poynter's portrait of Whistler imitated the appearance of a prone figure with a relaxed expression but eliminated the romantic attributes and associated context of the Courbet painting. Carolus-Duran, a student in Paris during the same period, would adapt the Courbet to similar purposes in an 1861 self-portrait, *The Sleeping Man*.[41]

Poynter's other portraits of Whistler were done two years later in London, during the winter of 1858–1859. Whistler visited London frequently during his student years. Since 1847 he had been a welcome visitor at 62 Sloane Street, the home of his half-sister Deborah and her husband, Dr. Francis Seymour Haden.

Fig. 1:18.
Whistler Napping by Sir Edward John Poynter (1836–1919). Pencil, 1856. Unlocated

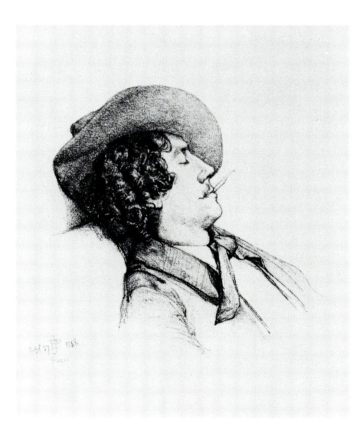

Whistler spent two months in London beginning in early November, a period of significant artistic activity. Working with Haden, who was an etcher as well as a physician, Whistler resolved a number of printmaking problems during this period and began marketing his first series of prints, *The French Set*.[42] He also began *At the Piano,* the first great success of his painting career, which was shown at the Royal Academy exhibition of 1860.

Poynter returned to London periodically during his four years of study in Paris, and one of his visits coincided with Whistler's two-month stay at the Hadens' home.[43] The English artist did three more drawings of Whistler at this time, two quick pen-and-ink sketches on a single sheet and the third in the delicate pencil technique of the earlier *Whistler Napping.* In the ink sketches *Whistler Drawing Poynter* and *Back View of Whistler*

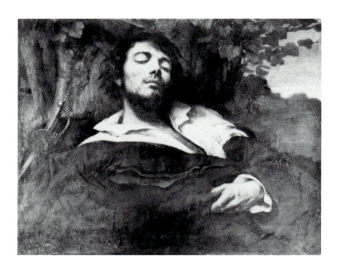

Fig. 1:19.
The Portrait of the Artist Called the Wounded Man by Gustave Courbet (1819–1877). Oil on canvas, 81 x 97 cm. (31 7/8 x 38 3/16 in.), circa 1844–1854. Musée d'Orsay, Paris

Fig. 1:20.
Whistler Drawing Poynter and *Back View of Whistler Seated* by Sir Edward John Poynter (1836–1919). Ink, 18.1 x 22.5 cm. (7 1/8 x 8 7/8 in.), 1858. Freer Gallery of Art, Smithsonian Institution, Washington, D.C.

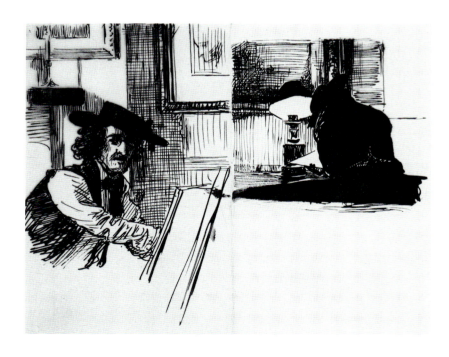

Fig. 1:21.*
James McNeill Whistler by
Sir Francis Seymour Haden
(1818–1910). Sepia drawing,
17.1 x 15.9 cm. (6 3/4 x 6 1/4
in.), 1858. The S. P. Avery Col-
lection, The Miriam and Ira D.
Wallach Division of Art, Prints
and Photographs, The New
York Public Library, New York
City, Astor, Lenox and Tilden
Foundations

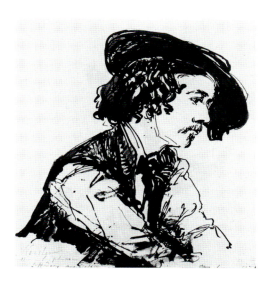

Seated [Fig. 1:20], Poynter captured the
artist in a domestic setting. Whistler
appears to be in his brother-in-law's home;
the paintings on the wall and the lamp on
the table indicate the location as 62 Sloane
Street.[44] On the left, Poynter depicts
Whistler half-length, in the act of either
drawing or painting on a canvas supported
on an easel. The familiar features and cos-
tume are represented, although the jaw is
too square. Whistler is wearing a dark
vest, an informal working outfit. Haden
depicted Whistler in a sepia drawing dat-
ing from the same time, which shows the
artist in profile wearing an identical cos-
tume [Fig. 1:21]. The other side of the
Poynter sheet views Whistler—identified
by the vest and hat—from the back, lean-
ing over a table. Poynter rendered the
bright glare of the light by contrasting the
untouched paper with the shade and the
solid black of the artist's back. The line-
work and hatching of both halves of the
sheet are indebted to woodblock illustra-
tions in contemporary English periodicals.

Poynter's other drawing of the artist,
Portrait of Whistler [Fig. 1:22], is initialed
and dated December 1858. The style is
similar to the earlier *Whistler Napping*.
Poynter carefully executed each detail
of this study, not as a quick impression of
Whistler but as a finished academic draw-
ing. The meticulous manner of the draw-
ing is related to its function as a study
for a portrait of Whistler that Poynter
painted on a sideboard designed by
William Burges.

William Burges was one of the out-
standing architects and designers of
his age.[45] He is credited with major

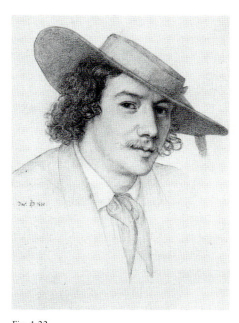

Fig. 1:22.
Portrait of Whistler by Sir Edward
John Poynter (1836–1919).
Pencil, 18.6 x 13.2 cm.
(7 5/16 x 5 3/16 in.),
December 1858. Freer Gallery of
Art, Smithsonian Institution,
Washington, D.C.

Fig. 1:23.
"Wines and Beers" sideboard
by William Burges
(1827–1881), 1859. The
Board of Trustees of the
Victoria and Albert Museum,
London

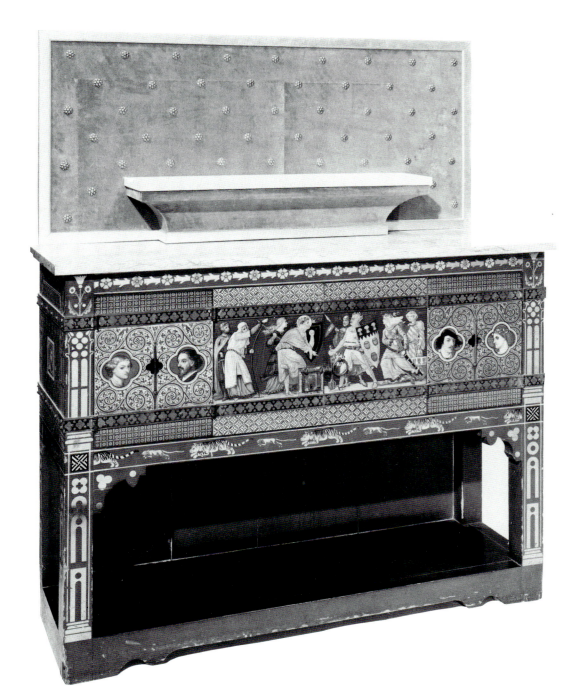

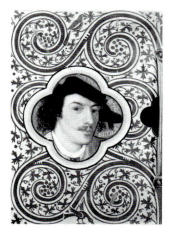

Fig. 1:24.
Detail of sideboard portrait of
Whistler by Sir Edward John
Poynter (1836–1919), 1859.
The Board of Trustees of the
Victoria and Albert Museum,
London

architectural achievements, including the design of Cork Cathedral and the restorations of Cardiff Castle and Castell Coch. His enormous range of interests extended from mosaics and medieval stained glass to Japanese pottery. Burges was acquainted with many of the most progressive artists in design and painting, being an intimate in the circle of Dante Gabriel Rossetti and the Pre-Raphaelite Brotherhood. He knew Edward John Poynter in the early 1850s through the painter's father, the architect Ambrose Poynter. Burges and the young Poynter spent time together in Rome in 1853–1854, and possibly in Paris in 1856, where he also could have met Whistler.[46] The painter and the architect met occasionally after the American immigrated to Britain in 1859; Burges's dinners with the "gallicised Yankee" are recorded in the diaries of a mutual friend, the artist G. B. Boyce.[47]

Burges began to employ Poynter to design stained glass and other decorative work in 1857, and they collaborated when Burges received his first contracts for painted furniture in a medieval style in 1858. At that time, Herbert George Yatman commissioned the architect to make a carved and painted cabinet that would include scenes from the legend of Cadmus and from the lives of Dante Aligheri and William Caxton. In addition to these figural scenes, Poynter included two portraits on the inside of the doors, accompanied by identifying inscriptions, "WILLIAM BURGES ARCH: INVENT" and "EDWARD J POYNTER: PICTOR PINXIT."[48]

In 1859 they worked together on one of Burges's most celebrated creations, the neo-Gothic "Wines and Beers" sideboard [Fig. 1:23], designed by Burges and painted by Poynter. The subject of the central panel on the sideboard is a battle between Sir Bacchus and Sir John Barleycorn. Bacchus, representing France and wine, is supported by personifications of Burgundy, Hock, and Champagne. Sir John Barleycorn, representing Britain and native brewing, is surrounded by Porter, Pale Ale, and Scotch Ale. Six quatrefoils with inscribed faces wrap around the sides and the front of the sideboard. Only two of the quatrefoil decorations contain clearly recognizable portraits: to the left of the central panel is a portrait of Rossetti and to the right is Poynter's portrait of Whistler [Fig. 1:24]. Whistler's iconographic association with the right side of the panel is not apparent, since the expatriate seems an unlikely choice to represent Britain, and he seems to have been fonder of wine than of beer or ale. Nor is there any discernible rationale for Rossetti, who was of Italian extraction, to represent France or wine. There is no doubt, however, that the drawing Poynter did in December of 1858 is the basis for the portrait of Whistler. The sideboard was shown at the 1859 Architectural Exhibition in London, and again at the International Exhibition of 1862, when it was purchased by the South Kensington Museum (now the Victoria and Albert), becoming the first portrait of Whistler to enter a public collection.

An 1859 drypoint [Fig. 1:25] is the artist's final self-portrait of his student years. He presents himself as an accomplished young artist with a strong, confident look in his eyes. The mature handling of the technique matches the assured gaze of the sitter. The etcher concentrated on the upper part of the plate,

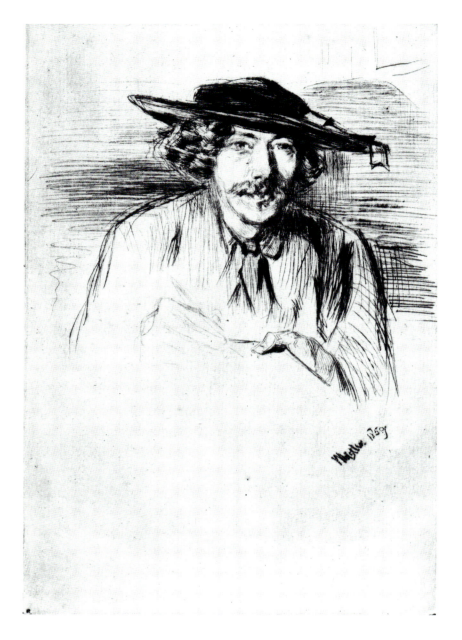

Fig. 1:25.*
Self-Portrait by James
McNeill Whistler. Drypoint,
22.5 x 15 cm. (8 7/8 x
5 7/8 in.), 1859.
S. P. Avery Collection,
The Miriam and Ira D.
Wallach Division of Art,
Prints and Photographs,
The New York Public Library,
New York City, Astor, Lenox
and Tilden Foundations

with only the artist's name and the year
on the lower section of the image. Here
and in other early portrait prints, Whistler
was influenced by the etchings of Van
Dyck, adopting a high degree of finish in
the heads, in contrast to a summary
working of the remainder of the plate.
Whistler emphasized his eyes and his
facial features, and reinforced the signa-
ture curls and straw hat with rich dry-
point highlights. The hands are barely
distinguishable; his left hand holds an
etching plate, while he draws with a nee-
dle held in the right. The artist appears
to have just glanced up into a mirror to
study his reflection—in another moment
he will look back down and continue
working on the plate. The sense that the
viewer is a witness to the progress of the
print gives the plate an immediacy beyond
most of Whistler's early works.

The student years behind, Whistler
moved to London to immerse himself in
the English art scene. Arriving in London
in May 1859, he stayed first at Sloane
Street with the Hadens and later took a
studio on Newman Street. During the
following year, he continued painting and
began working on another series of etch-
ings, *The Thames Set*. In the spring of
1860, Whistler submitted *At the Piano* to
the annual Royal Academy show, where
in May it became his first painting exhib-
ited in Britain. The work was praised by
several prominent painters and critics,
establishing him as a promising young
artist.

In the early 1860s, Whistler's circle of
friends included the Hadens, Dante
Gabriel Rossetti, the illustrator Charles
Keene, Thomas Armstrong, and George
Du Maurier. Du Maurier had left Paris in
1857 to pursue his studies in Antwerp,
where he suffered a complete loss of
vision in his left eye. After two years of
therapeutic travel and rest in Malînes and
Düsseldorf, he returned to London in
May 1860. Though painting was no
longer possible, the Englishman hoped to
pursue a career as an illustrator of popu-
lar weeklies.

Du Maurier contacted his friend
Whistler soon after arriving in London.
In a letter to his mother, he wrote that
Whistler had been very kind to him and
had offered to introduce him to the

Hadens and to his friend Charles Keene.[49] He related how he had seen Whistler's painting in the Royal Academy, and that it was the finest work in the exhibition. Du Maurier also wrote that Whistler's work was praised by the eminent Pre-Raphaelite artist John Everett Millais and by Sir Charles Lock Eastlake, director of the National Gallery of Art. Despite his admiration for Whistler's success, however, Du Maurier indulged in a bit of criticism of his friend's boasting: "But to hear Jemmy talk about it beats anything I ever heard. A more charming vagabond cannot be conceived."[50]

By June, Du Maurier had moved into Whistler's Newman Street studio, which "Jemmy" had vacated while working along the riverside in Rotherhithe. On occasion Whistler would come and spend a night or two, and they would stay up drinking and talking about their hopes for the future: "J. and I slept two nights here together and spent 48 hours during which he talked nearly the whole time. He is in my opinion the grandest genius I ever met, a giant."[51] Though the Englishman later tired of the egocentric American, he continued to admire his art.

Du Maurier solicited work as an illustrator from several periodicals, including the two most prestigious, *Punch* and *Once a Week*.[52] He had no success during the summer, but eventually had drawings accepted by both magazines in the autumn. One of his first contributions to *Punch* included a likeness of Whistler.

Du Maurier represented himself, with Whistler and Thomas Lamont, entering a photographer's studio in a wood engraving called *No Smoking Here, Sir!* [Fig. 1:26] in the October 6, 1860, issue of *Punch*. The humor of the situation is revealed by the caption.[53] Whistler is shown in a fashionable costume, with his jaw jutting forward and a serious expression on his face. Instead of the soft felt hat or the straw boater, he wears an elegant top hat and has a monocle in his right eye. Both articles appear here for the first time—recent additions to the Whistler persona. None of the figures in the illustration are identified by name, so only a few acquaintances may have recognized the artists.

A second illustration appeared in *Punch* on October 27. *Whistler as the Letter Q* [Fig. 1:27] was one of three ornamental letters that Du Maurier published in the magazine at this time.[54]

Fig. 1:26. *No Smoking Here, Sir!* by George Du Maurier (1834–1896). Wood engraving published in *Punch*, October 6, 1860

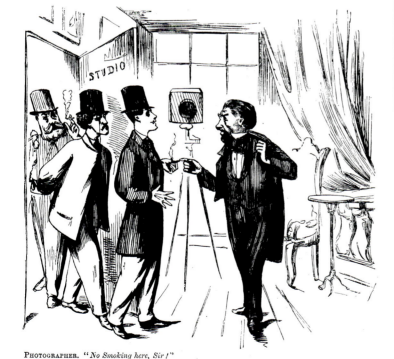

PHOTOGRAPHER. "*No Smoking here, Sir!*"
DICK TINTO. "*Oh! A thousand pardons! I was not aware that——*"
PHOTOGRAPHER (interrupting, with dignified severity). "*Please to remember, Gentlemen, that this is not a Common Hartist's Studio!*"——[N.B. Dick and his friends, who *are* Common Artists, feel shut up by this little aristocratic distinction, which had not yet occurred to them.]

Fig. 1:27.
Whistler as the Letter Q
by George Du Maurier
(1834–1896). Wood
engraving published in
Punch, October 27, 1860

The artist drew Whistler in profile, seated on the lower side of the "Q," his thin legs ingeniously crossed to form the tail of the letter. He is wearing his familiar straw hat and the newly acquired eyepiece. Again, Whistler is not identified in the surrounding text, but is clearly an artist in the act of painting.

Almost a year later, Du Maurier included a likeness of Whistler in an illustration for a story in *Once a Week*. Du Maurier wrote "Recollections of an English Gold Mine" about his experiences seven years earlier, when the Victoria Gold and Copper Mine Company had hired him as a young chemist to do scientific analysis at a mine at North Melton in Devon.[55] No gold was found, but Du Maurier recalled a splendid day when the directors and their families came for a visit, bearing hampers that contained a pastoral feast. Du Maurier rendered the scene of the picnic within sight of the mining operations, with the artist seated on the ground in the midst of the fashionably dressed Daumier-like company. The figure on the ground is not the author, however, but Whistler, with all of his characteristic attributes!

Du Maurier and other artists used likenesses of Whistler because of his distinctive features and dress—not because he was a recognizable figure. The identification of the subject was not necessary to the understanding of the illustrations, although a small circle of Whistler's acquaintances would have appreciated their visual wit.

Du Maurier repeatedly depicted Whistler in letters and sketches of the time, chronicling their common social life. In January 1861 the Englishman produced a program for a private dramatic performance at Tulse Hill, the home of Alexander Ionides, a wealthy Greek patron of the arts.[56] His son, Alecco Ionides, a friend of the artists since their student days in Paris, was represented between them at the top of the program, with other cast members below. Whistler and Du Maurier were frequent guests in the Ionides house at this time, and both enjoyed the amateur theatricals that were part of the entertainment at the formal balls.[57] Du Maurier reported his impressions of the evening in a letter to his mother: "The Theatricals went off splendidly. . . . I did my part stunningly, Bill [Henley] also distinguished himself. Jimmy was magnificent, but unfortunately got awfully drunk at supper and misbehaved himself in many ways. What splendid people these Greeks are."[58]

Another drawing of this time was inspired by similar circumstances. Du Maurier depicted a group of his talented friends in *Kycke and His Chummes*.[59] The artist identified each figure along the lower margin, including himself (labeled as Kycke, a childhood nickname) at the center table, along with Emma Wightwick and close friends Alecco Ionides and Poynter. Thomas Lamont, Thomas Armstrong, and Charles Keene stand on the left, while Lionel "Bill" Henley, the architect Thomas Jekyll, and the American artist John Chandler Bancroft are on the right. Du Maurier portrayed Whistler in a prominent location, on the floor at the

lower right. His dissipated appearance is suggested by his open mouth and narrowed eyes. Du Maurier had begun to tire of Whistler at about this time, as is evident from his letters: "Jimmy Whistler gone to Paris—*bon débarras; j'en devenais las;* nothing is more fatiguing than an egotistical wit."[60] In other letters, Du Maurier cited Whistler's contempt for those outside his immediate clique, as noted in a planned group exhibition of his work with Dante Gabriel Rossetti, Henri Fantin-Latour, and Alphonse Legros.[61] Du Maurier's admiration for Whistler remained constant throughout the 1860s, despite his personal feelings, as recorded in a letter he wrote to his mother in 1864: "Whistler is getting on very well now, wonderfully so considering that he is the great genius and innovator, the sort of fellow who dies in a hospital, while centuries after he has a statue put up."[62] Du Maurier's response to Whistler at mid-decade can be summed up in letters he wrote to his close friend, the painter Thomas Armstrong. While Du Maurier's letters to his mother were characterized by exaggeration, the letters to Armstrong contain candid observations about their mutual acquaintances. In a letter to Armstrong in 1865, he wrote: "I don't believe Jemmy *will* go to Paris, he will be less appreciated there than here. If he *does,* why, I don't suppose England will be exactly 'brackish with the salt of human tears.'"[63] At the same time, Du Maurier continued to praise Whistler's achievements. In a letter written to Armstrong in a pseudo-antiquarian style, he conveyed his feelings for both Whistler's work and their relationship: *I have moreover eaten the salt of James, the James that whistleth! We are friends. I marvel much*

at the cunning work his fingers have woven on the stretched cloth. The two damsels in snowy samite! and many a scape of sand & sea & sky which he hath lately wrought on some distant coast— I know not where.[64] Though he was disillusioned with Whistler as a trusted friend, Du Maurier was not blind to the quality of Whistler's painting. Another thirty years passed before Whistler appeared regularly again in Du Maurier's illustrations, in his 1894 roman à clef *Trilby* (see Chapter 3).

During Whistler's early London years, he returned frequently to France for extended periods to work and to exhibit. He had difficulty finding buyers for his work in Paris, as did other foreign artists. He had moved to London in part to find a more receptive market for his work, for, as Du Maurier later wrote to Armstrong about the possibility of their friend going to Paris, "As for his pictures he will send them over here—trust me."[65] Whistler wanted to remain involved in the Paris art community, as shown in his correspondence with Fantin and other French painters. He maintained contact with the progressive Parisian scene by exhibiting his work in art galleries and by submitting his work to the Salon and other exhibitions. Whistler spent substantial time in France during each of the first six years that he lived in London.

On one of these visits to the Continent, Whistler sat for portrait photographs by the French artist and photographer Étienne Carjat. Carjat had opened a photographic studio in Paris on the rue Laffitte in 1861.[66] A letter dated "20 juin 1863" from Carjat to Whistler begins, "in the next few days you will receive your portraits and your cards."[67] Whistler had

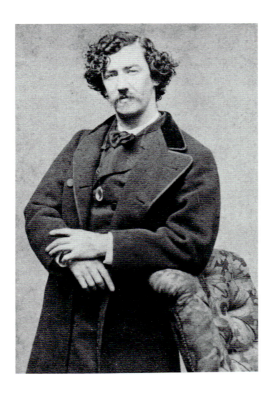

Fig. 1:28.*
Whistler by Étienne Carjat
(1828–1906). Photograph,
9.5 x 5.5 cm. (3 3/4 x 2 1/8
in.), circa 1863. Department
of Special Collections,
Glasgow University Library,
University of Glasgow,
Scotland (PH 1/95)

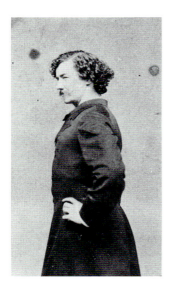

Fig. 1:29.*
Whistler by Étienne Carjat
(1828–1906). Photograph,
9.5 x 5.5 cm. (3 3/4 x
2 1/8 in.), circa 1863.
Department of Special
Collections, Glasgow
University Library,
University of Glasgow,
Scotland (PH 1/96)

been in Paris in April, and had probably posed for the photographs at that time, although he may have sat during one of his earlier visits. The colloquial style and intimate tone of the letter indicate a familiarity between the artists that extends beyond a business transaction.

Whistler's appearance is similar in the two photographs, which may date from the same sitting. In one [Fig. 1:28], Carjat posed Whistler in his overcoat, leaning on the back of a chair, and almost directly facing the camera; a monocle hangs on his chest above his awkwardly placed hands. In the second photograph [Fig. 1:29], Whistler posed in profile to the left, with his left arm akimbo. The profile portrait is a less-accessible image, with a spare quality accentuated by the absence of the over-coat, the monocle, and the chair. The photographer represented Whistler as mature and serious, but gave no clue as to his occupation. The images are not radically different from other contempo-rary *cartes* by Carjat or other French portrait photographers of the period,

although Nigel Thorp has suggested that the poses in the photographs could have been inspired by Velásquez.[68] The pho-tographs may have been used as an aid to Whistler's friend Fantin in his important group portrait of 1864, the *Hommage à Delacroix* (see Chapter 2).[69]

Whistler first met Henri Fantin-Latour in the fall of 1858. According to the Pennells, Fantin was copying Veronese's *Marriage Feast at Cana* in the Louvre when he was approached by "Personnage étrange, le Whistler en chapeau bizarre."[70] Though Fantin was two years younger, he had been studying in Paris since 1850 and copying in the Louvre since 1853. He took Whistler with him to the Café Molière, where the artists spent many evenings enthusiastically discussing their ideas about the latest developments in art with Alphonse Legros, Carolus-Duran, Félix Bracquemond, and others. Whistler and Fantin became close friends, and the letters between them over the following decade attest to their mutual respect and affection. With Legros they formed a group that Whistler referred to as the Société de Trois. In 1859, when all the members of the society were rejected from the Salon, they placed their works in a small exhibition of *refusés* at the studio of their friend François Bonvin. Whistler was represented by *At the Piano* in this show, "L'atelier flamand."[71] Fantin recalled that Courbet visited the exhibition and was impressed by Whistler's contributions.[72] Legros, Whistler, and Fantin never really constituted a formal group, but the exhi-bition gave evidence of their credibility as artists, their common roots in the realism of Courbet, and their interest in Dutch art. A later reference by Edgar Degas

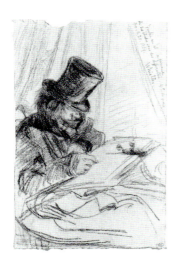

Fig. 1:30.
Fantin-Latour au lit by James
McNeill Whistler. Crayon,
24.5 x 15.6 cm. (9 5/8 x 6 1/8
in.), December 20, 1859.

confirmed these origins: "In our begin-
nings, Fantin, Whistler and I were all on
the same road, the road from Holland."[73]
The Société de Trois members remained
close for less than a decade, but their
relationship was critical to their early
development as artists.

Two early drawings document the first
years of the friendship. Whistler's sketch
Fantin-Latour au lit [Fig. 1:30] represents
the artist in bed, fully dressed with over-
coat and top hat, a scarf tightly wrapped
around his neck and chin, and his hand
heavily wrapped against the cold. An
inscription in Whistler's hand relates,
"Fantin au lit à la poursuite de ses ètudes
sous des difficultés." The figure of Fantin
matches the figure in another drawing
from the same period, a self-portrait
called *Whistler with Friends* [Fig. 1:31].[74]
Whistler is seen from behind, wearing his
"chapeau bizarre," his hands in his pock-
ets, conversing with a man in a top hat.
Behind them is the faintly drawn image of
a woman. This slight sketch is a charm-
ing record of their student days.

Whistler's development had begun in
Paris, studying in Gleyre's atelier, copying
in the Louvre, and interacting with a circle
of artists. The earliest self-portraits thus
are assertions of his identity as an artist,
executed in the realist vein popularized by
Gustave Courbet. Later drawings of
Whistler done by his friends Poynter and
Du Maurier mark his entry into the British
art scene in the early 1860s—a time during
which he continued to exhibit regularly in
France. The following decade would wit-
ness Whistler's growing fame on both
sides of the Channel and his increasing
identification as one of the leaders in the
contemporary art movement.

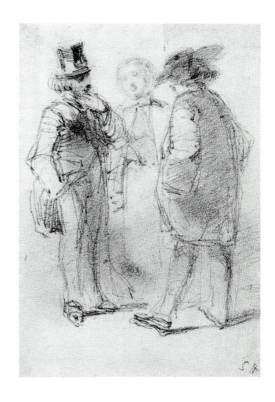

Fig. 1:31.
Whistler with Friends by
James McNeill Whistler.
Pencil, 16.4 x 10.8 cm.
(6 7/16 x 4 1/4 in.), 1859.
Freer Gallery of Art, Smith-
sonian Institution,
Washington, D.C.

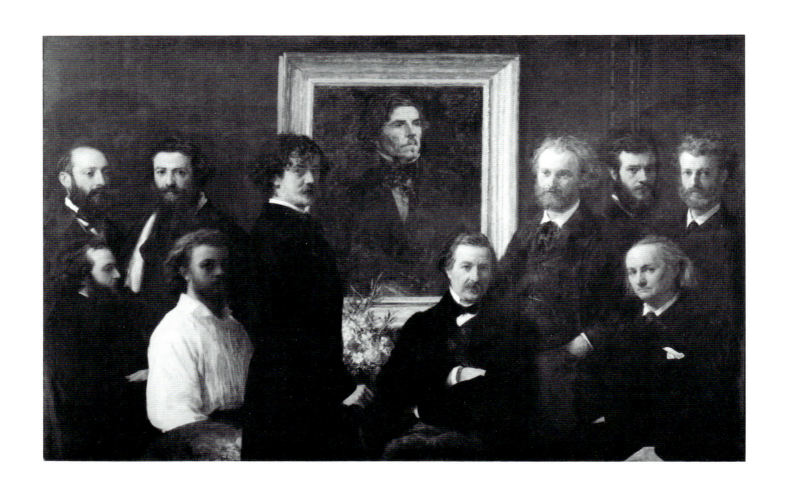

2

Early Recognition in Paris and London

Henri Fantin-Latour and Whistler remained in regular contact after Whistler's immigration to England, and Fantin was one of his first visitors at the Hadens' house on Sloane Street. Whistler, in turn, returned to France for a portion of each year to paint and to arrange for his work to be exhibited. The two artists respected each other's art and ideas, and Whistler's letters to Fantin during this period are among the most candid and revealing of all of his correspondence.[1] Fantin was Whistler's closest friend and most trusted confidant. When the jury rejected Whistler's painting *The White Girl* for the 1863 Salon, it was to Fantin that Whistler wrote, requesting him to submit the work to the *Salon des refusés*. Later in the year, when Fantin conceived a group portrait of contemporary artists gathered in tribute to the recently deceased Eugène Delacroix, it was logical that he would include Whistler in a prominent location.

Delacroix had died on August 13, 1863. The funeral arrangements were modest for a painter who had been widely acknowledged as the leader of the Romantic movement for the past half century and as a "living immortal."[2] A handful of mourners, mostly painters and critics, heard two brief eulogies. Edouard Manet, Fantin, Jean-François Millet, and Antoine-Louis Barye were among the artists who were there, along with photographers Gaspard Félix Nadar and Étienne Carjat and critics Charles Baudelaire, Jules-François-Félix Champfleury, and Jules Castagnary. Fantin, Manet, and Baudelaire were indignant that the government had ignored the passing of the great painter and that there was no official eulogy. Shortly after the funeral, Fantin conceived of a group portrait to protest the shabby official arrangements and to pay appropriate homage at the death of such an important artist. Encouraged by Manet and Baudelaire, the artist began planning the *Hommage à Delacroix* [Fig. 2:1] within a month of Delacroix's death.[3]

Fantin wrestled with questions of conception and composition during the next six months. Would the painting be allegorical, with symbolic figures included to honor Delacroix, or should he choose a more contemporary approach? The earliest surviving sketch [Fig. 2:2] for the *Hommage à Delacroix*, dated September 11, 1863, defines the problems that Fantin experienced. Gathered around a bust of Delacroix are nine figures, seven of whom are artists and critics, identified by a number corresponding to a legend in the margin. From the chart to the right of the sketch, it is clear that Fantin was including artists who had not actually attended Delacroix's funeral. A central grouping is

Fig. 2:1.
Hommage à Delacroix by Henri Fantin-Latour (1836–1904). Oil on canvas, 160 x 250.2 cm. (63 x 98 1/2 in.), 1864. Musée d'Orsay, Paris

45

Fig. 2:2.
Earliest surviving sketch for
Hommage à Delacroix by
Henri Fantin-Latour
(1836–1904). Pen and ink
with wash, 14 x 20 cm.
(5 1/2 x 7 7/8 in.),
September 11, 1863.
Musée d'Orsay, Paris

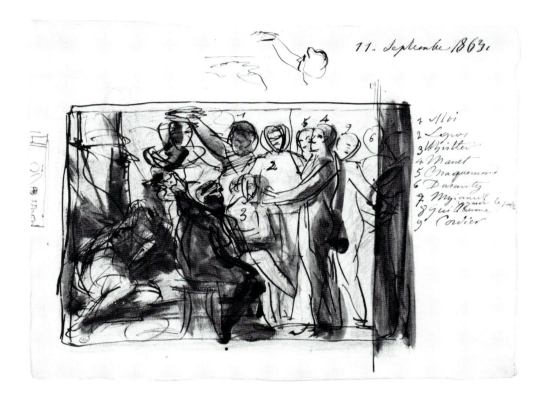

comprised of the Société de Trois—the artist ("Moi"), Alphonse Legros, and Whistler. Fantin himself is represented crowning the bust with a traditional laurel wreath. Edouard Manet, Félix Bracquemond, and the artist Louis Cordier are grouped on the right with the critic Edmund Duranty. The two figures crouching at the base of the bust of Delacroix are allegorical representations of grieving muses. This mix of contemporary and allegorical figures appeared in Fantin's successive studies during the next several months, although mostly without being clearly identified.

At this time, Baudelaire suggested a composition representing the apotheosis of Delacroix, with the deceased surrounded by great writers who had inspired him, including Shakespeare, Goethe, and Byron.[4] Fantin rejected the idea of historical figures, eventually settling on *personnages réels*. In a small oil sketch of late

1863, the artist resolved the question of realism or allegory, placing figures in contemporary costume surrounding a bust of Delacroix. Fantin sent Whistler a sketch of this work, together with a letter that is now lost. Whistler's reply survives in a note dated February 3, 1864: "Ton tableau sera superbe! La composition très belle, et je vois les têtes peintes par toi d'une couleur magnifique. Le buste sera peut-être difficile à arranger, mais j'ai la plus grande confiance en toi."[5] In the final study, dated January 27, 1864, the bust was replaced with a portrait of Delacroix that hung on the rear wall, behind a table with a vase of flowers.[6] Sixteen figures in contemporary costume encircled the table. In the final painting, Fantin reduced the number of figures to ten.

In *Hommage à Delacroix*, Fantin painted a group portrait of those he believed to be the contemporary artistic

avant-garde. The somber atmosphere of the work is in keeping with its function as a symbolic tribute, a public homage to the notable painter. All of the artists and critics in the portrait are dressed in dark, formal costume, as befits the seriousness of the occasion, with the exception of Fantin himself, who is wearing a painter's white smock. The figures are arranged in a shallow space, in two groups of five, divided by the portrait of Delacroix in the center. The cluster immediately to the left of center is the Société de Trois of the Paris years, with Alphonse Legros standing behind Whistler and Fantin. Louis Cordier, a painter little known today, stands next to Legros, with the writer and critic Edmund Duranty seated in profile next to Fantin. Manet stands on the opposite side of Delacroix's portrait, with his hand in his pocket. Standing next to him are the artists Félix Bracquemond and Albert de Balleroy. The critic Champfleury is seated in front of the portrait, and Charles Baudelaire is seated to his left. Seven of the individuals who were included in Fantin's first sketch of the *Hommage* also appear in the final composition; the figures of Champfleury, Baudelaire, and de Balleroy were added.

Fantin clearly took great pains to decide which artists and critics to include in the *Hommage*, and how they should be arranged. The portrait of Delacroix appropriately occupies a position just to the right of the painting's central vertical axis. Although the depiction of Delacroix appears superficially similar to a number of known likenesses of the painter, Fantin probably adopted the portrait-within-a-portrait from photographs or engravings. The monochromatic hue of the painted image contrasts with the range of tones in the surrounding figures. This tonal difference both emphasizes the posthumous nature of the Delacroix portrait and differentiates between the painting-within-the-painting and the living artists depicted. On either side of Delacroix are the two celebrated artists of the 1863 *Salon des refusés*, Whistler and Manet. Whistler's *The White Girl* and Manet's *Déjeuner sur l'herbe* were the two most excoriated paintings of the exhibition of works rejected at the Salon. These painters generally were recognized by other young realist artists and critics as the most advanced of their generation.[7]

Manet had included portraits of some of the same artists and critics in his 1862 *Concert in the Tuileries Gardens,* exhibited at Galerie Martinet in March of the following year. Within his updated version of the *fêtes champêtres* theme, Manet included portraits of himself, his old friend de Balleroy, Baudelaire, Champfleury, and Fantin, among other friends and relatives. Manet's painting is a slice of contemporary life, a recreational gathering depicted in the bright colors and social atmosphere of Second Empire Paris. Fantin's familiarity with Manet's work may have helped influence his choice of recognizable contemporary figures for the *Hommage*. Possibly he considered the painting a counterpart to the Manet, a representation of a serious gathering from daily life that portrayed the veneration of an artistic master.

Whistler is not only individually prominent, but he is also at the forefront of the Société de Trois, which occupies a conspicuous position to the left of center. Fantin removed himself from the place of honor he had had in the earliest sketches, yielding that spot to Whistler. Fantin

retained a distinguished position, however, identifying himself as the painter by wearing a smock and holding a palette. His head and shoulder also initiate a strong diagonal that leads through Whistler's collar and face to the head of Delacroix. Despite the visual evidence that Fantin had de-emphasized his place in the hierarchy of represented artists, contemporary criticism seized upon the ostensible egotism of his including himself in the *Hommage*.[8]

Manet is standing closest to the portrait of Delacroix on the right. The figure next to Manet is Félix Bracquemond, an old friend of the members of the Société, and a well-known printmaker and painter. Bracquemond, Manet, Whistler, Fantin, and Legros were all in the 1863 *Salon des refusés*, and they are the artists most closely grouped around the honored portrait of the master. The standing painters at either end of the composition are Louis Cordier on the left and de Balleroy on the right, the two least successful artists of their day and the two least remembered today. Cordier's inclusion is not well understood, but there were a number of reasons that Fantin included de Balleroy.[9]

The critics included in the group were all sympathetic to aspects of contemporary painting, though there was no unanimity of opinion among them. Baudelaire is included because he was the greatest critical champion of Delacroix; because of his support of Manet; and because he had praised the work of Whistler, Manet, Legros, and Bracquemond two years earlier in his article "Peintres et Aquafortistes."[10] However, Baudelaire does not have the most prominent position among the critics—that is left to his rival, Champfleury.[11]

The artist who is most celebrated in the painting is Whistler. Fantin placed his friend in the most prominent place in the composition, standing just left of center, the closest to the viewer of any of the figures and also the closest to Delacroix. Whistler's three-quarter profile parallels the position of Delacroix in the background, creating a significant association between the acknowledged master and the young American painter. The frame of Delacroix's portrait is interrupted by Whistler's familiar features, again emphasizing his preeminence in this gathering.

Whistler is also entrusted with the cut flowers that are a key part of the *Hommage à Delacroix*. Fantin himself was noted for his delicate floral paintings, and he was undoubtedly aware that Delacroix had sent a number of still lifes to the Salon in his later years. The decision to include a vase of flowers in the *Hommage* was partly a result of that shared interest in still life. Fantin's choice of cut flowers invites speculation on the essential character of the painting's realism. The bouquet does not simply represent nature but functions as an artful selection from nature. In a parallel manner, the figures in the *Hommage* are not representative of an actual gathering, but serve as a credible and thoughtful reconstruction of reality. The selection of Whistler to bestow the conspicuous bouquet upon the object of veneration bolsters both his and the still life's significance in this painting.

One major change in the final composition from the earlier studies holds an important key to understanding the *Hommage*. Throughout the various studies, Delacroix was either crowned with a laurel wreath or was the focus of adoration by the surrounding figures. In the final

painting, with the exception of Duranty, who is shown in profile, all of the figures look out toward the viewer, not at the portrait of Delacroix. Many writers commented on the bad manners of the sitters, but they misunderstood Fantin's intention. Even the prominent caricaturist Gill, in his lampoon of the *Hommage*, had included two figures who are seen from behind, facing the portrait of Delacroix.

The artists and critics depicted are not represented as followers or artistic descendants paying tribute to their master. They stand as a group, confident and aware of their role as leaders of a new era in the history of art. Fantin focused his attention, as well as that of his audience, on Whistler and Manet and the generation of youthful artists and contemporary critics who constituted the present and future of painting. The homage in this painting is not to the acknowledged leader of a vibrant, ongoing tradition, but to the master of a school that has run its course.[12] Delacroix was respected as an artist who had pursued his own vision and who supported the intellectual freedom of the younger generation. The flowers in Whistler's hand are in tribute to Delacroix, but are also symbolically placed on the tomb of Romanticism, which had expired the previous summer with the passing of its greatest exemplar. Fantin portrayed the artists who he believed would assume the status that Delacroix had held for earlier painters and critics, with Whistler at the forefront of the new group.

The *Hommage à Delacroix* was exhibited in the Salon of 1864 and met with mixed critical reviews.[13] Théophile Gautier and Henri-Julien Rousseau were laudatory, recognizing the scene as a realist subject and acknowledging the intent of the artist. Recognition of the key figures played an important role in the appreciation of the painting in the minds of the sympathetic critics. The writers depicted were widely understood to represent those reviewers who wrote in support of Courbet, Manet, and realism itself. The painters received harsher treatment than the writers from the critical press. As a group, the artist-models were regarded as youthful and inexperienced realists in the line of Courbet. Several writers commented that the artists were presumptuous to have placed themselves in the same context with Delacroix. The critic Alphonse Audéod defined the group as "exclusivement le culte du laid, du vulgaire et du grossier." Critics also questioned the nature of the tribute Fantin was attempting. His choice to portray obscure rather than well-known artists, instead of the writers and musicians who might have been more appropriately included, raised doubts in the critics' minds, as did the placement of the painting of Delacroix in the background.[14] As mentioned above, many reviewers also cited the bad manners of the sitters in turning their backs on the portrait so that they might look at the public, bringing glory on themselves rather than on the deceased.

In May 1864, Fantin wrote to the editor of *Figaro* in response to Rousseau's criticism, which had appeared in the same periodical. Rousseau had written that Fantin's self-portrait represented "modern painting," to which the artist took exception in his response. Fantin noted the importance of Whistler and Manet in the composition and suggested that they

would have been better choices to symbolize contemporary art: "Je la représenterai du reste encore bien moins que M. Whistler, l'auteur de la 'Jeune fille blanche' [sic] qui a été si remarquée au salon des Refusés en 1863; que M. Manet, cet incontestable talent qui a le don de déplaire aux amis du fade et du convenu."[15]

Whistler was appreciative of the place he had been given in the *Hommage*. In an earlier letter of February 3, 1864, he had said that the painting would be good for Fantin and was bound to bring him attention.[16] After the painting was exhibited, and he had visited the Salon and read the ample critical response, Whistler wrote to Fantin expressing his admiration for the character of the painting and telling Fantin that he had won for himself the position he had so long deserved in Paris.[17]

Fantin executed another group portrait during the following year, which was exhibited at the 1865 Salon—*Le toast: hommage à la vérité*.[18] He had been excited by the critical reception and notoriety that he had received at the previous Salon, but felt that his intentions had been misconstrued. As a result, he set about planning a painting that would convey his sense of the importance of truth in modern art, transcending the labels of romanticist or realist as they had been applied to the *Hommage à Delacroix*. During a period of ten months, extending from the middle of May 1864 until March 1865, the artist worked through various solutions to a contemporary tribute to the concept of truth.

Fantin's earliest drawings for the new work depicted a nude figure, holding a mirror to symbolize Truth, placed out-of-doors and surrounded by men dressed in contemporary costume. None of the men were individually identified; however, several included attributes to distinguish them as types: a figure with a violin representing music, an artist with an easel, a writer or printmaker at a desk. The setting was soon transferred into an interior. Although the number and placement of the men varied from study to study, the anonymous figures remained in most of the sketches done during 1864. A notable variation occurred in the studies from December, when Fantin temporarily replaced the symbolic figure of Truth with first one, and then two, painted portraits of Velásquez and Rembrandt. The final composition began to take shape in January, with the nude figure of Truth returning to the center of the composition, and with the characters surrounding her becoming clearly identifiable.

A drawing dated January 15 and 16 [Fig. 2:3] contained the earliest compositional arrangement leading to the finished painting as it was seen in the Salon of 1865. A female nude representing Truth is in a niche in the center of the composition, holding a mirror in one hand. Eight men in contemporary outfits, including two prominent standing figures, are around a table, divided evenly on either side of the allegorical figure. Marginal notes to the left of the sketch identify two of the artists included in the group—Whistler and Manet—who would occupy important positions in the final composition. In the lower left is a violinist representing Music, and in the lower right is an artist with a sketchbook representing Art. These symbolic figures disappeared

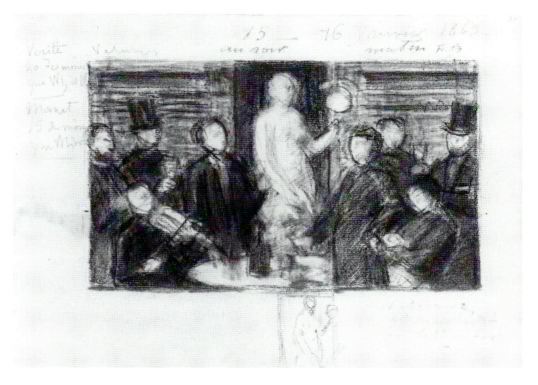

Fig. 2:3.
Drawing for *Le toast: hommage à la vérité* by Henri Fantin-Latour (1836–1904). Charcoal, 13.7 x 22.3 cm. (5 3/8 x 8 13/16 in.), January 15 and 16, 1865. Musée d'Orsay, Paris

from the ultimate composition, replaced by allegorical still-life elements on the table.

A ninth figure was added in a subsequent sketch, dated January 16 and 17 [Fig. 2:4]. In this study, Whistler is now identifiable in a conspicuous position in front of the table. He is also clearly listed in the marginal notes to the left of the drawing, with the standing figure to the right of Truth labeled as Manet. The two artists retained these positions in the painting submitted to the Salon in March. Although the painting no longer exists, a reproduction of a preparatory oil sketch conveys some idea of the final composition.[19] The artists included were Fantin himself, Whistler, Manet, Bracquemond, Cordier, Jean Cazin, and Antoine Vollon; the critics portrayed were Duranty and Zacharie Astruc. Fantin described the painting in a letter to his friend Edwin Edwards in February 1865: *Against a darkened background a bright cloud*

descends, it unfolds and in the center appears Truth, nude, glorious in her youthfulness; with one arm she rests against the cloud, in the other hand is a mirror. A bit of white drapery veils the lower part of her body. Below, partially obscuring her, is a table laden with flowers, fruit, glasses, bottles, musical instruments, a palette, attributes of the Arts and Sciences. In front of the table, standing, his hand on his hip and a glass in his hand, Whistler in a Japanese robe. Me, the no. 1 figure, turning and pointing to Truth, and on all sides people with glasses in their hands, raising a Toast to Truth. They are drinking to Truth, their ideal, and by one of those licenses granted to painting, which constitute one of its charms, their ideal, the object of their Toast, is made visible to the viewer.[20] Fantin named only himself and Whistler in the letter, noting Whistler's significant position. According to Adolphe Jullien, Fantin's friend and biographer, Whistler

Fig. 2:4.
Sketch for *Le toast: hommage à la vérité* by Henri Fantin-Latour (1836–1904). Charcoal, pen, and ink, 16 x 23.2 cm. (6 5/16 x 9 1/8 in.), January 16 and 17, 1865. Musée d'Orsay, Paris

had asked Fantin for this prominent spot, "la belle place, celle du devant."[21] The drawings and oil sketch do not reveal the most salient aspect of Whistler's appearance in the painting as Fantin described him in his letter to Edwards—the Oriental robe, distinct from the contemporary European costume of the other artists and critics. This was also Whistler's suggestion: "Pense à la robe, superbe à faire, et donne la moi."[22] The robe was Chinese, although Fantin later referred to it as Japanese. The artist considered it central to his conception of the painting. "Tous les portraits autour, autant de têtes dont on pourrait faire des chefs-d'oeuvre, la belle robe de Whistler."[23] The American was one of many artists—including Manet, Degas, Monet, and Bracquemond—fascinated by Asian art and costume in the 1860s. Whistler frequented La Porte Chinoise on the rue de Rivoli, where he purchased prints, porcelain, and other Oriental artifacts, as they were referred to at that time. He is credited with helping to initiate the taste for Japanese prints and Chinese porcelain in London. His paintings of this period— *Purple and Rose: The Lange Leizen of the Six Marks*, and *Caprice in Purple and*

Gold: The Golden Screen, both of 1864— indicate the strength of his attraction to Asian art and furnishings.

Whistler was represented in Paris in the 1865 Salon by *La Princesse du pays de la porcelaine* [Fig. 2:5]; this was the same exhibition where Fantin was showing *Hommage à la vérité*. The connection between Whistler's painting and Fantin's group portrait was undoubtedly in Whistler's mind when he submitted *La Princesse*, reinforcing his identification with the avant-garde contemporary taste for Asian art. Fantin included the robe as another indication of the breadth of Truth in art, not conceding to any one culture or school a monopoly on an homage to this principle. Later he came to regret the mixing of allegory and contemporary life, and the inclusion of the robe. "Je l'ai encore revu dans l'atelier en 1865, il me posa dans un tableau aujourd'hui détruit 'Le Toast,' ou il était costumé d'une robe Japonaise."[24]

Fantin had experienced serious doubts about his subject while planning the *Hommage à la vérité*, but submitted it to the Salon jury despite his uncertainty. The day after the submission deadline, he wrote to Edwards expressing his feelings

about the painting: *Presque tout est resté inachevé, ce qui maintenant m'afflige beaucoup. Il y a un morceau surtout beau: c'est Whistler en costume chinois. Son costume, le temps qu'il m'a donné, son attention à la pose, à ne rien négliger, en fait le meilleur morceau. Quelques têtes pas mal, voilà.*[25]

When the painting was accepted for the Salon, Fantin had new hopes that it would look better in the exhibition than it had in the studio. These hopes were dispelled by a visit to the Salon, where he was disgusted by his work, as he wrote to his friend Edwin Edwards.[26] With few exceptions, the critics agreed with Fantin's judgment that the blending of allegory and reality had been a mistake and was

beyond his capabilities as an artist. The artist considered some of the heads to be good, and the figure of Whistler to be well done, but he found little else with which to be pleased. When *Hommage à la vérité* was returned from the Salon, Fantin destroyed it, save for the heads of Vollon, Whistler [Fig. 2:6], and his own self-portrait.[27]

Whistler was one of Fantin's few friends who had appreciated the painting while it was in progress, and he maintained his high regard for it later, despite what the critics had written.[28] His opinion is not surprising, given his significant position in the scheme of the work. He later wrote to Fantin, telling him that despite his regret at the destruction of the

Fig. 2:5.
La Princesse du pays de la porcelaine by James McNeill Whistler. Oil on canvas, 200 x 116.2 cm. (78 3/4 x 45 3/4 in.), 1864. Freer Gallery of Art, Smithsonian Institution, Washington, D.C.

Fig. 2:6.
Head of Whistler by Henri
Fantin-Latour (1836–1904).
Oil on canvas,
46.8 x 36.6 cm.
(18 7/16 x 14 7/16 in.),
1865.
Freer Gallery of Art,
Smithsonian Institution
Washington, D.C.

painting, he was very flattered that his portrait had been preserved. He also expressed a desire for the remnant of his likeness to eventually go to the United States, since nothing would be more charming than to be represented in America by Fantin's portrait, a wish that was ultimately fulfilled.[29]

Fantin's two early group portraits depicted the artists he considered significant young talents within the context of the art of the time. In the *Hommage à Delacroix* he selected the painters who he felt had attained some degree of success, either in the Salon or in the *Salon des refusés*. He thought of these artists as the contemporary innovators in painting, carrying on the tradition of artistic freedom and the new realist style that had been first established by Courbet in the 1850s. The tribute to Delacroix had been intended not as an homage to the leader of a current and popular style, but to that master's artistic integrity and devotion to his own vision of artistic truth. In the *Hommage à la vérité*, the combination of realistic and symbolic details proved even less successful than in the earlier tribute.

Despite their unfavorable critical reception, the paintings did fulfill one of Fantin's goals. The artists and critics portrayed became more familiar as a result of being depicted in paintings that were shown in the Salon. The writers were the most identifiable among the two groups, followed by the best-known artists. Contemporary interest in the work was now directed toward likeness—much of the Salon criticism dealt with Fantin's abilities as a portraitist and on the recognition of the figures portrayed. In both *Hommage à Delacroix* and *Hommage à la vérité*, Whistler occupied the

place of honor, associated with the greatness of the master in one and giving the toast to Truth in the other. Fantin represented Whistler as a leader of the modern movement in painting. If the critics disagreed about the importance of the group as a whole, they would have understood that the artists had at least tacitly allowed Whistler to be represented as the preeminent painter in their circle, equal to or better regarded than Manet. Only the most unsympathetic writers of the time could have ignored the hierarchy employed by Fantin in these paintings. Whistler understood the significance of placement within the context of the group, as revealed by his own expressed desire for an important position. Can there be any doubt why Whistler lamented the demise of Fantin's *Le toast: hommage à la vérité*?

In 1865 Whistler began plans for a large figural composition, inspired in part by Fantin's two canvases. A letter to Fantin, dated August 16, 1865, described the planned painting.[30] Whistler was working on a canvas for the Salon that would represent "une réunion de nos autres à mon tour" in his studio. Fantin, Albert Moore, and Whistler himself would be included, with two female models portrayed—one seated, dressed in white, and another "la Japonaise," walking around.[31] Altogether, Whistler wrote, it would be an "apothéose" of everything that could scandalize the Academicians. The canvas would be rendered in "charming color," with Whistler dressed in gray, his mistress Jo Hiffernan in white, the Japanese model in flesh tones, and Fantin and Moore in black. Whistler mentioned that he had already done "une esquisse qui est bigrement bien," but that the painting was to

Fig. 2:7.*
The Artist's Studio by
James McNeill Whistler.
Oil on cardboard,
62.2 x 46.4 cm.
(24 1/2 x 18 1/4 in.), 1865.
Hugh Lane Municipal
Gallery of Modern Art,
Dublin

be very large, ten feet high and six or seven feet wide. The artist never executed the full-scale work, although two finished studies exist.

The sketch that Whistler mentioned is *The Artist's Studio* [Fig. 2:7], now in the Municipal Gallery of Modern Art in Dublin. The composition includes Whistler and two models, but the other artists have been eliminated. The models occupy one side of the painting—Jo sits on the settee, and an unidentified model in Japanese costume stands in front of her, holding a fan. In the corner beyond is a part of Whistler's collection of porcelain. The artist depicted himself on the right, holding a paintbrush in one hand and a palette in the other. On the wall behind Whistler are two framed works that are not identifiable. These same elements, with slight variations in detail, are repeated in a similar canvas at the Art Institute of Chicago, which is a later version of the Dublin sketch.[32]

The Artist's Studio is a manifesto of Whistler's diverse artistic inspirations. His early drawing of an artist at work had been an unsophisticated, realist depiction of the surroundings of an art student in Paris [see Fig. 1:9]. His familiarity with Courbet's large portrayal of an artist's studio, replete with allegorical allusions, has already been detailed. Here, in contrast, Whistler gathered a number of references to the art that he most admired at this moment in his career. Whistler's awareness of Courbet's painting was an embryonic element of the initial conception. Fantin's two group portraits provided a contemporary impetus for the planning of a large-scale portrayal of a gathering of artists. The elimination of the other painters from the

sketch shifted the focus from the group to Whistler himself. He included his own likeness in the painting within a complex scheme of references that compose a visually allusive self-portrait.

The most important source for *The Artist's Studio* is Velásquez's *Las Meninas* (1656), which also includes a self-portrait of the artist. Whistler had not seen the actual painting, but would have been familiar with the image through reproductions. A photograph from the artist's collection contains a remarkable detail of the left side of the composition [Fig. 2:8]. Only three foreground figures are included—the artist, the attendant, and the Infanta. The remaining figures, and the easel and canvas next to the artist, have been eliminated. Although no documentation exists for dating Whistler's acquisition of the photograph, the visual parallels between the detail of the Velásquez and *The Artist's Studio* are striking.[33]

Velásquez's masterpiece is similar in size to the canvas that Whistler had originally planned, ten feet high and more than eight feet wide. Whistler, holding a brush and palette, looks directly out of the painting at the viewer, as the Spanish master does in *Las Meninas*. While Velásquez depicted the working canvas within his composition, however, Whistler only suggests its presence. In *Las Meninas*, the implication is that Velásquez the artist is studying Philip IV and Queen Mariana, who are reflected in the mirror in the background. The subject of the painting becomes what the King and Queen observe while posing: the Infanta, the maids of honor, the dwarfs, the dog, the attendants, and most important, Velásquez in the act of painting their por-

Fig. 2:8.
Detail of Whistler's photograph of Velásquez's *Las Meninas*. Department of Special Collections, Glasgow University Library, University of Glasgow, Scotland (PH 3/8)

traits. The conceit of the painting is that it is about the concept of constructing the painting itself. The Baroque illusion of realism becomes a more compelling subject than the particular reality depicted. Velásquez skillfully contrived a meditation upon the relationship of art to the nature of perception and reality.

In *The Artist's Studio*, Whistler transported Velásquez's mirror from the back wall of the studio to a position parallel to the viewer, so that it literally reflects the inspirations of the studio. When Whistler looks directly out of the painting, he is, in fact, looking into a mirror, as verified by his depicting himself holding the brush with his left hand, which was not his painting hand. We see what the artist saw in the reflection: his own mirror image, his models, and his collection of porcelain. The elements of his work studio echo the realism of Velásquez, Japanese decorative art, and the classicism of Albert Moore. These influences are synthesized in Whistler's construction of a modern conception of art and its inspiration. He has turned decisively away from the realist intentions of Courbet and his milieu to an increasing emphasis upon artifice. Whistler's limited palette and broad

brushwork are evidence of the significant shift in his artistic concerns during the mid-1860s. During this period, he deliberately shunned the realist attempt to record nature in favor of the selective aesthetic interests of the nocturnes and arrangements.

Whistler held the work of Velásquez in high esteem in his pantheon of artistic achievement. During his student years, he had been impressed by the Spaniard's work in the Art Treasures exhibition in Manchester, England, in 1857, and had done a drawing after a now-reattributed equestrian work by Velásquez.[34] In the autumn of 1862, he had set out for Madrid to see Velásquez's works firsthand. Although he never reached his destination, his letters to Fantin, attempting to persuade his friend to join him, hold out the promise of seeing the works by the great Spanish painter together.[35] Whistler and Fantin shared an adulation for both Velásquez and Rembrandt during this period, as demonstrated by the brief substitution of portraits of these two masters for Truth during the development of Fantin's second group portrait. Whistler's continued reverence for Velásquez is visually represented in an undated watercolor, *Jimmy* [Fig. 2:9] by the caricaturist A. J. Clayton ("Kyd") Clarke. The painting on the rear wall in the watercolor is identified by the name appearing on the frame— Velásquez—and "Kyd" imitated the Spaniard's style in both the framed oil and the portrait of Whistler. In later years Whistler frequently cited Velásquez as among the greatest painters of the past.[36] He showered him with lyrical and laudatory praise in the Ten O'Clock Lecture in 1885: *At the Court of Philip, Velasquez, whose Infantas, clad in inaesthetic hoops,*

Fig. 2:9.*
Jimmy by A. J. Clayton
("Kyd") Clarke (lifedates
unknown). Watercolor,
61.3 x 49.5 cm.
(24 1/8 x 19 1/2 in.) framed,
not dated. The Board of
Trustees of the Victoria and
Albert Museum, London

*are, as works of Art, of the same quality
as the Elgin marbles. . . . From the sunny
morning, when, with her glorious Greek
relenting, she (Art) yielded up the secret
of repeated line, as, with his hand in hers,
together they marked in marble, the mea-
sured line of lovely limb and draperies
flowing in unison, to the day when she
dipped the Spaniard's brush in light and
air, and made his people live within their
frames, and stand upon their legs, that all
nobility and sweetness, and tenderness,
and magnificence should be theirs by
right, ages had gone by, and few had been
her choice.*[37] Whistler understood and
employed the art of the past within the
context of his personal idiom. His con-
struction of a self-image was based on the
old masters, but transformed by his mod-
ern formal concerns.

The Ten O'Clock Lecture also included
references to classical sculpture and archi-
tecture, Venetian Renaissance painting,
Japanese craftsmen, and Rembrandt.
*Arrangement in Grey: Portrait of the
Painter* [Fig. 2:10] was Whistler's final
visual tribute to the great Dutch master,
whom he considered art's "high priest."[38]
In the summer of 1871, Rembrandt's
Self-Portrait of 1659 [Fig. 2:11] was

shown publicly in Britain for the first
time.[39] Whistler's *Arrangement in Grey*
appeared in London at the Society of
French Artists exhibition in November of
1872.[40] His debt to Rembrandt's self-por-
trait is revealed by several crucial details.
The pose is almost identical, half-length
with the left shoulder turned perpendicu-
lar to the picture plane. In each work,
the heads have been painted with a thick
impasto, and they are more clearly
defined than the clothes or background.
The modified three-quarter view of the
head animates the portraits in a similar
fashion, as if the sitter has turned to
notice the viewer's presence. In both
paintings the dark beret functions as a foil
to emphasize the hair and illuminated
face. Whistler even appears to have bor-
rowed Rembrandt's raised eyebrow.
Obvious contrasts exist between the
brushwork and tonality of the two works,
deriving from Whistler's increasing focus
on the formal concerns of design and
composition. Nonetheless, the portrait
owes much to the inspiration of Rem-
brandt's *Self-Portrait*.

The contrasting intentions of the
painters, separated by two hundred
years, yield paintings that are superficially
similar but strikingly different in effect.
Rembrandt presented himself at about the
age of fifty-three, in a sober mood, as a
serious and thoughtful individual. He
sounds the depths of introspection, expos-
ing a private vein of emotion that was
revealed by few other artists. The
younger Whistler portrays himself with an
outward expression of confidence, as a
painter ready to make his mark on En-
glish art. His image is a rendering of the
surface of the persona, just as his interest
is in the harmony of color and form

Fig. 2:10.
Arrangement in Grey: Portrait of the Painter by James McNeill Whistler. Oil on canvas, 74.9 x 53.3 cm. (29 1/2 x 21 in.), circa 1872. Detroit Institute of Arts; bequest of Henry Glover Stevens, in memory of Ellen P. Stevens and Mary M. Stevens

on the two-dimensional surface of the canvas.

The *Arrangement in Grey* also includes the first appearance of the white lock, which became one of Whistler's trademarks in the years to come. First appearing around 1870, the white lock became the most original addition to the Whistler image, a singular note that would be his most recognizable physical attribute. Whistler claimed that it ran in his family.[41] The Pennells discussed it in their biography: *We never asked him about it, and his family, friends and contemporaries whom we have asked, cannot explain it. Some say it was a birth-mark, others that he dyed all his hair save the one lock. Many, seeing it for the first time, mistook it for a floating feather. He used to call it the* Mèche de Silas, *and one explanation it amused him to give was that the Devil caught those whom he would preserve by a lock of hair which turned it white. Whatever its origin, Whistler always cherished it with the greatest care.*[42] A number of contemporaries recorded the importance of the white lock to Whistler. Mortimer Menpes, one of his students during the 1880s, related a story of Whistler at a barbershop, drying, combing, and teasing the white lock so that it would stand out as a "feathery plume."[43] Otto Bacher, an American who lived in the same rooming house as Whistler during his time in Venice, described his emphasis on this unique feature: *Whistler always tried to make this blemish prominent, laboring before a mirror, holding it in one hand, and fluffing out his curls with the other. The last touch was always given to the white feather. The soft brown hat which*

he wore was always tilted back behind it. He would often say, "The white lock should be seen first when Whistler enters a drawing room."[44] Bacher also told the story of a time in Venice when their landlady came up to Whistler and, saying that she wanted to remove something that marred his appearance, "tried to knock off Whistler's feather!"[45] In his memoirs, Bacher quoted a passage from an American newspaper that posthumously summed up the notoriety of the white lock: *No single item in Whistler's appearance was so celebrated as the solitary white lock that stood out from among the mass of his hair. It was his oriflamme, his panache. It nodded defiantly wherever his warring spirit carried him. It shone with a new gleam as he scattered the glittering shafts of his bitter wit.*[46]

During the early 1870s, Whistler would paint portraits of his mother, of Thomas Carlyle, and of Cicely Alexander that would establish his credentials as an artist in Victorian England. The self-portrait *Arrangement in Grey: Portrait of the Painter* concludes the initial stage of his career. Whistler's central position in the *Hommages* by Fantin had placed him at the center of the avant-garde in Paris, in the milieu of Manet, other *refusés* artists, and progressive French critics. His self-portraits of 1865 and 1872 demonstrate a confidence and awareness of his artistic heritage, which are balanced by the concerns of his own developing artistic aesthetic. Within a few years of painting the 1872 self-portrait, Whistler would become an easily recognized and oftentimes infamous presence in the contemporary art scene in London, sometimes admired and sometimes ridiculed, but always a celebrated public figure.

Fig. 2:11.
Self-Portrait by Rembrandt van Rijn (1606–1699). Oil on canvas, 84.5 x 66 cm. (33 1/4 x 26 in.), 1659. Andrew W. Mellon Collection, National Gallery of Art. © 1994, Board of Trustees, National Gallery of Art, Washington, D.C.

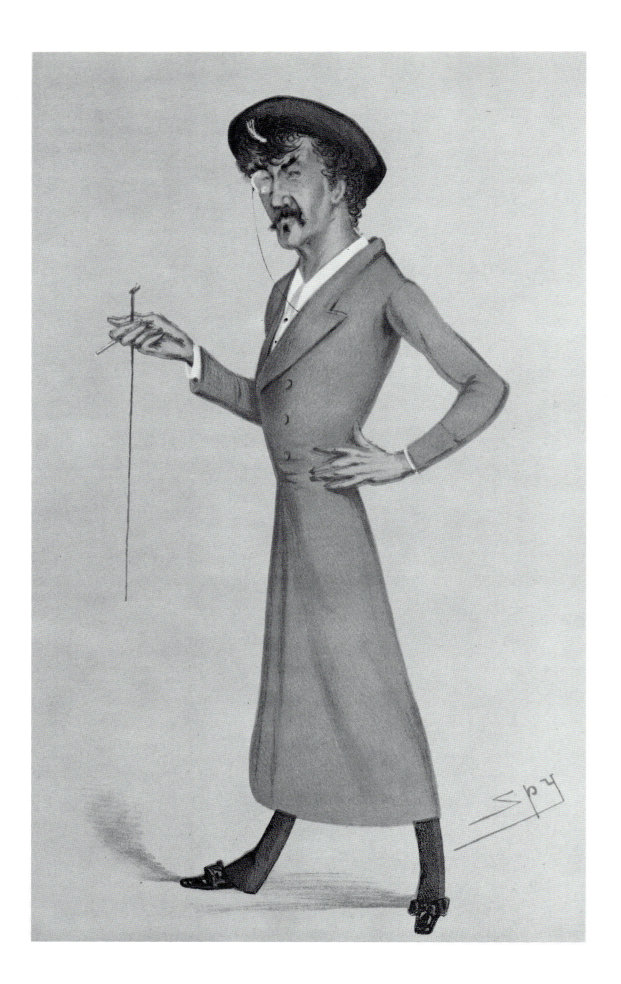

3

The Butterfly and the Press

The early 1870s were a period of relative stability and aesthetic development for Whistler. A decade of experimentation that had embraced forays into Japanese art, the realism of Courbet, the economy and strength of Baroque portraiture, and the decorative classicism of Albert Moore culminated in a phase of mature artistic evolution. Whistler absorbed these diverse sources, forging an art characterized by subtle compositional arrangements and delicate tonal harmonies. Among the significant works of this period are the portraits of the artist's mother, Frederick Leyland, Thomas Carlyle, Cicely Alexander, and a series of nocturnal views of the Thames. In the spring of 1871, Whistler published *Sixteen Etchings of Scenes of the Thames*, a selection of riverscapes in a Realist style, most of which were executed around 1860. The set received critical praise in the press.[1] Yet despite his achievements in painting and the positive critical reception of his prints, Whistler remained in tight financial straits throughout much of the decade.

Whistler periodically submitted his paintings to the spring Royal Academy shows into the early 1870s. *Arrangement in Grey and Black: Portrait of the Painter's Mother* [Fig. 3:2] was shown in 1872 and received generally favorable comments in the press.[2] Initial controversy over its acceptance, however, had resulted in Sir William Boxall threatening to resign from the Academy if the picture was refused.[3] Boxall and Whistler were longtime acquaintances, and Boxall's portrait of the youthful artist had been exhibited at the Royal Academy in 1849 [see Fig. 1:6]. Whistler never showed there again after 1872, perhaps because of the controversy over the hanging of the portrait.

At about this time, Whistler began to exhibit his work regularly in small London galleries, turning away from the Paris Salon and the French market. The artist had sent paintings to the Salon and Exposition Universelle of 1867, but did not submit again until 1882. Instead, he cultivated an English clientele by showing paintings at Durand-Ruel's London gallery, the Society of French Artists, and at the Dudley Gallery. In 1874, the month before his fortieth birthday, Whistler had his first one-man exhibition in the Flemish Gallery, Pall Mall. The show consisted of fifty etchings, thirty-six drawings, and thirteen canvases, including *Arrangement in Grey and Black, No. 2: Portrait of Thomas Carlyle* [Fig. 3:3] and portraits of Cicely Alexander and Frederick Leyland, a Liverpool shipping magnate. Leyland had become one of Whistler's principal patrons in the late 1860s, commissioning and purchasing important canvases.

Fig. 3:1.*
A Symphony by Sir Leslie Ward ("Spy") (1851–1922). Lithograph printed in color, 38.8 x 18.5 cm. (15 5/16 x 7 5/16 in.), 1878. © The Cleveland Museum of Art, Ohio; gift of Mr. and Mrs. Ralph King (24.84)

Fig. 3:2.
Arrangement in Grey and Black:
Portrait of the Painter's Mother
by James McNeill Whistler.
Oil on canvas, 144.1 x 162.5 cm.
(56 3/4 x 64 in.), 1871.
Musée d'Orsay, Paris

Few portraits of Whistler were executed during the first half of the 1870s.
A sketchy *Self-Portrait* [Fig. 3:4] in the Freer Gallery appears to have been painted at about the same time as the *Arrangement in Grey* [see Fig. 2:10] and may have been an unsuccessful study for the latter, though their tonalities are markedly different.

Whistler executed a number of self-portrait drawings during this period, including charcoal sketches on toned paper in the collection of the Freer Gallery of Art and the Rhode Island School of Design. A very spontaneous asymmetrical drawing in a private collection in New York [Fig. 3:5] may be related to the self-portrait oils of this time.

Two distinguished portraits mark the beginning and end of this hiatus in Whistler portraiture. Sir Joseph Edgar Boehm's sculpted portrait bust of Whistler [Fig. 3:6], now in the National Portrait Gallery in Washington, D.C., is one.[4] The other is Sir Leslie Ward's caricature *A Symphony* [see Fig. 3:1], published in *Vanity Fair* in 1878.

Boehm was an eminent Victorian sculptor of Hungarian extraction.[5] He settled in England in 1862, later becoming a member of the Royal Academy. He was one of the most sought-after sculptors of the period in Britain, executing portrait busts of prominent military and political leaders, as well as many royal commissions. In addition, during the decade after his arrival in England, he created a number of busts and statuettes of living artists, including John Everett Millais, Alphonse Legros, and the illustrator John Leech. Boehm and Whistler had known each other prior to 1869, when the American had written to his patron George Lucas that Boehm was "one of the most distinguished sculptors of London."[6] His bust of Whistler is a realistic likeness, animated by the knitted brow, the inquiring eyes, and the rough handling of the surface of the artist's jacket. Boehm eliminated all of the colorful attributes that Whistler portraitists had exploited over the previous fifteen years. Instead, the sculptor emphasized the actual details of the artist's physiognomy. The result was a rather pedestrian bust, with only a somewhat derisory expression to enliven the presentation. The bust was shown at the Royal Academy in 1873, receiving mixed reviews. "The sketchy, off-hand, defiant treatment of the face and head remind one not a little of Mr. Whistler's mannerism in his own deportment," said one critic.[7] The reviewer for the *Saturday Review* was on the other side of the critical discussion, stating, "Mr. Boehm's terra-cotta of Mr. Whistler . . . is feeble and convulsive."[8] Whistler's own opinion is implied in a story told by T. R. Way, the artist's printer, in a later description of the artist's house: *In this drawing room the only other work of art which I recall at that time was the very fine bust which Sir J. E. Boehm had made*

Fig. 3:3 (*left*).
Arrangement in Grey and Black, No. 2: Portrait of Thomas Carlyle by James McNeill Whistler. Oil on canvas, 171 x 143.5 cm. (67 3/8 x 56 1/2 in.), 1872. Glasgow Museums: Art Gallery and Museum, Kelvingrove, Scotland

Fig. 3:4 (*right*).
Self-Portrait by James McNeill Whistler. Oil on canvas, 70 x 55.3 cm. (27 1/2 x 21 3/4 in.), 1870–1875. Freer Gallery of Art, Smithsonian Institution, Washington, D.C.

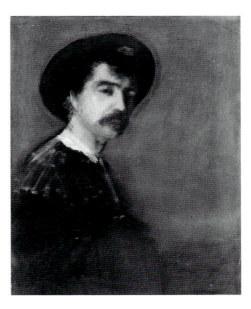

of *Whistler, and, as far as I can recall, it was the only work by any living artist which I ever saw in his rooms.*[9] Way bought the bust at the bankruptcy sale of Whistler's effects at Sotheby's in 1880 and retained it until his death in 1913.[10]

Whistler experienced increasing difficulties during the second half of the 1870s. The two chief sources of tension were a decline of steady patronage and virulent attacks upon his artistic integrity. The former was caused by a dispute between Whistler and his patron, Frederick Leyland; the latter culminated in the famous Whistler-Ruskin libel suit of 1878.

In 1876, as part of the decoration of his London residence, Frederick Leyland commissioned the artist to do a set of panels for the stairs. The centerpiece to the new home was to be the dining room, designed by the architect Thomas Jekyll to house some of Leyland's treasured collection of Chinese porcelain and leather wall-hangings.[11] A place of honor was

reserved for Whistler's *La Princesse du pays de la porcelaine* [see Fig. 2:5], which had entered Leyland's collection some years before. During the summer of 1876, Whistler worked on the hall and stairs of the house. By September he had persuaded Leyland to allow him to make minor alterations in the dining room to accentuate the subtle tones of *La Princesse*. Whistler's minor retouching evolved into wholesale changes after Leyland's departure for Liverpool at the end of the summer. The artist allowed his creative talents to operate full tilt over the next several months—gilding over the shelves, painting over Leyland's precious leather, and adding peacocks and peacock-feather motifs as wall and ceiling decoration. The result was a brilliant decorative scheme that became known as the Peacock Room, but it was thoroughly at odds with what his patron had expected. Adding offense to his unendorsed changes, the artist frequently entertained visitors during the redecoration. Whistler's

Fig. 3:5.*
Self-Portrait by James McNeill Whistler. Charcoal on brown paper, 26.7 x 17.1 cm. (10 1/2 x 6 3/4 in.), circa 1872. Private collection

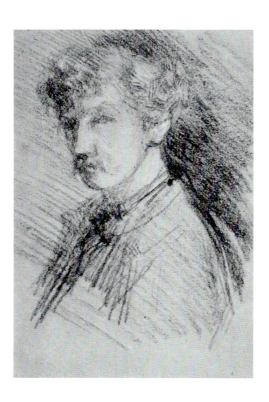

gift for self-promotion emerged at this time: on February 9, 1877, without informing Leyland, he invited the press to see the recently completed ensemble, *Harmony in Blue and Gold* [Fig. 3:7]. Whistler's courting of journalists indicates his early understanding of the power of the media to promote his career. His influence on the press was an important part of his conscious construction of an image.

Leyland reacted angrily to the changes in the original decor, and to the artist's insolence. A dispute arose over the terms of payment when Whistler requested twice the originally agreed-upon amount, inexorably leading to a permanent breach between the artist and his most important patron. As a result of the Peacock Room decorations, Whistler became celebrated,

but not as he might have wished. His usual financial difficulties were exacerbated by the long preoccupation with the Peacock Room and the adverse publicity of his quarrel with Leyland.

At this time, Whistler hoped to attain needed publicity and sales from his contributions to an exhibition at the new Grosvenor Gallery. Sir Coutts Lindsay had opened the gallery as a financial venture, with the purpose of giving selected artists an alternative exhibition space to the annual Royal Academy shows.[12] The owner would handpick the painters he wished to show, and display their works in carefully appointed surroundings. The initial exhibition opened in May 1877, and included works by both respected academic artists and independent avantgarde painters. Whistler, Dante Gabriel Rossetti, John Everett Millais, Edward Poynter, Edward Burne-Jones, Holman Hunt, George Frederick Watts, and Walter Crane were among the artists represented in the first show, and Boehm's bust of Whistler was also included. Since Whistler's time had been devoted to the decorations of the Peacock Room, he had no new work to send to Lindsay's first show. Instead, he sent eight older paintings, some of which were done as far back as the beginning of the decade. The two most prominent were the portrait of Thomas Carlyle [see Fig. 3:3], and *Nocturne in Black and Gold: The Falling Rocket* [Fig. 3:8]. The *Nocturne* was one of the artist's most abstract compositions shown to date, representing a night scene of fireworks exploding above the dim lights of Cremorne Gardens, a celebrated amusement park in Chelsea. A favorite haunt of Whistler's, the park had been the site of a number of his nocturne paintings

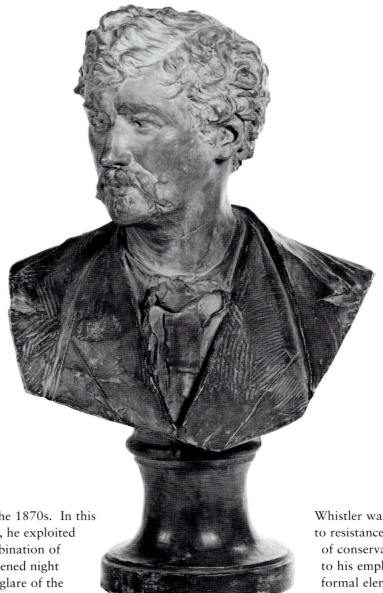

Fig. 3:6.*
James McNeill Whistler by
Sir Joseph Edgar Boehm
(1834–1890). Terra-cotta,
67.9 cm. (26 3/4 in.) height, 1872.
National Portrait Gallery,
Smithsonian Institution,
Washington, D.C.; transfer from
the National Gallery of Art,
bequest of Albert E. Gallatin,
1952

during the 1870s. In this painting, he exploited the combination of the darkened night sky, the glare of the fireworks, the evocation of smoke, and the mists along the river to create a harmonious composition. For an English public who cherished narrative painting, the canvas had no apparent subject. As *Punch*, one indicator of contemporary taste, remarked:

> *One showed blue chaos flecked with*
> *falling gold,*
> *Like Danaë's tower in dark;*
> *A painter's splash-board might more*
> *meaning hold;*
> *Than this aesthetic lark.*[13]

Whistler was accustomed to resistance on the part of conservative critics to his emphasis upon formal elements. Contemporary paintings that received favorable reviews illustrated stories with religious or literary themes. During the 1870s, Whistler occasionally wrote letters to the press in response to reviews, explaining how his aesthetic intentions differed from those of narrative painters. Despite the lack of substance in contemporary criticism, or perhaps because of it, he seems to have taken great pleasure in compiling newspaper clippings containing reviews of his work. His reaction was different when, in July 1877, the American artist George Boughton gave

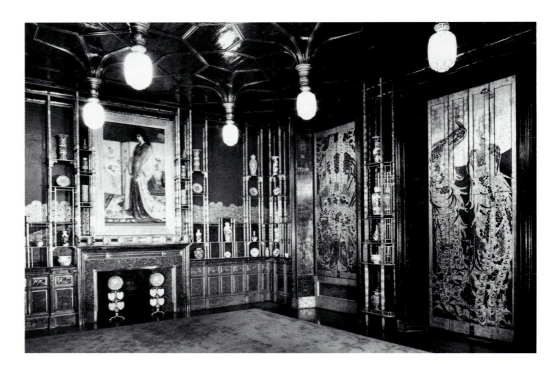

Fig. 3:7.
Harmony in Blue and Gold:
The Peacock Room by James
McNeill Whistler. Oil paint on
gold leaf on leather and wood,
1876. Freer Gallery of Art,
Smithsonian Institution,
Washington, D.C.

him a review to read at the Arts Club
in London.

The review was by John Ruskin, in his
Fors Clavigera, and was the now-famous
harshly worded condemnation of Whistler
and his work: *For Mr. Whistler's own*
sake, no less than for the protection of the
purchaser, Sir Coutts Lindsay ought not
to have admitted works into the gallery in
which the ill-educated conceit of the artist
so nearly approached the aspect of wilful
imposture. I have seen, and heard, much
of Cockney impudence before now; but
never expected to hear a coxcomb ask
two hundred guineas for flinging a pot of
paint in the public's face.[14]

Whistler's initial rage gave way to a
calculated decision to bring suit against
the critic for libel, resulting in one of the
most celebrated trials in the history of art,
Whistler v. Ruskin. The exact motivation
for the suit may never be precisely under-

stood. Did Whistler believe that he could
win substantial damages and escape his
current financial plight? Did he think
that the trial would provide him a stage
on which to express his own theories on
art? Or was the rationale for a high-
profile suit part of his penchant for self-
promotion? All of these motives con-
tributed to his decision to sue Ruskin.
Whether or not publicity was his goal at
the outset, the trial was the first in a
series of events in Whistler's career that
would receive extensive press coverage.
The expatriate's life was journalistic news
in London for the following twenty-five
years.

The initial action in the suit took place
in August 1877, with Whistler's attorney
notifying Ruskin of his client's intention
to seek damages for libel. Pre-trial
motions, and frequent postponements due
to Ruskin's ill health, delayed the trial

until November 25, 1878. During the early delays, the press printed frequent updates on motions or unfounded rumors of dismissal.[15] The press cooled to the subject after the first few months of postponements, until it virtually disappeared from the papers.

The publicity created by the controversy over the Peacock Room, and the early interest in the libel suit, gave Whistler a greater public presence than at any previous time. At this same moment, in December 1877, Whistler's name and image were also brought to the public's attention on the stage.[16] *The Grasshopper*, an adaptation of a French comedy by Henri Meilhac and Ludovic Halévy, was presented at the Gaiety Theatre. The lead role in the play was altered for the British audience from that of an Impressionist artist to Pygmalion Flippit, a painter who was an obvious parody of

Whistler. The vain hero names one of his works a "harmony in grey," makes reference to Whistler as his master, and is described as having "Hyperion curls."[17] Most astounding, a life-size caricature of Whistler was brought onto the stage during the performance! Carlo Pellegrini, the caricaturist "Ape" for *Vanity Fair*, had created the standing, full-length sketch, with the cooperation of the subject.[18] Thomas Armstrong described the style of the work—now lost—as "Whistlasquez."[19] Pellegrini aspired to be a portrait painter, and "Whistler's work he adored," but he was unable to reach beyond his original talent as a caricaturist.[20] He also executed a small drypoint portrait of Whistler [Fig. 3:9], as well as his large-scale lampoon.

Sir Leslie Ward—"Spy"—was Pellegrini's chief rival at *Vanity Fair* in the 1870s.[21] In 1869 *Vanity Fair* began including a caricature portrait in each weekly issue, a practice that continued for forty-four years. Most of the more than two thousand figures parodied were noted political leaders, writers, scientists, and clergymen. A painter with sufficient fame was occasionally included, but fewer than one artist per year were featured over the run of the magazine. Whistler's recent notoriety had brought him enough attention to warrant a caricature by Ward in the issue of January 12, 1878.

Ward's portrait, *A Symphony*, is one of the quintessential images of Whistler [see Fig. 3:1]. The lithograph includes all of the attributes of the mature artist's persona seen in concert for the first time: the monocle, the white lock, the maulstick, and the ubiquitous cigarette. Ward shows Whistler wearing a double-breasted frock

Fig. 3:8.
Nocturne in Black and Gold: The Falling Rocket by James McNeill Whistler. Oil on panel, 60.3 x 46.6 cm. (23 3/4 x 18 3/8 in.), circa 1875. Detroit Institute of Arts, Michigan; gift of Dexter M. Ferry, Jr.

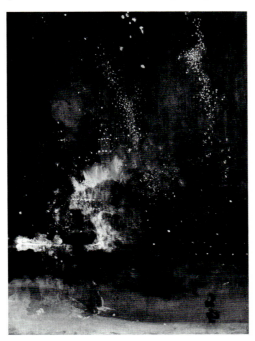

Fig. 3:9.*
Whistler by Carlo Pellegrini
(1839–1889). Drypoint,
approximately 33 x 25.4 cm.
(13 x 10 in.), circa 1883.
Rosenwald Collection,
National Gallery of Art.
© 1994, Board of Trustees,
National Gallery of Art,
Washington, D.C.

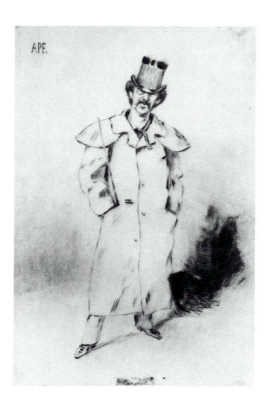

coat, with the unusual accessory of
patent-leather opera shoes adorned with
grosgrain silk bows. The confident,
almost arrogant, pose is reminiscent of
one of Whistler's favorite Velásquez por-
traits, *Pablo de Valladolid* [Fig. 3:10].[22]
The caricaturist gave the artist an expres-
sion of wry amusement, conveying an
impish, mischievous intelligence. His left
arm is defiantly placed on his hip for an
added hint of insolence, and the arms
attenuate to the thin, delicate fingers that
were another Whistler trademark. Three
studies extant for the portrait indicate
stages in the development of Ward's
image [Figs. 3:11 and 3:12].

Ward and Whistler were friends, and
their paths crossed often in social and
artistic circles. Ironically, Ward later

wrote that while Whistler was an excel-
lent subject, he did not feel entirely suc-
cessful in capturing his personality in the
lithograph: "His unlimited peculiarities
lay more in his gesture and speech and
habits. I never went to a social function
at which he was present without hearing
his caustic, nasal little laugh, 'Ha-ha-ho-
ho-he-he' raised at the wrong moment."[23]
Ward then qualified this characterization,
adding that the American artist was fasci-
nating and irresistible despite his lack of
social grace.[24]

Whistler appears to have liked Ward's
portrait of him, since a number of impres-
sions exist with Whistler's dedication and
signature butterfly, which the artist must
have bestowed as gifts.[25] His apprecia-
tion of the caricature would have been
increased by the accompanying article on
"Jimmy." The essay began with a bio-
graphical section, followed by an account
of his contemporary work, which sup-
ported his aesthetic position and his
integrity in pursuing artistic truth. The
article called attention to his contribu-
tions in etching, comparing him favorably
to Rembrandt, and concluded with a
description of Whistler as witty and
charming. Whistler undoubtedly wel-
comed this public praise as the libel trial
drew closer.

Whistler v. Ruskin began later that
year, on November 25. The trial focused
attention on the artistic debates of the
day and provided many memorable
exchanges between Whistler and the
defense attorney. Linda Merrill has
painstakingly reconstructed the arguments
from various sources to produce the most
complete account of the trial now possi-
ble. Accurate transcriptions replace the
many apocryphal versions of the trial

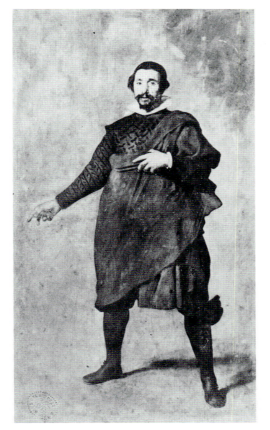

Fig. 3:10.
Whistler's photograph of
Velásquez's *Pablo de Valladolid*.
Department of Special Collections, Glasgow University
Library, University of Glasgow,
Scotland

published in the contemporary press and by Whistler himself.[26] Despite the publicity, the actual presentation of the case took only eight hours, and the jurors needed just two hours on November 26 to reach a decision. They found in favor of the plaintiff, Whistler, agreeing that Ruskin had committed libel. However, the jury awarded Whistler only one farthing, as opposed to the one thousand pounds that he had sought in the action. In addition, Whistler was burdened with paying his own court costs, which normally would have been assessed against Ruskin, the defendant. The judge had interpreted the jury's award as a reproach to Whistler for having brought the matter to trial, and he consequently directed that the two sides each absorb their own expenses. The decision led to Whistler's bankruptcy in 1879, a substantial price to pay for the largely symbolic victory.

The brevity of the trial itself allowed the weekly magazines only retrospective coverage of the case. The press reported the proceedings with enthusiasm, particularly the colorful exchanges between counsel and witnesses. In the aftermath, Whistler appeared in numerous caricatures in the illustrated press, the first time in his career that he had commanded widespread attention. Several examples represent the types and the tenor of the illustrations. Alfred Bryan contributed *Mr. J. Whistler: An Arrangement in Done-Brown* [Fig. 3:13] to *The Entr'acte and Limelight Almanack* of 1879. Bryan showed the artist, with his usual attributes, standing and painting "DAMAGES ONE FARTHING" onto a canvas. The illustrator expressed his support for Whistler's plight in the title of the drawing, for "done-brown" was nineteenth-century British slang for being absolutely swindled. As a result, the title serves as both a pun on the name of a Whistler painting—*The Arrangement in Brown*—that was shown in an 1877 Grosvenor Gallery exhibition and as an allusion to the inequity of the award. Bryan's wit is also evident in his choice of Whistler to be painting this image, as if money, rather than the creation of a work of art, was the artist's objective.

An anonymous cartoon in *Funny Folks* from December 28, 1878, captures an eccentric aspect of the artist's working manner as it had been revealed during the trial. In *Funny Folk's Fairy Tales; or, Old Friends with New Faces* [Fig. 3:14], Whistler appears on the lower right, hanging his canvases on a clothesline to dry. He had described this procedure for toning down the glossiness of the painted surface during his testimony, a procedure that observers considered eccentric. A bird with Ruskin's head hovers threateningly above the artist in the drawing,

Fig. 3:11 (*left*).*
James McNeill Whistler by
Sir Leslie Ward ("Spy")
(1851–1922). Watercolor
and graphite on blue paper,
52.5 x 38.7 cm. (20 11/16 x
15 1/4 in.), 1877. Rosenwald
Collection, National Gallery of
Art. © 1994, Board of Trustees,
National Gallery of Art,
Washington, D.C.

Fig. 3:12 (*right*).*
James McNeill Whistler (recto)
by Sir Leslie Ward ("Spy")
(1851–1922). Watercolor,
34.9 x 21 cm. (13 3/4 x
8 1/4 in.), 1877. National
Portrait Gallery, London

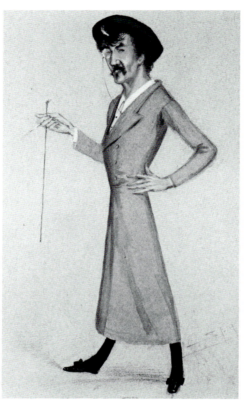

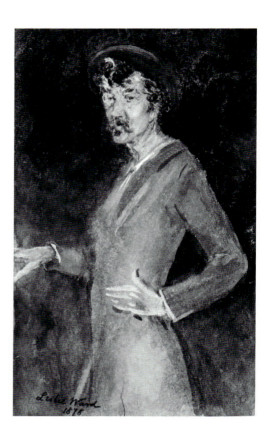

and a verse below mentions the damages.
While Whistler is depicted as an object of
wry amusement, Ruskin is characterized
in an unpleasant, critical light. Profes-
sional illustrators were inclined to sympa-
thize with the artist's position in the libel
case, as opposed to the opinions
expressed by contemporary art critics.

Linley Sambourne's *Whistler versus
Ruskin* in the December 7, 1878, issue
of *Punch* [Fig. 3:15] is an exemplary, if
unusually complex, caricature on the
results of the trial as they appeared in the
pictures in the press.[27] Sambourne
included the judge prominently in the
center, an oversized farthing in his hands,
facing the plaintiff and the defendant.
Above is a voice bubble explaining,

"The law allows it, the court awards it."
A half-dozen block-headed jurors depicted
as paint tubes are seated to the right, and
above them is a bubble that reads, "No
symphony with the defendant," a refer-
ence to Whistler's musical terminology.
One of the jurors is labeled "Dun Broun,"
a reference mentioned previously in
regard to the Bryan illustration. Ruskin,
who missed the trial because he was ill, is
shown as an old pelican, a biblical refer-
ence to Psalm 102, verse 6, where David
describes the isolation of the defeated and
afflicted as "like a pelican of the wilder-
ness."[28] Whistler, seen from behind, is
also birdlike and identified by the promi-
nent white lock protruding from his thick,
dark curls. Ornithologically, a "whistler"

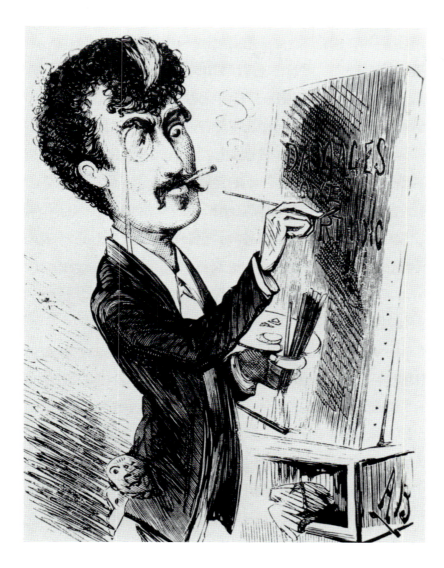

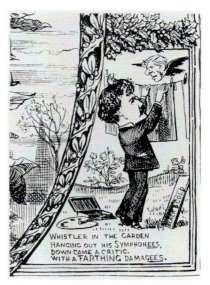

Fig. 3:14.
*Funny Folk's Fairy Tales; or,
Old Friends with New Faces*
(detail). Wood engraving pub-
lished in *Funny Folks*,
December 28, 1878

Fig. 3:13.
*Mr. J. Whistler: An Arrange-
ment in Done-Brown*
by Alfred Bryan (1852–1899).
Wood engraving published in
*The Entr'acte and Limelight
Almanack*, 1879

is a type of bird, such as a goldeneye, that makes a whistling sound with its wings while in flight. The artist's legs are drawn as pennywhistles in the obvious pun on his name. Between the two adversaries are snakes, the natural enemy of birds, with heads labeled "costs," the natural enemy of the litigants. The message is clearly spelled out in the caption below: "An Appeal to the Law." "Naughty Critic, to use bad Language! Silly Painter, to go to Law about it!"

An exchange of letters between Whistler and Sambourne helps illuminate the creation of the drawing. Sambourne wrote to Whistler on December 1 to alert him to a "little bit of nonsense" about the trial that would soon be in *Punch*.[29] He

explained that he was forced to illustrate any topic his editor selected, and that his goal was to register the facts of the trial without bias. "I have every sympathy with you in what must be a most trying & irritating time."[30] Sambourne's sensitivity to Whistler's feelings struck a responsive chord, as may be seen from a section of Whistler's reply: "My dear Sambourne—I know I shall be only charmed, as I always am, by your work, and if I am myself its subject, I shall only be flattered in addition."[31]

Whistler sent his response to *The World*, where it was published as part of a longer letter including an attack on Tom Taylor, *Punch*'s editor, who had appeared for the defense in the trial. The published

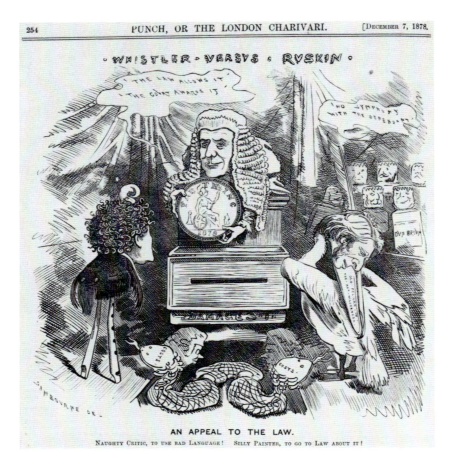

Fig. 3:15.*
Whistler versus Ruskin ("An Appeal to the Law") by Linley Sambourne (1845–1910). Wood engraving published in *Punch*, December 7, 1878. Private collection

reference to Sambourne's note was considered bad manners at the time, as it would be today. Whistler would rarely have been so courteously notified in advance of an article or illustration, and his abuse of the confidence was typical of his mercurial temperament.

In Sambourne's depiction, the two foes were both taken to task, since they had been equally criticized in *Punch*'s text devoted to the trial. Several pages after Sambourne's illustration, a parody called *Une Cause Célèbre* gave a humorous recounting of the trial, mostly at Whistler's expense. In the end, "Penny Whizzler," the plaintiff, is awarded one farthing and renamed "Farthing Whizzler," in an attempt at additional humor. However, a serious poem critical of Ruskin preceded Sambourne's illustration. Whistler and Ruskin were evenly admonished.

The trial thrust Whistler into the pub-

lic consciousness. His eccentricities of appearance and speech drew the attention of caricaturists at a time of heightened interest in illustration. The coverage of the trial began the pattern of regularly introducing Whistler's image in periodicals for his individual idiosyncrasies and as a representative of the artistic type. As a result, he would appear in the popular press regularly for the next twenty years.

The sustained symbolic value of the trial is evident in two later depictions. Thirteen years later, Phil May published *On the Brain—Mr. Whistler* [Fig. 3:16] as part of a series of *On the Brain* images in *Pick-Me-Up* magazine. In these images, May focused on obsessions of well-known people of the day.[32] In the sketch, a small figure of Ruskin is shown quite literally on Whistler's mind. A butterfly, endowed with a well-developed stinger, attacks Ruskin from above. By this time, Ruskin was no longer identified

Fig. 3:16.
On the Brain — Mr. Whistler
by Phil May (1864–1903).
Wood engraving published in
Pick-Me-Up, 1892

as the champion of the traditional art establishment. The 1890 publication of Whistler's writings, *The Gentle Art of Making Enemies*, included the artist's entertaining, though inaccurate, account of the trial and was probably the reason that May drew the image at that time. Whistler was fond of May's work, as he related in an 1895 letter: "I take a great delight in Phil May. Certainly his work interests me far more than that of any man since Charles Keene—from whom he is quite distinct."[33]

Another powerful image referring to the trial was painted a hundred years later. An American expatriate and a target of the British critics like Whistler, R. B.

Kitaj exhibited his *Whistler versus Ruskin* [Fig. 3:17] at the Royal Academy exhibition in the summer of 1992. The artist borrowed his composition from American artist George Bellows's painting *Dempsey versus Firpo*, but substituted likenesses of Whistler and Ruskin for the faces of the boxers. The figures are not labeled, but Whistler is the victorious artist left standing after knocking Ruskin out of the ring. Kitaj himself is the referee, the living witness to the historic outcome of *Whistler versus Ruskin*, as well as the creator of the painting. Bellows provided the compositional scheme for Kitaj's contest between two great protagonists, which the artist then used as an arena for a

Fig. 3:17.
Whistler versus Ruskin by
R. B. Kitaj (born 1932).
Oil on canvas, 152.4 x
152.4 cm. (60 x 60 in.),
1992. Marlborough Fine Art
Ltd., London

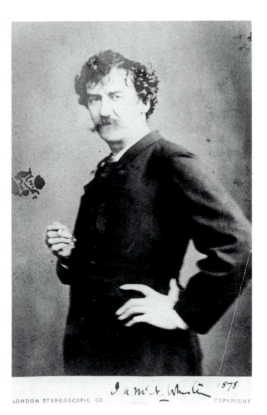

Fig. 3:18.*
James McNeill Whistler by the
London Stereoscopic Company.
Gelatin silver print, 15.6 x 9.5
cm. (6 1/8 x 3 3/4 in.), 1878.
Charles Lang Freer Papers,
Freer Gallery of Art Archives,
Smithsonian Institution,
Washington, D.C.

battle between a renowned artist and a
powerful critic. The result is the painter's
symbolic triumph over the critic in the
field of art, an image as relevant to Kitaj
as it was to Whistler.[34]

Whistler responded visually to the Vic-
torian illustrators' construction of his
image by turning to photography in the
carte-de-visite format. Two London
Stereoscopic Company photographs of
Whistler derive from the months immedi-
ately after the trial.[35] These images help
articulate Whistler's state of mind in the
aftermath of the verdict, since he clearly
maintained control over the design and
composition of these commercial por-
traits. The photographs display two sepa-
rate views of the artist's intended public
image. In one [Fig. 3:18], Whistler glares
defiantly into the camera, his expression
and his pose challenging the viewer. Few
cartes-de-visite could have contained less
inviting images. Either this photograph,
or one closely resembling it, must have
been what Otto Bacher saw in Venice in
1881, and described as "that detestable
photograph with an evil sneer he once

showed me—a picture he was fond of,
and wished the world to know him by,
while he talked caressingly of the sneer as
the way Whistler would look at his ene-
mies."[36] Here is the combative Whistler,
unrepentant after his recent financial
reverses, obstinately meeting the world on
his own terms. A careful examination of
the image reveals several areas that are
out of focus on either side of the torso
and around the artist's left hand. This
may be the unsatisfactory photograph
referred to in a letter from the London
Stereoscopic Company to Whistler, sug-
gesting an additional session.[37] A subse-
quent portrait [Fig. 3:19] shows the artist
in an uncharacteristic pose, his chin rest-
ing on his hand and his elbow resting on
a wooden stand. The stand provided a
stable support, eliminating the possibility
that Whistler would move during the
exposure. The pose communicates a dif-
ferent side of the artist's personality.
Whistler assumes a graver, meditative pos-
ture, gazing off contemplatively into the
distance. Here he eschewed his normal
public image as an outsider, engaged in a
battle with conservative artists and Vic-
torian society, for a more refined and seri-
ous representation. This portrait was
widely reproduced and continued to be
sold by the photographers after Whistler's
death.[38]

Likenesses of Whistler appeared
increasingly in the press in the years fol-
lowing the trial. Sambourne's view of the
artist from behind produced a spate of
imitations in various illustrated maga-
zines. The same artist used the motif
again [Fig. 3:20] on page 213 in the May
10, 1879, issue of *Punch*, in the seventh
of a series of articles entitled "Injyable
Injia." The series lampooned a recent

scene is then described in a combination of precious allusion and pedestrian reference, with the Sambourne illustration inserted in the text. The back of the head is recognizable as Whistler's, with his prominent white lock. He is facing toward the sun, which is "not rising, but setting for his portrait to me, who love him dearly." Lighthearted humor was at the core of *Punch*'s appeal, and Whistler did not resent a little jesting if it did not impugn his character or work.

Alfred Thompson adapted this view of Whistler for two jocular images of the artist in 1879. In *The Mask* of May 31, Whistler was depicted from behind, holding an immense palette and painting on a large canvas. He held two oversize brushes, simultaneously painting with both hands. In addition to the familiar white lock, Whistler was identified by his pennywhistle legs and a garment new to the iconography—a shirt composed of the stars and stripes of the American flag. The canvas contained two of the artist's personal emblems, the butterfly design to the lower left and the peacock feather to the lower right. Thompson's image focused attention on Whistler's American background and poked fun at his eccentric use of large brushes to cover broad expanses of canvas.

The caricaturist repeated the rear view six months later, in a parody called

book called *Imperial India* with illustrations by the academic artist Val Princep. The parody relates various misadventures in India, until the narrator reaches the *Jimmivizlah Hills and the Grove Nahgalaree*. The third spring exhibition at the Grosvenor Gallery had opened the previous week and included five oils and various graphics by Whistler. The text continues, "The Jimmivizlah Hills are not an A.R.A.ngement in colours, but a rhapsody in blue, green, and yellow." The

Fig. 3:21.
Ididdlia—On the Grand Canal by Alfred Thompson (lifedates unknown). Wood engraving published in *The World*, December 1878

"Ididdlia" in the special 1879 Christmas number of *The World*. The story is a romantic satire of the wealthy Countess Iddidlia and her artist-suitor, Fluke Fizzledowne, who wants to paint her portrait. Abundant references associate Fizzledowne with Whistler, who had left for Venice in September, in the wake of his bankruptcy, with a commission to etch a series of views of that city. The illustration, *Ididdlia—On the Grand Canal* [Fig. 3:21], depicts two figures standing on a balcony, looking at gondolas along the Grand Canal. On the left is Whistler (Fizzledowne) with his white lock. Standing next to him is Ididdlia, a tall woman with a Japanese fan who appears to be Maud Franklin, the artist's model, mistress, and the recent mother of his child. Thompson also refers to Whistler with the butterfly at the base of Ididdlia's dress and with the unusual design of the frame. Unaesthetic beetles replace the artist's typical peacock or butterfly frame decorations. Thompson added a witty touch in the decorative iron grillwork that forms Whistler's initials. These lighthearted

illustrations assert no profound social message; they are only the simple jests of a fellow artist at a recognized figure in a familiar destination for Victorian travelers. Humor was a central attraction of the illustrations in contemporary magazines; the reader would have appreciated the references to a notable figure in exaggerated circumstances.

Large-scale group scenes of Victorian life were another popular type of contemporary illustration. Whistler was depicted in a number of these imaginary gatherings as both a recognizable individual and as one of the representatives of contemporary art types. Alfred Bryan, whose sympathetic image of the libeled artist was discussed above, included Whistler in one of these mythical group portraits shortly after the conclusion of the libel suit. *At the Play* [Fig. 3:22] was issued as part of the Christmas number of *The World* in 1878. A key to the lithograph was included to help in identifying the less-familiar faces. Bryan depicted ninety-two prominent Victorian personalities in the audience at a performance by Henry Irving, one of the great actors of the English stage. The Prince and Princess of Wales are present, as well as other lesser nobility and eminent personalities. Whistler, at the far end of a row in the center, is distinguished by his monocle and white lock. He is one of a handful of artists represented, also including Frederick Leighton, Val Princep, and John Everett Millais, each a prestigious member of the Royal Academy. Whistler's inclusion is a sign of Bryan's esteem for him. His presence is also understandable in light of the artist's fondness for theater, as both an amateur participant and as a spectator. In 1876 Whistler had painted the *Arrangement in*

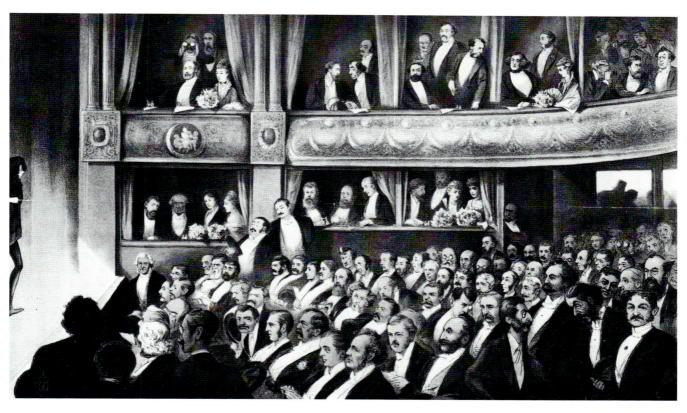

Fig. 3:22.
At the Play by Alfred Bryan (1852–1899). Wood engraving published in *The World*, December 1878

Black, No. 3: Sir Henry Irving as Philip II of Spain, a portrait of the actor onstage in Bryan's print. The painting was another of the works sent to the 1877 Grosvenor Gallery show and also exhibited and discussed during the Whistler-Ruskin trial. Bryan included Whistler for his significance on the artistic scene, as well as for his relationship to theatrical circles and his connection with Irving.

John Wallace was responsible for one of the most entertaining of these imaginary representations of Victorian celebrities, a country fair in *Cope's Christmas Card* of December 1883 [Fig. 3:23].[39] Wallace, whose pen name was George Pipeshanks, caricatured more than one hundred nobles and politicians, actors and writers, servants and evangelists, and

artists and critics. Actors are clustered on the stage to the left and include Henry Irving, Ellen Terry, and Edwin Booth.[40] In the upper center on a bandstand, Wallace depicted the Prince of Wales conducting while Arthur Sullivan plays a cello, and Cetewayo, the dethroned Zulu chieftain, plays the bones. The foreground is dominated by leading political figures of the time, including William Ewart Gladstone, Lord Salisbury, Randolph Churchill, and Charles Stewart Parnell. The right side of the image is the artists' pavilion, the "School of Art Advertising," with Oscar Wilde prominently perched atop the facade. Although not an artist himself, Wilde was recognized as a leading figure in the aesthetic movement of the time. At the top of a ladder leaning against the

Fig. 3:23.
Cope's Christmas Card by John
Wallace ("George Pipeshanks")
(died 1903). Watercolor,
44.5 x 56.2 cm.
(17 1/2 x 22 1/8 in.), 1883.
Unlocated

Fig. 3:24.
Notes from a Whistler by
Harry Furniss (1854–1925).
Wood engraving published
in *Punch*, March 23, 1883

building is the popular genre painter Sir
Hubert von Herkomer with a large paint-
brush, while at the base of the ladder
stands the academician John Everett Mil-
lais. Between these two artists, Ruskin
attempts to climb the ladder of art, but
his path is blocked by Whistler, who is
seated on a rung and playing a penny-
whistle. The hierarchy of artists, if one is
intended, is confusing. Wilde represents
aestheticism and modernity at the top,
and Whistler blocks Ruskin's attempts to
rise to that level. Is Herkomer's place-
ment atop the ladder an indication of
Wallace's reverence for sentiment in acad-
emic narrative scenes? How does this rec-
oncile with the artist's view of Wilde?
Without additional information, the com-
bination appears arbitrary.

The painted facade of the building has
the word "symphonies" next to the seated
artist, a reference to Whistler's titles

Fig. 3:25.*
James McNeill Whistler
by Harry Furniss (1854–1925).
Pen and ink, 24.1 x 11.1 cm.
(9 1/2 x 4 3/8 in.), not dated.
National Portrait Gallery,
London

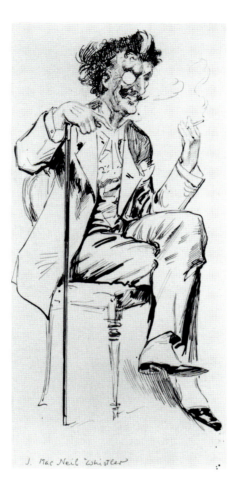

rather than to the music that he or the band are performing. Wallace blended the various spheres of the social and political world of the 1880s, capturing the imaginative and creative personalities of the time in an amusing compendium of contemporary life. Wallace's inclusion of Whistler among the hundred select reinforces his notoriety.

Whistler appeared in another caricature in *Punch* in March 23, 1883. The illustration on page 123, *Notes from a Whistler* [Fig. 3:24], contains five different vignettes drawn by Harry Furniss, a prolific draftsman who worked for a range of weekly and monthly magazines. The upper-left drawing, which Furniss initialed, shows a caged bird, presumably a parrot, with Whistler's familiar emblems. The caption reads, "The Whistler a few bars behind," a punning reference to the explanation of the surrounding text. The caricaturist suggested that Whistler's quotation of earlier criticism in the catalogue of his recent show at the Fine Art Society was not original. Furniss did other drawings of Whistler over the course of his long career, including several that were never published. His *James McNeill Whistler* [Fig. 3:25] is a pen-and-ink sketch that wittily examines the artist's features and costume.

An overwhelming number of the caricatures concern the eccentric character of the artist, his belligerent behavior, or his unusual dress. In relatively few cases during Whistler's lifetime is an actual work the focus of the exaggeration or criticism. Comparing Whistler's appearance and his work in the press to the caricatures of Gustave Courbet or Edouard Manet, we find that a much higher proportion is given to the personality and appearance of Whistler than to his work.[41] This is partly

Fig. 3:26.*
Whistler Playing Tennis by
Alfred Bryan (1852–1899).
Ink on paper, 11.4 x 19.8 cm.
(4 1/2 x 7 13/16 in.), 1884.
Hunterian Art Gallery,
University of Glasgow,
Scotland

a function of the differences between the English and the French approaches to art in the nineteenth century. The French were more theoretical and ideological in discussions of art than were the English, accounting for the greater variety of experimentation among the French avant-garde. Whistler had initially attracted attention with the obvious differences between his goals and the goals of the establishment British artists. His high level of recognition was maintained by his penchant for self-advertisement and notoriety. The English caricaturists contributed to Whistler's celebrity by employing him as a regular feature in their work, dwelling on his unique appearance more often than his aesthetic ideas.

Alfred Bryan, mentioned previously with regard to his caricatures of the late 1870s, combined elements of Whistler's artistic affairs and his social circle in a remarkable series of representations in a feature article of the period. The Christmas issue of *The World* in 1884 was titled *A Week with the Mahdi: The Adventures of the Extra-Special Correspondent of The World in Central Africa* and subtitled

"The Whole Number Profusely Illustrated with Portraits of All the Leading Central African Celebrities, by Alfred Bryan."[42] The article is an anonymous parody of the typical wide-eyed reports of foreign correspondents of the time, including exotic locales, pitched battles, and fierce natives. Whistler is depicted four times in the course of the story, in various guises. The first illustration [Fig. 3:26] features Whistler playing lawn tennis, a popular sport in British colonial outposts.[43] The match featured the "Harries" playing the "Jimmies" in what was described as "a most fashionable and philosophic game with us, and much affected by the gentler sex." A description of the teams followed: *Mr. Justice Henry Hawkins (whose long terms of servitude were of great advantage to his side) and Mr. Henry Irving (whose "returns" were simply immense) were opposed to the American Minister and "our James," the oratorical delivery of the former and the graceful gambols of the latter player being much admired. But, spite of all that Diplomatic Literature and Impressionist Art could do, Law and the Drama romped home easy winners.*[44] Bryan had previously represented Whistler in association with an illustration of Irving, referring to a notable work and connecting the artist to the contemporary theater.

The caricatures in the issue sometimes illustrate the text, as in the lawn-tennis match, but in other cases are entirely omitted from consideration in the narrative. For example, no reference is made to the drawing containing another portrait on page 17 of the same article [Fig. 3:27]. Whistler's features are inscribed in the head at the top of a maulstick within a cluster of paintbrushes.

Fig. 3:27.
Whistler at the top of a
maulstick by Alfred Bryan
(1852–1899). Wood engrav-
ing published in *The World*,
November 27, 1884

The monocle, the white lock, and the cig-
arette at the end of an exaggerated arm
make the identification unmistakable.
The names of Rembrandt, Claude, and
Turner are scattered among the brushes,
which have indistinct cartoon faces.
Bryan has depicted Whistler literally ris-
ing above the great artists of the past.
Later in the article, the narrative returns
to the subject of art in the guise of an
insurrection by a rebel tribe, and Whistler
is identified as a leader of the insurgents.[45]
He is also shown on a page of caricatures
as one of the "Jimmies," a series of
celebrities with the first name James. The
portrait heads are placed on the bodies of
black natives, revealing ongoing under-
currents of racism in Victorian England.
A Bryan drawing of the same period,
Head of Whistler with a Cigarette
[Fig. 3:28], may have been intended for
use in the same article.

Another illustration [Fig. 3:29], usually
referrred to as a caricature of Whistler, is
not mentioned in the narrative. The dark-
skinned figure is shown barefooted in a
togalike dress, wearing a necklace made of
what appear to be teeth and shells. How-
ever, it is almost certainly not Whistler:
the nose is not his, the hair is uncharacter-
istic, there is no white lock, the tips of the
mustache point up instead of down, as
in other contemporary representations,
and the cane is completely different from
Whistler's elegant wand. No documents
from the period suggest that Whistler ever
donned women's clothing.

J. Bernard Partridge published *The
White Feather* [Fig. 3:30], an interesting
variant of Whistler's *Harmony in Black,
No. 10*, within a short time after the
Bryan article.[46] Whistler is in the same
pose, and with a costume similar to one

Fig. 3:28.*
*Head of Whistler with
a Cigarette* by Alfred
Bryan (1852–1899).
Ink on paper,
5.4 x 2.5 cm.
(2 1/8 x 1 in.),
circa 1885. Hunterian
Art Gallery, University
of Glasgow, Scotland

he had used in a now-lost portrait of
Maud. The title is as ambiguous as the
image. Is the white feather simply a refer-
ence to the famous white lock or a veiled
reference to the cowardice that the feather
implied to the Victorian audience?[47] Par-
tridge's rationale for placing Whistler in
Maud's dress is obscure; uncovering the
published context of the illustration might
explain its significance.

An illustration by Partridge is another
exception to the general British focus on
the artist rather than the art. Whistler
exhibited several portraits at the Society
of British Artists on Suffolk Street in
November 1886. Partridge represented
the artist and several of these paintings in
a drawing entitled *At the Whistleries*
[Fig. 3:31], reproduced in *Judy* on Decem-
ber 8, 1886.[48] The familiar figure of the
painter is rendered in a Whistlerian style
in the center, labeled "The Dominant
Element." *Harmony in Red: Lamplight*,
Whistler's portrait of Beatrice Godwin, is
depicted in the upper right. The unlocat-
ed *Harmony in White and Ivory: Portrait
of Lady Colin Campbell* is in the upper
left, with the now-lost *Harmony in Black,
No. 10*—the portrait of Maud Franklin—

Fig. 3:29.*
Whistler in a Toga (?)
by Alfred Bryan
(1852–1899). Ink on
paper, 18.1 x 5.5 cm.
(7 1/8 x 2 1/8 in.), 1880s.
Hunterian Art Gallery,
University of Glasgow,
Scotland

Fig. 3:30.
The White Feather by
J. Bernard Partridge
(1861–1945). Wood engrav-
ing, 1886. Department
of Special Collections,
Glasgow University Library,
University of Glasgow,
Scotland

at the lower left. A comparison between Partridge's version of the portrait and the existing *Harmony in Red: Lamplight* demonstrates that the caricaturist was attempting a fairly straightforward translation of the paintings.

Throughout the 1880s and 1890s, Whistler's activities were closely covered by the press. He was in the pages of *Punch* on half-a-dozen occasions in the decade after the trial, most often in small drawings noting an important event. Some events did not lend themselves as readily to caricature, garnering more written descriptions than drawn illustrations. For example, in February 1885, Whistler delivered his famous Ten O'Clock Lecture, elaborating his views of art and aesthetics.

The press coverage was extensive, but relatively few artists depicted the scene.[49] The most memorable contemporary British representation was in *Punch* [Fig. 3:32] on the magazine's masthead on July 4, 1885, a nod toward Whistler's American heritage. Charles Keene, an old friend of the artist, created a cross between Whistler dressed in formal evening wear and the magazine's mascot, Mr. Punch, as the title page to volume 89.[50] J. Bernard Partridge also did an illustration of Whistler delivering the Ten O'Clock Lecture, which appeared in *Lady's Pictorial* magazine.[51]

In June 1886 Whistler was elected president of the Society of British Artists, where he had been a member for less than two years.[52] The SBA had a distinguished history, but by the 1880s it had become overshadowed by the eminence of the Royal Academy and the novelty of the Grosvenor Gallery. Whistler's election as a member, and later as president, was an attempt to regain some of its former luster. The Pennells relate that Whistler, though usually characterized as vehemently anti-English, appreciated the honor bestowed by the society and worked hard to improve its fortunes.[53] A few weeks after his election, *Punch* published a very Whistlerian little drawing, *Note of a recently "Established President"* [Fig. 3:33]. In a pose reminiscent of Ward's *A Symphony*, Whistler is depicted in black, holding an open parasol on his shoulder. The parasol is transformed into a clock face labeled "P. S B A," with the hands indicating ten o'clock. The artist's head is placed against a butterfly motif, and Whistler's butterfly emblem is to the right. The word "note" is another reference to Whistler's musical titles, as

Fig. 3:31.
At the Whistleries by
J. Bernard Partridge
(1861–1945). Pen and ink,
37.4 x 27.3 cm. (14 3/4 x
10 3/4 in.), 1886. The
Harvard University Art
Museums, Cambridge,
Massachusetts; bequest of
Grenville L. Winthrop

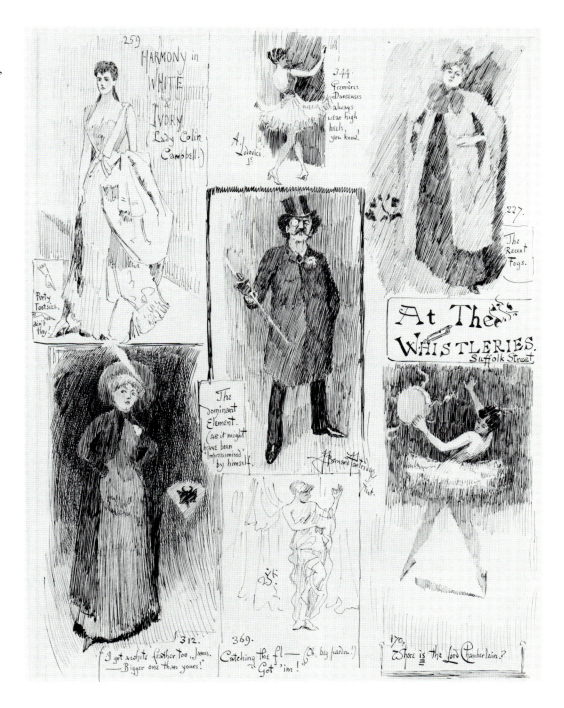

Fig. 3:32.*
Ten O'Clock Lecture by
Charles Keene (1823–1891).
Wood engraving published in
Punch, July 4, 1885.
Private collection

knowledgeable readers would have recognized from the name of the artist's exhibition at Dowdeswells' the previous month, "Notes"—"Harmonies"—"Nocturnes." Whistler appeared as president of the SBA in *Punch* two months later in *An Affair of Art* by Furniss [Fig. 3:34], a jovial parade of art dignitaries. Furniss gave Whistler a jaunty, Yankee-Doodle flavor—high-stepping, playing his palette like a banjo, and dressed in a jacket of stars and stripes. His outfit and demeanor are markedly different from the dignified English presidents in the procession, a humorously disparaging commentary on the background of the SBA's American president. Whistler resigned as president of the society two years later, after an extended period of disagreements with the older members, but no images offer commentary on his departure.

In the mid-1880s, caricatures of

Whistler also began to appear in American publications. Whistler had achieved greater recognition in the United States at this time due primarily to two events: the exhibition "Arrangement in Yellow and White," held in New York in 1883 and circulated to Boston, Philadelphia, Chicago, Detroit, and Baltimore; and the Ten O'Clock Lecture, which was extensively covered by the American press.[54] The exhibition revealed a more complete view of Whistler's talents as a printmaker and designer than the occasional representation of individual works had previously allowed. The reporting on the lecture was instrumental in preparing an American audience for Whistler's significance as a theorist redefining the goals of art. Throughout 1886 the press carried notices of Whistler's plans to tour America, delivering the Ten O'Clock Lecture in various cities.[55] When the visit never materialized,

Note of a recently "Established President."

Fig. 3:33.
Note of a recently "Established President." Wood engraving published in *Punch*, June 1886

Fig. 3:34.
An Affair of Art by Harry Furniss (1854–1925). Wood engraving published in *Punch*, August 1886

the *Evening Telegram* in New York ran a large caricature by John White Alexander, lampooning the artist in a clown's outfit. The illustration, with its caption *Why Do You Tarry, Mr. Whistler?* [Fig. 3:35] casts aspersions on the artist's seriousness while also expressing a desire to have the opportunity to hear the lecture. In general, however, the American media's reports on Whistler tended to be commentary rather than caricature. Whistler's reputation as a flamboyant personality and Victorian wit had crossed the Atlantic Ocean in the British periodicals. The American press anticipated the expatriate's arrival during these years, but for a variety of reasons Whistler never came.[56]

Whistler achieved a higher level of critical recognition in the next decade, from the fame surrounding the 1891 purchases of the portrait of his mother by the Musée du Luxembourg and the portrait of Carlyle by the Corporation of Glasgow. These were the first paintings by Whistler to be bought by major public collections. The artist was further honored by the French the following year, when he was made an *officier* of the Légion d'Honneur. Whistler's reputation was secured by the retrospective exhibition held at the Goupil Gallery in London in March and April 1892. "Nocturnes, Marines & Chevalet Pieces" was praised by the critics, earning considerable written attention. For the

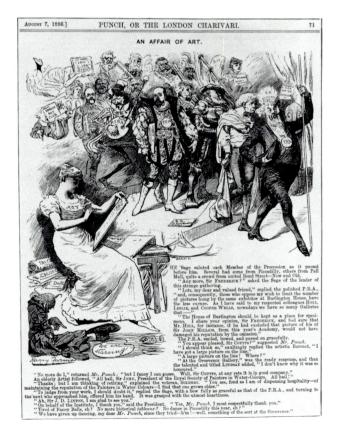

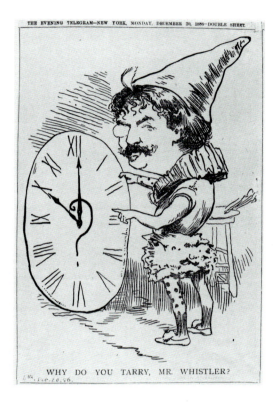

THE EVENING TELEGRAM—NEW YORK, MONDAY, DECEMBER 20, 1886—DOUBLE SHEET.

WHY DO YOU TARRY, MR. WHISTLER?

Fig. 3:35.
Why Do You Tarry, Mr. Whistler? by John White Alexander (1856–1915). Wood engraving published in *Evening Telegram*, December 20, 1886

remaining decade of his life, Whistler's paintings were eagerly sought, as the artist received his long-awaited recognition from the public and from collectors.

Whistler married Beatrice Godwin, the widow of his friend E. W. Godwin, in August 1888, with only one small vignette entitled *The Fate of an "Impressionist"* [Fig. 3:36] among the notices marking the event. The marriage changed the artist's lifestyle considerably, and images of him appeared less often in the press. From 1892 until 1895, Whistler and Beatrice spent substantial time in Paris, removing the artist from the constant scrutiny of the London illustrators. He and Trixie were a devoted couple, and the artist spent less time in men's clubs and with his male companions than during the contentious decade that had followed the Ruskin trial. He continued to appear in the press during

occasional bouts of litigation, or if an event was sufficiently newsworthy, but he was depicted most often by his friends and admirers in the glory of his final years.

Caricatures concerning litigation typify the changing image of the artist. Edward Tennyson Reed drew Whistler several times in the 1890s in works that economically encapsulate the artist's spirited character, such as *Whistler Descending the Stairs* [Fig. 3:37]. In an illustration for *Punch* in June 1890, he captured the popular image of Whistler as the stinging butterfly, pursuing his enemies over artistic causes. In *The Mephistophelian Whistlerian Butterfly "On the Pounce" at Antwerp* [Fig. 3:38], Reed portrayed the artist with butterfly wings and armed with the spiked tail that was Whistler's special gift to entomology. The occasion was Whistler's suit against a

Fig. 3:36 (*left*).
The Fate of an "Impression-ist" by an unidentified artist. Wood engraving, 1888. Department of Special Collections, Glasgow University Library, University of Glasgow, Scotland (PC 10/24)

Fig. 3:37 (*below*).*
Whistler Descending the Stairs by Edward Tennyson Reed (1860–1933). Pencil, 16.5 x 14 cm. (6 1/2 x 5 1/2 in.), 1890s. A. E. Gallatin Collection, The Miriam and Ira D. Wallach Division of Art, Prints and Photographs, The New York Public Library, New York City, Astor, Lenox and Tilden Foundations

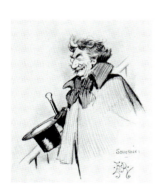

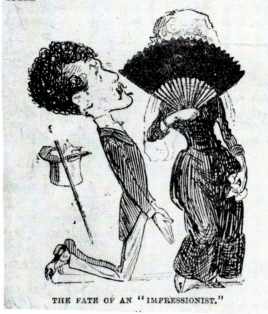

Mrs. W. E. Godwin, who was a daughter of the late Mr. Phillip, the sculptor, is a remarkably clever artist and decorative draughtswoman. Since she has been under the influence of the great James M'Neil it can be readily imagined that her undoubted artistic talents have been considerably matured. Mrs. Godwin's sister, the widow of the late Mr. Lawson, the artist, is also an accomplished wielder of the brush.

THE FATE OF AN "IMPRESSIONIST."

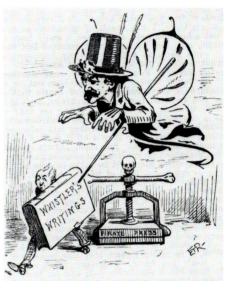

The Mephistophelian Whistlerian Butterfly " On the Pounce" at Antwerp.

Fig. 3:38 (*above*).
The Mephistophelian Whistlerian Butterfly "On the Pounce" at Antwerp by Edward Tennyson Reed (1860–1933). Wood engraving published in *Punch*, June 1890

pirated edition of *The Gentle Art of Making Enemies* that Sheridan Ford had brought out in Brussels in February. The drawing coincided with *Punch*'s review of Whistler's own edition, published in June by William Heinemann. Whistler's suit was successful, and the ersatz *Gentle Art* was removed from circulation.

In 1897 Whistler's friend Joseph Pennell sued Walter Sickert for libel over an article published in *Saturday Review*. Sickert had asserted that Pennell's use of transfer lithography did not produce a genuine artistic product. Pennell may even have been spurred to the suit by the example of his litigious comrade. Whistler appeared on behalf of Pennell in the April trial, defending the process of transfer lithography, which he had used for many years. The jury found in favor of the plaintiff, and Pennell was awarded

damages of fifty pounds and court costs. Whistler's final appearance in a life marked by trials was recorded by contemporary writers and artists.[57] Typical of the coverage of the trial was Arthur Boyd's *Mr. Whistler in the Witness Box* [Fig. 3:39] published in the *Daily Graphic* on April 6, 1897. Boyd's vignette of the artist is one of several scenes from the trial captured in this collage of courtroom episodes. The signs of Whistler's aging are clear as the artist holds a sheet of transfer paper in one hand and gestures with the other. Reed's stinging butterfly of earlier years is gone, replaced by Boyd's rendering of a mature and respected master.

In January 1894, George Du Maurier began the serial publication of his novel *Trilby* in *Harper's Monthly*, an American journal that had a European edition with an extensive readership in London. *Trilby* was a sentimental Victorian story of a young girl under the spell of the evil Svengali. Du Maurier composed the story partly along the lines of *Scènes de la Vie Bohème* and partly from Dumas's *La Dame aux Camélias*, but he set it amid a fictionalized world based on the Paris of his student days. The main character was invented, but many of the supporting cast were thinly disguised portrayals of Du Maurier and his friends, including Thomas Armstrong, Alecco Ionides,

Fig. 3:39.
Mr. Whistler in the Witness Box by Arthur Boyd (life-dates unknown). Wood engraving published in *The Daily Graphic*, April 6, 1897

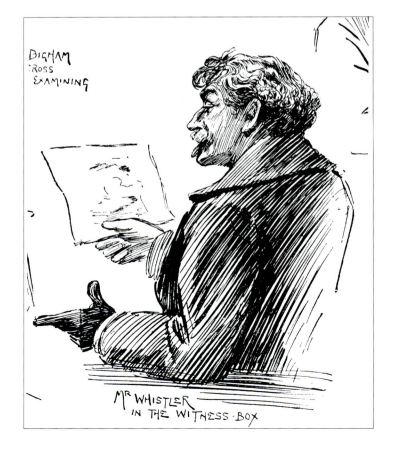

BIGHAM CROSS EXAMINING

M͏ͬ WHISTLER
IN THE WITNESS·BOX

Thomas Lamont, Edward Poynter, and Whistler. The Whistler character, Joe Sibley, did not appear until March.[58] Du Maurier portrayed Sibley as a lazy student, the "idle apprentice," contrasting him with Lorrimer, the industrious fictional counterpart of Poynter. The writer based his description of Sibley on Whistler, both in character and in costume: *vain, witty, and a most exquisite and original artist; and also eccentric in his attire (though clean), so that people would stare at him as he walked along— which he adored! . . . He was genial, caressing, sympathetic, charming; the most irresistible friend in the world as long as his friendship lasted—but that was not for-ever!*

The moment his friendship ended, his enmity began at once. Sometimes this enmity would take the simple form and straightforward form of trying to punch his ex-friend's head;[59]

. . . He is now perched on such a topping pinnacle (of fame and notoriety combined) that people can stare at him from two hemispheres at once; and so famous as a wit that when he jokes (and he is always joking) people laugh first, and then ask what he was joking about. And you can even make your own mild funniments raise a roar by merely prefacing them, "As Joe Sibley once said."[60]

. . . He was a monotheist, and had but one god, and was less tiresome in the expression of his worship. He is so still— and his god is still the same—no stodgy old master in this divinity, but a modern of the moderns! For forty years the cosmopolite Joe has been singing his one god's praise in every tongue he knows and every country—and also his contempt for all rivals to this godhead—whether quite

sincerely or not, who can say? Men's motives are so mixed! But so eloquently, so wittily, so prettily, that he almost persuades you to be a fellow-worshipper— almost, only!—for if he did quite, you (being a capitalist) would buy nothing but "Sibleys" (which you don't). For Sibley was the god of Joe's worship, and none other! and you would hear of no other genius in the world![61]

Although Du Maurier changed the physical description of Whistler, there was no mistaking his target. Du Maurier also illustrated his story, and several of the drawings included the identifiable American artist. *All As It Used to Be* [Fig. 3:40], a scene of a fencing match in the studio, shows Whistler leaning against the wall in the background on the right. Whistler can also be seen on the left side of *Taffy à l'échelle* [Fig. 3:41], a depiction of a brawl in the atelier. Neither of these representations, nor the others including Whistler, are unusual or offensive.

Whistler resented the renewed attacks upon his work habits as a student, and upon his character. At a time when his reputation was at a high point, he despised the typically English description of him as an indolent youth. The artist responded in letters to the press and initiated a suit involving both Du Maurier and *Harper's*. The case resulted in a nonfinancial, out-of-court settlement. The magazine printed an apology in its October issue, and Du Maurier made changes in the book version of *Trilby*. The illustrations, however, were essentially unchanged in the book, since they were not patently offensive.[62] Du Maurier claimed never to have completely understood the painter's reaction to the serial, blaming the incident on Whistler's

Fig. 3:40.
All As It Used to Be by
George Du Maurier
(1834–1896). Wood engrav-
ing published in *Trilby*, 1894

Fig. 3:41.
Taffy à l'échelle by George
Du Maurier (1834–1896).
Wood engraving published
in *Trilby*, 1894

Fig. 3:42.
Whistler Showing Claws to Du Maurier by George Du Maurier (1834–1896). Autograph letter with pen and brown ink drawing on blue paper, 15.2 x 19.1 cm. (6 x 7 1/2 in.), circa 1894. The Art Institute of Chicago, Illinois; Walter S. Brewster Collection of Whistleriana (1933.225 recto). © 1994, The Art Institute of Chicago.

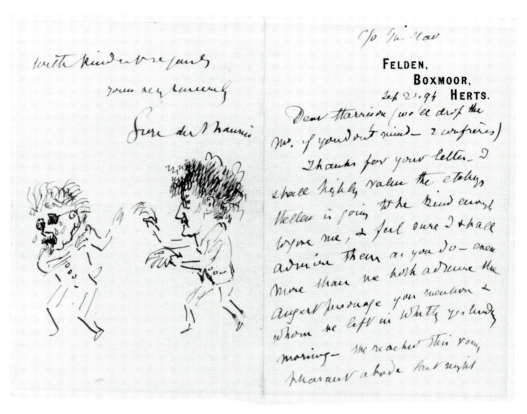

capricious temperament. The English artist expressed his sentiment in a contemporary sketch, an interesting contribution to the pantheon of Whistler portraits called *Whistler Showing Claws to Du Maurier* [Fig. 3:42].

Life magazine published a caricature in November of the same year [Fig. 3:43], referring specifically to the *Trilby* events, and generally to Whistler's reputation. The unidentified artist depicted the painter standing with a brush and a palette marked "my platform" in his hand, beside a trash basket full of "criticism." At Whistler's feet are copies of *Trilby* and *The Gentle Art of Making Enemies*. The accompanying caption reads: "*The Man Whistler at the Telephone*: Are there any more publications in which I am mentioned? If so, send my lawyer to them at once. It's dirty work, but I like it, and I am getting famous."[63] In America, much of Whistler's fame remained centered on his notorious

behavior and litigious nature, long after the tide had turned in Europe toward more substantive coverage of the artist and his work.

An outstanding portrait by Sir William Nicholson closes the chapter on images published during Whistler's lifetime. Nicholson was working for the *New Review* in 1897, doing a series of portraits of celebrities, including Queen Victoria, Sarah Bernhardt, and Rudyard Kipling.[64] He was commissioned by his publisher, W. E. Henley, to do Whistler's portrait for the September issue of the magazine. Nicholson's refined, spare rendition is one of the most memorable of all late images of Whistler [Fig. 3:44]. The original was executed as a woodblock print, exploiting Nicholson's bold, economic design, which was intended to be published later as a lithograph. The artist shows Whistler as an elegant, well-dressed figure standing alone in the center of an indeterminate space. The setting

Fig. 3:43.
The Man Whistler at the Telephone by an unidentified artist. Wood engraving published in *Life*, November 8, 1894

and costume recall the images of Whistler on stage delivering the Ten O'Clock Lecture. The dress trousers contrast starkly with the glare of the stage, while the black evening jacket blends imperceptibly into the background. The white lock and monocle are familiar, but the calm demeanor of the artist is an eloquent addition. The majestic serenity of the figure is unusual among the published Whistler images and characterizes only a few late portraits, mostly those by friends and fashionable artists. This "harmony in black" is set off by a single dash of crimson for Whistler's ribbon of the Légion d'Honneur, reportedly the painter's own suggestion for the costume. He proudly displayed the ribbon during his final years as a sign of official French

recognition in the face of long-term British neglect.[65]

Whistler liked Nicholson's work, and in 1896 had introduced him to his friend, the publisher William Heinemann. In 1899 Heinemann included the lithograph of Whistler in the young artist's volume, *Twelve Portraits*. Whistler's appreciation of Nicholson is stated in an introductory note attributed to him for an exhibition of the Englishman's work in 1900: *Out of opposing masses of black and tint of apparently the most clumsy shape emerge forms of the most convincing, and often beautiful, description. The result is gained by balance, by suggestion, and by the art of saying exactly what is wanted. The art of leaving out is proof of the perfect acquaintance with the art of putting in. Mr. Nicholson states the few essential facts, and makes all else accessory.*[66]

Whistler understood Nicholson's talent for bold design and understated tonal harmony, skills he himself had honed over a lifetime of "nocturnes" and "arrangements." Nicholson's image of Whistler defines and summarizes the late acknowledgment of the artist's importance, as Ward's *A Symphony* had captured his audacious persona in the 1870s. The aging American painter appeared infrequently in the press during the few remaining years of his life, only to reappear, phoenixlike, in print in the decade after his passing.

Fig. 3:44.*
James McNeill Whistler by Sir William Nicholson
(1872–1949). Woodcut, 44 x 35.5 cm.
(17 5/16 x 14 in.), 1897. The Art Institute of
Chicago, Illinois; Walter S. Brewster Collection of
Whistleriana (1933.237). © 1994, The Art
Institute of Chicago. All rights reserved

4

In the Studio: Artists, Disciples, and Friends

"Whistler said he could not afford to keep a friend, but he was never without one, never without many."[1] Writers, musicians, and artists were among Whistler's usual studio companions, as well as the disciples who accompanied him through much of his career. Painters and pupils recorded intimate and prosaic aspects of the artist's daily life—on the street and in the studio—that were unknown to the illustrators of Victorian journals and newspapers. The imagery produced by Whistler's inner circle reveals a different side of the painter's life and personality.

Although Whistler was friendly with many artists during the early London years, only two can be identified as his pupils: Henry and Walter Greaves. Whistler later recalled, "I know the two Greaves very well. When I first went to Chelsea they were boys, the son of Greaves the well known boat builder, my neighbor in Lindsay Row. They were more my pupils than anyone has ever been—and full of talent."[2] The brothers were artists whose best work, despite Whistler's later recorded appraisal, was a mix of competent draftsmanship and naïveté. Chelsea and its inhabitants were their sole interest. Walter Greaves, the more productive of the brothers, produced Whistlerian views of the Thames, as well as many portraits in the style of his American master. In the course of a career that spanned fifty years, Walter depicted Whistler on canvas or paper more than one hundred times. While the dating of the works is problematic, the variety and number of the portrayals deserve serious consideration.

Whistler moved to 7 Lindsay Row in Chelsea in March 1863, and met his neighbors the Greaveses within a short time. Charles William Greaves was a waterman who earlier had been engaged by J. M. W. Turner to row the painter on the Thames.[3] The Greaves family lived on the end of Lindsay Row, close to their boatyard and just a few doors away from the young Whistler. Two of the Greaves children, Henry and Walter, had an early interest in painting and drawing, partly deriving from their detailing of boats in their father's yard, and partly inspired by their father's stories about Turner and John Martin, other Chelsea neighbors. The brothers often collaborated on drawings of local scenes; Walter's talent lay in composition and figures, while Henry provided the precise architectural elements. Henry and Walter were already in their late teens when they first met Whistler, and their lives would be tightly intertwined with his during the following twenty years. Walter later recalled their first meeting: *One day we were painting on the*

Fig. 4:1.
Whistler at His Easel by Walter Greaves (1846–1930). Oil on canvas, 121.9 x 78.7 cm. (48 x 31 in.), 1876. Michael Parkin Fine Art, London

river when Whistler, whom we knew by sight as a neighbor, came up to us and watched us work. He said suddenly "Come over to my place," and we went there and he showed us his work and his Japanese things. I lost my head over Whistler when I first met him and saw his painting.[4] Whistler became very fond of the brothers, and they spent much time together. During the day, the boys would lead the painter around the dilapidated waterfront of the old village, or across to Battersea, or to the amusements of Cremorne gardens. Whistler also spent many evenings at the Greaveses' house, becoming an adopted member of the family for most of the 1860s and 1870s. He was fond of the boys' parents and their sisters, particularly the youngest, "Tinnie." However, it was Henry and Walter who interested Whistler most. Walter defined their relationship later in his life by noting, "He taught us to paint and we taught him the Waterman's Jerk."[5] The brothers gave Whistler a great deal more than simply teaching him to row, however, since it was the Greaveses who took the painter out on the Thames at dusk to view the light and atmosphere of the river. Later in the decade, Whistler would develop his ideas for the nocturnes from his observations of how evening light veiled the details of the river views and created unified scenes of delicate tonal harmony.

The young artists idolized Whistler, adopting not only his painting style but his appearance and dress as well. In consciously imitating their teacher, they foreshadowed the legion of disciples who would surround the artist in the 1880s. The Pennells relate a story told to them by James Christie, a Chelsea artist, that

conveys much about the tenor of their relationship. Whistler sometimes attended evening life classes at the local studio of Victor Barthe, to sharpen his skills in anatomy. *Whistler was not a regular attender at the Limerston Street Studio, but came occasionally, and always accompanied by two young men—brothers—Greaves by name. They let out rowing-boats on the Thames and Battersea Park. They simply adored Whistler, and were not unlike him in appearance, owing to an unconscious imitation of his dress and manner. It was amusing to watch the movements of the trio when they came into the studio (always late). The curtain that hung in front of the door would suddenly be pulled back by one of the Greaves, and a trim, prim little man, with a bright, merry eye, would step in with "Good evening," cheerfully said to the whole studio. After a second's survey, while taking off his gloves, he would hand his hat to the other brother, who hung it up carefully as if it were a sacred thing—then he would wipe his brow and moustache with a spotless handkerchief, then in the most careful way he arranged his materials, and sat down. Then, having imitated in a general way the preliminaries, the two Greaves sat down on either side of him. There was a sort of tacit understanding that his and their studies should not be subjected to the rude gaze of the general. . . . The comical part was that his satellites didn't draw from the model at all, that I saw, but sat looking at Whistler's drawing and copying, as far as they could, that. He never entered into the conversation, which was unceasing, but occasionally rolled a cigarette and had a few whiffs, the Greaves brothers always requiring their whiffs at*

the same moment. The trio packed up, and left before the others always.[6]

From 1863 to 1878, the Greaveses worked with Whistler in the studio as general handymen and workshop assistants. They purchased and prepared his colors, stretched his canvases, and often framed his work in accordance with his designs.[7] The brothers were Whistler's constant companions on the river and in the studio, with access to his most intimate working methods. "I know all of these things because I passed days and weeks in the place standing with and beside him," Walter Greaves told the Pennells when they were preparing their biography.[8] The brothers were present during the painting of many of Whistler's most important works at this time, including the portraits of his mother [see Fig. 3:2], Thomas Carlyle [see Fig. 3:3], Cicely Alexander, and Frederick Leyland.[9] They also assisted Whistler with larger decorative works, from the mundane painting of his Chelsea home to the application of blue and gold on the ceiling and walls of the Peacock Room.[10]

Walter and Henry learned from observing Whistler and from the master's instruction. They modified their own meticulous drawing style of the 1860s in favor of broadly painted abstract images of the Thames and of Chelsea. In addition, they began to include Whistler in their scenes of the local environs, such as Battersea, Chelsea, and Cremorne. No records exist of Whistler sitting for the brothers, nor are there contemporary references to any exhibitions of Walter's many representations of his teacher. It was apparently later, from memory, that Walter produced the seemingly endless portraits of the master.

In the later 1870s the relationship began to deteriorate, perhaps because of Whistler's move away from the working-class area of Chelsea, or possibly because of his peevishness toward the brothers for failing to attend one of his exhibitions.[11] After Whistler's return from Venice in 1881, Oscar Wilde became his favorite studio companion, followed by two other disciples, Walter Sickert and Mortimer Menpes. The final break with the Greaves brothers occurred in the latter part of the decade, at the time of Whistler's marriage. Beatrice Godwin was unhappy with her new husband's old friends and cronies, and may have been suspicious of Whistler's past affection for Tinnie. For the last fifteen years of his life, Whistler had only rare contact with his old friends. Walter Greaves, however, never relinquished his hopes of a reconciliation, nor did he forget the time he had spent with the artist in the past. His many late depictions of Whistler attest to his continuing fascination with the most significant relationship of his life.

Greaves executed more than one hundred depictions of Whistler in assorted contexts. The largest number of portraits are single-figure half- and three-quarter-length views. Typically, Whistler is represented almost life-size, and placed in a studio interior or outside, with a recognizable local view in the background. *Whistler at His Easel* [Fig. 4:1] is exemplary of the interiors, showing the seated artist holding a brush and a palette. The familiar white lock, monocle, mustache, and imperial clearly identify the stiffly portrayed figure of Whistler. The depiction is augmented by studio accessories: a Thames nocturne scene on an easel and a truncated print or drawing framed on the

rear wall, which derives from the background of Whistler's portrait of his mother. The date of 1876 below the signature is consistent with details of Whistler's life and work from the same time period. One sketch of Whistler [Fig. 4:2] is a smaller version of this type, although it is more detailed than most of the drawings.

The National Portrait Gallery's recently acquired portrait is typical of Greaves's views of Whistler outdoors [Fig. 4:3]. Here the artist is depicted with a sober expression, his wide-brimmed hat pushed back to reveal his tuft of milky hair. He holds a brush in his right hand but is not applying paint to the canvas. In the background is a river view with sailboats, and over one shoulder the square clock tower of Chelsea Old Church can be seen.

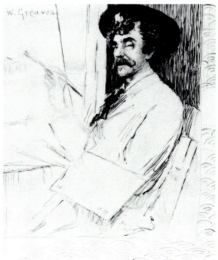

Fig. 4:3.*
James McNeill Whistler by
Walter Greaves (1846–1930).
Oil on canvas, 81.3 x 55.9 cm.
(32 x 22 in.), 1870. National
Portrait Gallery, Smithsonian
Institution, Washington, D.C.

Fig. 4:2.
Whistler Holding a Paintbrush
by Walter Greaves (1846–1930).
Pen and ink, 26.6 x 21.6 cm.
(10 1/2 x 8 1/2 in.), not dated.
Private collection

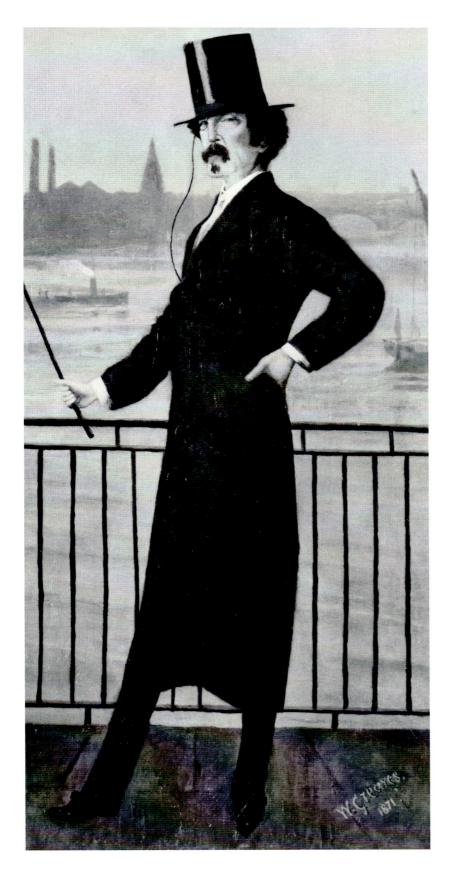

Fig. 4:4.*
Whistler on the Chelsea Embankment by Walter Greaves (1846–1930). Oil on canvas, 91.4 x 45.7 cm. (36 x 18 in.), inscribed 1871. Charles Goldsmith, Inc., New York City

The pose is reminiscent of those used in Whistler's own self-portraits, including the *Arrangement in Grey* [see Fig. 2:10]. The inscribed date of 1870 is credible with regard to the artist's age and costume.

Greaves occasionally rendered Whistler full-length out-of-doors, although with less frequency than the half-length versions. *Whistler on the Chelsea Embankment* [Fig. 4:4] represents Greaves's attempt at a monumental portrait type. The pose is borrowed from Ward's *Vanity Fair* caricature, *A Symphony* [see Fig. 3:1]. Greaves has exchanged Whistler's beret for a silk top hat, and here the painter's maulstick points to the sky. A river view beyond the handrail includes sails and a shipping crane and the shoreline of Battersea with the distinctive silhouette of Old St. Mary's Church across the river. The canvas is signed and dated 1871 in the lower-right corner. The date is demonstrably inaccurate, which is an all-too-common problem in Greaves's paintings, and creates difficulties when attempting to establish a reasonable chronology of these images.[12] The Ward caricature *A Symphony* was published in January 1878, and Whistler only began wearing the flat-brimmed top hat in about 1885. Details of costume and setting are often at odds with the dates, revealing the inscriptions to be apocryphal and of questionable value. Since no contemporary documentation exists for Greaves's portraits of Whistler, any attempt at accurate dating is speculative. Most of the portraits appear to have been done from memory, either after the artist and the brothers were estranged, or after Whistler's death. Only occasionally does a date seem to be accurate. Why?

Fig. 4:5.
Whistler and Maud Franklin
by Walter Greaves
(1846–1930). Oil, 76.2 x
50.8 cm. (30 x 20 in.), not
dated. Whistler House
Museum of Art, Lowell,
Massachusetts

Fig. 4:6.*
*Whistler Sketching on the
Thames* by Walter Greaves
(1846–1930). Pencil, ink,
and wash, 25.4 x 38.1 cm. (10
x 15 in.), 1860?
Tom Pocock

Whistler stopped dating his paintings in the early 1870s, which probably inspired the brothers to do the same. The master exerted substantial influence over his disciples, forcing them to paint only in his style and controlling what they exhibited.[13] Later, when the Greaves brothers were excluded from his circle, they sometimes returned to their previous detailed, descriptive style, and perhaps they felt that it was appropriate to return to dating their work. An interesting idea has been advanced by Michael Bryan: that the inscriptions in the Greaveses' works rep-

resent not the dates of the works but the years in which the scenes were set.[14] However, the Greaveses' memory for costume and setting was vague. As Bryan states, "This explanation would account for the contradictions and would be consistent with Walter's naiveté and, by all accounts, transparent honesty."[15]

An interesting variant among the portraits by Walter Greaves is *Whistler and Maud Franklin* [Fig. 4:5], in the collection of the Whistler House Museum of Art in Lowell, Massachusetts. Whistler is depicted in a domestic interior, casually leaning on his elbow, while his mistress displays a porcelain vase with her left hand for his inspection. Though the figures are awkwardly rendered, the painting serves as a rare example of a Greaves painting of Whistler's private life.

Walter also sketched scenes of Whistler's daily life as an artist in Chelsea. *Whistler Sketching on the Thames* [Fig. 4:6] depicts a common activity in the life of the artists, the master sitting and sketching in a rowboat, with a Whistleresque Henry holding an oar. In the background is a familiar scene along the Chelsea waterfront: Alldin's Coal Wharf blocking the view of Chelsea Old Church, coal barges unloading on the river, and the Cadogan Pier to the right. At the lower left the scene is signed and dated "'60," three years before the Greaveses met Whistler. *Whistler Sketching from the Balcony of the Adam and Eve* [Fig. 4:7] provides another glimpse of the artist rendering the local topography, with Old Battersea Bridge faintly visible in the distance. In these drawings, Walter Greaves conveyed a sense of Whistler working and also reinforced his own significance as an intimate and as a

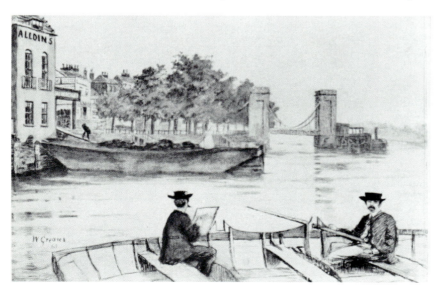

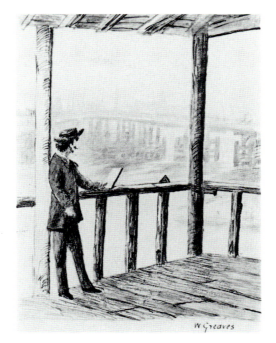

Fig. 4:7.
Whistler Sketching from the Balcony of the Adam and Eve by Walter Greaves (1846–1930). Pen and ink with wash, 21 x 16.5 cm. (8 1/2 x 6 1/2 in.), not dated. Private collection

collaborator of the famous painter.

The Greaves brothers collaborated on some of the most elaborate scenes of their lives in a series of works set in Cremorne Gardens, the amusement park located west of Chelsea along the Thames. Whistler had painted a group of nocturnes of the gardens in the mid-1870s, including the notorious *Nocturne in Black and Gold: The Falling Rocket* [see Fig. 3:8], which had been the center of attention during the Ruskin trial. The American painter exploited the aesthetic potential of the gardens for his experi-

ments in tonal harmony. In contrast, the Greaveses approached the gardens in a descriptive way, carefully using pencil and watercolor to record the buildings, the setting, and the costumes of the people who attended the pleasure park. *Whistler in the Cremorne Gardens* [Fig. 4:8] includes portraits of the expatriate artist and Tinnie at a table on the left, and Henry leaning against the fountain. Walter did the figures, but the careful detailing of the architecture is Henry's contribution. Henry's meticulous care in rendering the scene is evident in the Chinese bandstand in the left background and the stork fountain in the middle ground. This descriptive pencil technique was the Greaveses' earliest style, which Whistler had found repugnant; but the brothers returned to it after their parting with the master. The date of 1866 appearing below the inscription is more acceptable as the date of the action depicted than the date of execution. Other representations of Whistler in Cremorne Gardens include *James McNeill Whistler in the Cremorne Gardens*

Fig. 4:8.*
Whistler in the Cremorne Gardens by Henry Greaves (1844–1904) and Walter Greaves (1846–1930). Pencil and grisaille watercolor, 49 x 62.2 cm. (19 1/4 x 24 1/2 in.), 1866. Michael Parkin Fine Art, London

Fig. 4:9.
James McNeill Whistler in the Cremorne Gardens, Chelsea by Walter Greaves (1846–1930). Watercolor over pencil heightened with white, 61.6 x 48.9 cm. (24 1/4 x 19 1/4 in.), 1865. Peter Nahum Ltd., London

[Fig. 4:9] and *A Balloon Ascent from Cremorne Gardens* [Fig. 4:10], the brothers' delicate watercolor drawing of the amusement park.

Walter Greaves's most fascinating series of portraits were those of Whistler painting the *Arrangement in Grey and Black: Portrait of the Painter's Mother*. The brothers had been present in Whistler's studio in the early 1870s when the painting was executed, as the Pennells related in their biography: *There was scarcely any paint used, Mr. Greaves says, the canvas being simply rubbed over to get the dress,*

and, as at first the dado had been painted all across the canvas, it even now shows through the black of the skirt. That wonderful handkerchief in the tired old hands, Mr. Greaves describes as "nothing but a bit of white and oil."[16]

Whistler Arranging the Portrait of His Mother [Fig. 4:11] is the first in the sequence describing the progress of the *Arrangement in Grey and Black*. Greaves depicted Whistler standing in front of a blank canvas, contemplating the pose of his sitter before setting to work. The viewer is situated close to the scene, look-

Fig. 4:10.
A Balloon Ascent from Cremorne Gardens by Henry (1844–1904) and Walter Greaves (1846–1930). Pencil and watercolor, 48.9 x 62.2 cm. (19 1/4 x 24 1/2 in.), 1872 (?). Private collection

brush. This vantage point implies that the viewer is witness to the intimate moments at the conception of the painting, not simply watching the artist at work. The privileged viewpoint is another reminder of Greaves's close association with the artist. In an interesting parallel to his descriptions of Whistler's painting technique, Greaves has applied the paint in a thin veil of pigment, leaving the canvas clearly evident. The painting is signed at the lower right and dated 1917, one of the few dates that is wholly believable as the time of execution. The date confirms that Greaves was still painting from memory as a septuagenarian, fourteen years after the death of his teacher.

The small watercolor *Whistler in His Studio Painting the Portrait of His Mother* [Fig. 4:12] follows in the sequence, representing the artist putting the finishing touches on the portrait of his mother. Once again the viewer is close to the action, observing from a spot just behind the painter. Greaves emphasized the large framed canvas in this scene, with Whistler dabbing at the etching in the background. The artist is again shown in formal attire, perhaps out of Walter's deference to him. Drawings and photographs from the period show that Whistler usually dressed in work clothes when painting. Large ceramic vases around the room hold cut flowers, and Greaves has signed the drawing on the large carpet.

In a larger, related drawing, *Whistler in the Studio with the Portrait of His Mother* [Fig. 4:13], Walter included more incidental information. The viewer is farther from the artist, as Whistler steps back to admire an oversized rendition of the portrait. Greaves's construction of the studio invites the viewer to do likewise.

ing over the painter's shoulder. The recognizable accessories from Whistler's portrait of his mother are faithfully included here: the framed etching of *Black Lion Wharf*, the picture behind his mother's head, and a curtain that hangs in the center of the windowless rear wall. Other prints decorate the rear wall, and a spray of blossoms emerges from two vases on the right. In this depiction, Greaves focuses on Whistler's construction of the famous painting, rather than on its execution. No easel or canvas is included in the scene, although Whistler is holding a

Fig. 4:11.*
Whistler Arranging the Portrait of His Mother by Walter Greaves (1846–1930).
Oil on canvas, 62.9 x 75.6 cm. (24 3/4 x 29 3/4 in.), 1917.
Fogg Art Museum, Harvard University Art Museums, Cambridge, Massachusetts; gift of Mr. and Mrs. Stuart P. Feld

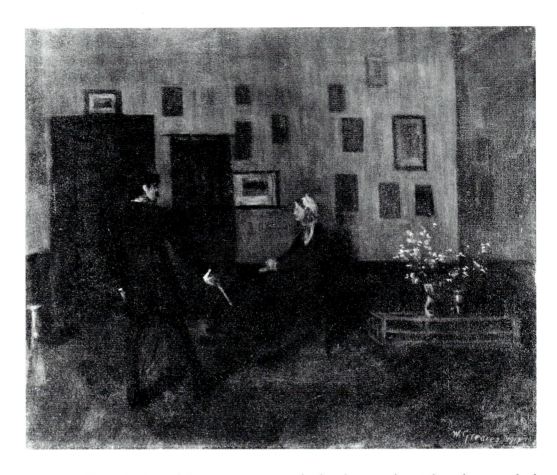

The wide-angle view of the studio contains numerous works tacked up on the walls, and in this version several of the framed canvases are identifiable. On the wall above Whistler's head is the 1871 self-portrait *Arrangement in Grey: Portrait of the Painter* [see Fig. 2:10]. To the left of the artist is *Nocturne: Blue and Gold—Old Battersea Bridge*, dated to 1872–1873 [Fig. 4:14]. These canvases were all painted during approximately the same period, so that in this instance Walter Greaves's memory provided him with a credible group of works.

Two pieces of furniture in front of the windows convey interesting information about Whistler's working methods. The Greaves brothers were his studio assistants when these canvases were painted. As the Pennells related in their biography: *The colours were arranged upon a palette, a large oblong board some two feet by three, with the Butterfly inlaid in one corner and, round the edges, sunken boxes for brushes or tubes. The palette was laid upon a table. He had at various periods two or three of these, and at least one stand, with many tiny drawers, upon which it fitted. At times it was slightly tilted. At the top of the palette the pure colours were placed, though, more frequently there were no pure colors at all.*[17]

The fourth and final picture in the sequence is Walter Greaves's *Whistler's Studio* [Fig. 4:15]. He represented Whistler facing the viewer, triumphant after completing his masterpiece. The pose is derived from Sir Leslie Ward's *Vanity Fair* caricature, which Greaves had used previously in several full-length portraits. To the right of the *Portrait of the Painter's Mother* is *Nocturne: Blue and Gold—Old Battersea Bridge*; several other unidentifiable paintings are also in the room. The palette table and the carpet are familiar details, although the shape of the room cannot be reconciled with the shape of Whistler's studio in Chelsea.

Fig. 4:12.
Whistler in His Studio Painting the Portrait of His Mother by Walter Greaves (1846–1930). Watercolor, 22.2 x 30.2 cm. (8 3/4 x 11 7/8 in.), not dated. Unlocated

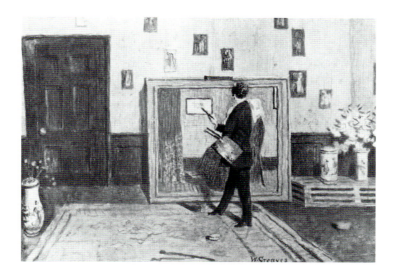

Fig. 4:13.*
Whistler in the Studio with the Portrait of His Mother by Walter Greaves (1846–1930). Pencil and watercolor, 33 x 45.7 cm. (13 x 18 in.), not dated. Private collection

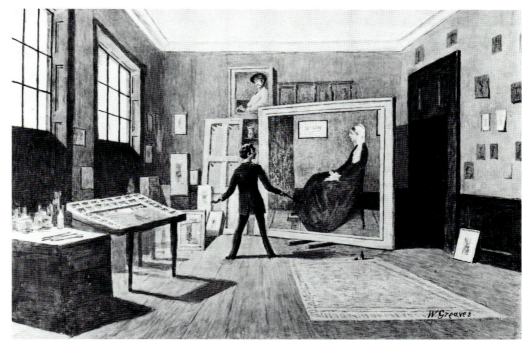

The painting is signed and dated in the lower right-hand corner, but both parts of the inscription are problematic. Greaves is spelled with an extra "v," and the date is given as 1869, several years before Whistler's portrait of his mother and the nocturne were actually done.

The four paintings form an interesting record of Walter Greaves's memories of the creation of one of Whistler's best-known works. The fame and recognition of *Arrangement in Grey and Black: Portrait of the Painter's Mother* began in 1891 with the French government's acqui-

sition of the painting. It is unlikely that Greaves would have singled out the portrait in the 1870s, when he was a fixture in Whistler's studio. The 1917 date on one of the paintings in the series helps to confirm that they were probably all done later from memory. With historical hindsight, Greaves chose to celebrate the conception and creation of Whistler's most famous work, most likely in the warm afterglow of the artist's life. In an oeuvre that provides many insights into Whistler's daily life in Chelsea, these paintings form the centerpiece of the representation

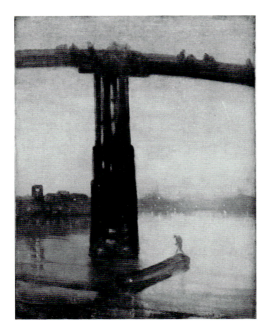

Fig. 4:14.
Nocturne: Blue and Gold—Old Battersea Bridge by James McNeill Whistler. Oil on canvas, 66.7 x 50.2 cm. (26 1/4 x 19 3/4 in.), 1872–1873. Tate Gallery, London

mal instruction from him. In the latter part of the 1870s, prior to the Ruskin libel suit, Whistler appears to have contemplated establishing an atelier, in the manner of the French training he had received as a youth. In the autumn of 1877 he commissioned his friend, the architect E. W. Godwin, to design a house and studio in Tite Street in the eastern end of Chelsea.[18] The top floor of the White House, as it was known, had a large space for an atelier, which Whistler hoped

Fig. 4:15.*
Whistler's Studio by Walter Greaves (1846–1930). Oil on canvas, 92.4 x 100 cm. (36 3/8 x 39 3/8 in.), 1869? Private collection

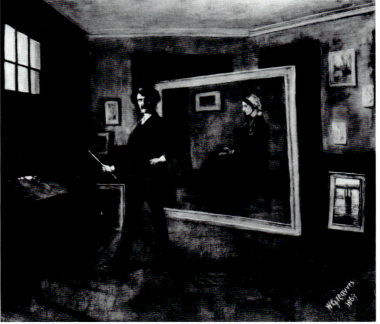

of an idolized master. The portrayals are an homage to the teacher, and a reminder that Greaves played a significant role in Whistler's life. If Walter was not Whistler's best pupil, certainly he was his most faithful.

Walter and Henry Greaves did indeed perceive themselves as pupils of Whistler, but in reality they received minimal for-

would attract students and ease his financial difficulties. Instead, he underestimated the costs of construction, which contributed to his worsening financial position. The Metropolitan Board of Works, owners of the leased property, also demanded numerous changes in the design of the house, increasing costs and delaying completion of the project. The

White House was largely finished by June 1878, but Whistler was unable to occupy the premises until the following autumn. The anticipated financial relief from a favorable verdict in the Ruskin libel case dissipated with the jury's decision. Whistler never had the opportunity to utilize the White House as an atelier and lived there for less than a year before declaring bankruptcy in May 1879. Although he lingered in the house for several more months, he abandoned his plans for opening a studio.

During the summer Whistler accepted a commission from the Fine Arts Society to make a series of prints in Venice. The agreement called for the artist to execute twelve etchings over a period of three months. Whistler left for Venice in September, but the three months stretched into fourteen, and a dozen plates increased to more than fifty prints, one hundred pastels, and a handful of paintings. These works were exhibited in a series of exhibitions upon the artist's return to London, and helped him reestablish his reputation after the trial and bankruptcy.

In September 1879 *The World* contained a notice of Whistler's commission from the Fine Arts Society and his upcoming trip to Venice.[19] Three months later, a parody appeared in *The World*, entitled *Ididdlia—On the Grand Canal*, and included an illustration with the same title [see Fig. 3:21]. London editors now considered Whistler's travels newsworthy. An astute observer might also have recognized Whistler in a wood engraving by R. Caton Woodville published in the *Illustrated London News* in 1880 [Fig. 4:16].[20] Whistler is seen with his monocle and his prominent straw hat on the left side of the composition, engaged in conversation at the Café Florian in the Piazza San Marco. The Basilica of San Marco and the Campanile are depicted in the background of this quintessentially Venetian scene, identifying the location for a knowledgeable readership. An American artist in Venice described this regular event in his later reminiscences of his time with Whistler: *We dined at some of the numerous restaurants that were to be found in the neighborhood of the piazza,*

Fig. 4:16.
Whistler in Venice by R. Caton Woodville (1825–1855). Woodcut published in the *Illustrated London News*, 1880

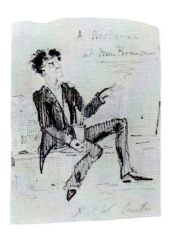

Fig. 4:17.
A Nocturne at Mrs. Bron-son's! by Ralph Curtis
(1854–1922). Pencil on
paper, circa 1880.
Unlocated

*afterward strolling along to the Café
Quadri or the Café Florian, where we
enjoyed our coffee in the open air, listen-
ing to the music, telling stories, and
watching the thousands who came and
went.*[21]

This productive period in the artist's
career was marked by his first regular
interaction with a group of young Ameri-
can artists. Whistler always had a num-
ber of artists and writers around him in
London, whether in the studio or at the
Victorian clubs. He knew few artists
when he first arrived in Venice, although
he quickly befriended the American con-
sul, John Grist, and his vice consul,
William Graham, himself an artist from
California. They introduced Whistler to
the circle of American expatriates then in
Venice.[22] Whistler became a regular at the
dinners held in the sumptuous palaces of
the Bronsons, the Brownings, and the
Curtises.[23] As Ralph Curtis later wrote to
the Pennells, *Whistler was a constant and
ever-welcome guest at Casa Alvisi, the
hospitable house of Mrs. Bronson, whom
he often called* Santa Caterina Seconda.
*During happy years from lunch till long
past bed-time her house was the open
rendezvous for the rich and poor—the
famous and the famished—*les rois en exil
*and the heirs presumptive to the thrones
of fame. Whistler there had his seat from
the first, but to the delight of all he gener-
ally held the floor.*[24]

Curtis, a relative of John Singer Sar-
gent, also provided a visual depiction of
Whistler in this milieu. In his sketch
A Nocturne at Mrs. Bronsons! [Fig. 4:17],
he represented the artist in evening dress,
holding a glass in his hand while expound-
ing upon a work of art to his left. Whis-
tler reveled in the company of the Ameri-

can upper classes but needed the company
of artists and writers as well.

Whistler had invited Walter Greaves to
accompany him to Venice, but Greaves
declined, possibly because of his own
financial difficulties.[25] Maud had fol-
lowed Whistler in October, cooking and
entertaining for him in the modest circum-
stances they endured during the Venetian
sojourn. The artist, however, always pre-
ferred male companionship when he was
working, and his model and mistress was
not received in polite society in London or
Venice. While Whistler maintained his
friendships with the fashionable American
expatriates who lived in the city, evidence
suggests that he spent most of his time
with the younger artists who had accom-
panied the American painter Frank Duve-
neck from Florence. Several of those
artists depicted Whistler in remarkably
candid images, far different from his pos-
turings for Victorian society.

Duveneck had taught a class for Amer-
icans in Munich for many years, but had
decided to move his class to Florence in
the fall of 1879. The students in the class
included John White Alexander, Otto
Bacher, Charles Corwin, Harper Penning-
ton, Ralph Curtis, Julian Story, and
Theodore Wendel. After instruction end-
ed in April, the class moved to Venice for
the summer of 1880. Otto Bacher
recalled that Consul Grist introduced the
Duveneck "boys" to Whistler, who was
living in inexpensive quarters near the
church of the Frari.[26] Whistler visited
them at their lodgings in the Casa
Jankovitz, an inexpensive pension in the
picturesque Castello district. The rooms
of the pension had marvelous views of the
city and the lagoon, which immediately
attracted Whistler's attention. Bacher not-

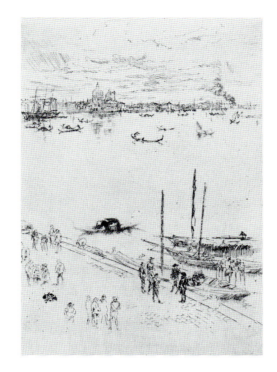

Fig. 4:19.*
No doubt this is "Jimmy" by
Robert Blum (1857–1903).
Pencil, 17.5 x 10.3 cm.
(6 7/8 x 4 1/16 in.), 1880.
Cincinnati Art Museum,
Ohio; Folsom Fund

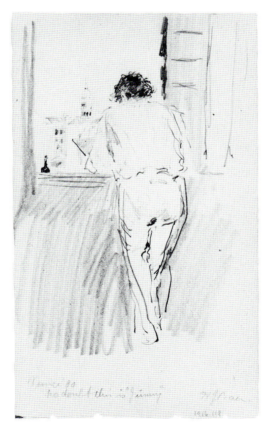

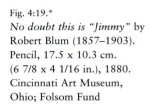

ed that the artist soon returned to draw pastels and etchings from their windows.[27] Shortly after, the older American artist moved to the Casa, which catered to foreign students and artists. Several of his etchings, including *Upright Venice* [Fig. 4:18], record the panoramic view from his windows, as usual in reverse, since Whistler characteristically drew the view on the plate without compensating for the natural reversal in the printing.[28] Robert Blum, another young American artist working in Venice in the summer of 1880, recorded Whistler sketching from one of these windows in *No doubt this is "Jimmy"* [Fig. 4:19].

Charles Corwin's monotype portrait [Fig. 4:20] is the most compelling image of Whistler from this period. Monotypes were created as a type of parlor game among the Duveneck students while in Florence and were known as Bachertypes because Otto Bacher owned the printing press.[29] Corwin utilized the painterly process to capture Whistler in a serene moment, his head inclined in contemplation, perhaps concentrating on a plate or pastel held outside the margin of the picture. The dark-manner technique of the monotype, beginning with a heavily inked surface and selectively wiping for the highlights, allowed Corwin to express the bright white of the artist's "feather" and shirt, in contrast to the rich blacks of the tie and jacket. Corwin's *Portrait of Whistler* depicts a private moment in the painter's life, one reserved for friends and trusted companions. These young men, perhaps reminding Whistler of his own treasured student days in Paris, were the artist's closest comrades in art in Venice. As Ralph Curtis later expressed to the Pennells, *Very late, on hot* sirocco *nights,*

Fig. 4:20.*
Portrait of Whistler by Charles
Abel Corwin (1857–1938).
Monotype, black ink,
22.4 x 15.4 cm.
(8 13/16 x 6 1/16 in.), 1880.
The Metropolitan Museum of
Art, New York City; The
Elisha Whittelsey Collection,
The Elisha Whittelsey Fund,
1960 (60.611.134)

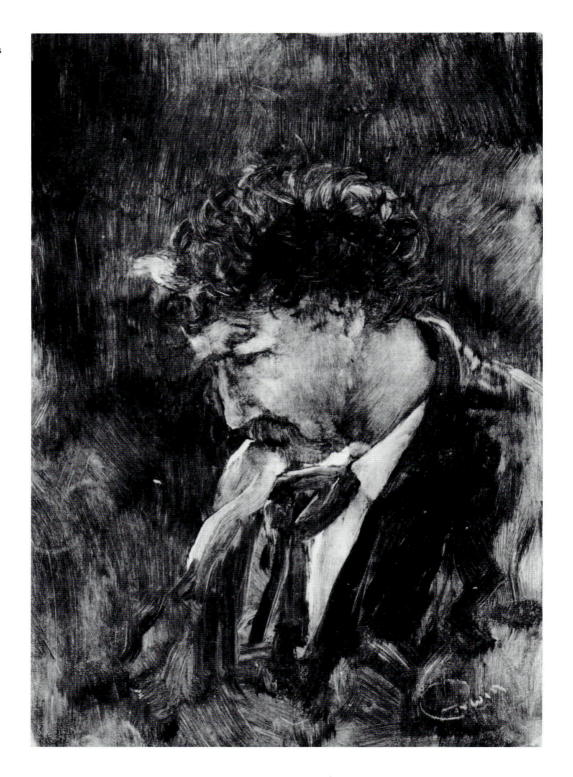

long after the concert crowd had dispersed, one little knot of men might often be seen in the deserted Piazza San Marco, sipping refreshment in front of Florian's. You might be sure that was Whistler, in white duck, praising France, abusing England, and thoroughly enjoying Italy.[30]

Friendships between Whistler and several of this group lasted well beyond their brief stay in Venice. Otto Bacher remained in close contact with Whistler during the next six years, occasionally seeing him in London and often corresponding with Maud. Whistler referred to Bacher as his pupil, although the younger artist later wrote that he neither deserved nor appreciated the compliment at that time.[31] In his reminiscences, Bacher provided some of the best descriptions of Whistler in Venice: *The latter was short, thin, and wiry, with a head that seemed large and out of proportion to the lithe figure. His large, wide-brimmed, soft, brown hat was tilted far back, and suggested a brown halo. It was a background for his curly black hair and singular white lock, high over his right eye, like a fluffy feather carelessly left where it had lodged. A dark sack-coat almost covered an extremely low turned-down collar, while a narrow black ribbon did service as a tie, the long pennant-like ends of which, flapping about, now and then hit his single eyeglass.*[32]

Bacher also photographed Whistler in London [Fig. 4:21]. The artist, dressed in black, is posed in the Tite Street studio in front of a black-velvet drapery that Whistler used in some of his portraits. The photograph captures the same elegant, lithe figure that Bacher later described. The dark costume against the black background conveys a stark image,

foreshadowing the economy of the later Nicholson woodcut [see Fig. 3:44].

Harper Pennington and John White Alexander were two of the other students who maintained cordial relations with Whistler long after his return to London. Pennington had already illustrated Whistler delivering his Ten O'Clock Lecture, one of several drawings he did of the artist in the mid-1880s. *Portrait of Whistler with a Paintbrush* [Fig. 4:22] depicts Whistler in the same sketchy pen-and-ink style as the readily dated representation of the lecture. A third sketch by Pennington, *A Certain Master*, was published in *Century Magazine* in October 1902.

John White Alexander was one of Duveneck's most advanced students in Italy, sharing the older artist's studio in Florence and teaching some of his classes.[33] Whistler came upon him one day painting alongside one of the back canals in Venice. As Alexander later recalled: *It was Whistler, posing characteristically and flourishing his mustaches. I spoke to him; and then he sat down on the stool, and, instead of criticizing the picture, he spoke only in the kindliest manner, suggesting where the composition might be improved, and where a bit of color needed a higher tone.*[34] Alexander was surprised by Whistler's courteous manner and quiet encouragement, and a friendship developed that continued for many years. In 1886, *Century Magazine* commissioned Alexander to make portrait studies of well-known American expatriates in London. Whistler agreed to sit for the younger artist but was his usual irascible self. As a portraitist, the stories of Whistler demanding long and excruciating sittings are commonplace. He rarely sat

Fig. 4:21.*
Whistler in the Tite Street Studio by Otto Bacher (1856–1909). Photograph, 1881–1884. Department of Special Collections, Glasgow University Library, University of Glasgow, Scotland (PH 1/221)

Fig. 4:22.*
Portrait of Whistler with a Paintbrush by Harper Pennington (1855–1920). Pen and ink over graphite on wove paper, 18 x 10.2 cm. (7 x 4 in.), circa 1885. National Gallery of Art; gift of Mark Samuels Lasner. © 1994, Board of Trustees, National Gallery of Art, Washington, D.C.

for others, however, and on the few occasions when he acquiesced, he was an impatient subject. When Alexander arrived at the studio to begin the portrait, several of Whistler's acquaintances were there, including Lady Colin Campbell. Alexander had not progressed very far before his sitter took up brush and palette and began to repaint the portrait. Only after Lady Campbell scolded Whistler for misbehaving was Alexander able to continue his study.[35] The painting may have never been completed, and is lost today; *Century Magazine* did not publish it in its series.

The charcoal *Portrait of Whistler* [Fig. 4:23] by Alexander is signed and dated 1886, but is different in technique and detail from the painting described in the story above. Whistler is depicted in three-quarter profile in this sizeable drawing. His hand is placed defiantly upon his hip in a familiar pose, here augmented by a large cloak thrown over his shoulder. Alexander emphasized Whistler's imperi-

ous expression and white lock by shrouding the rest of the composition in shadows. The drawing technique parallels some of Whistler's self-portrait drawings of the 1870s [see Fig. 4:37]. The charcoal sketch also bears a notable resemblance to a contemporary photograph of Whistler by H. S. Mendelssohn [Fig. 4:24], suggesting that Alexander may have used this or another photographic image in composing his portrait.

The young artists whom Whistler befriended in Venice helped to create Whistler's reputation when they returned to the United States. Some of them remained on good terms with him for the rest of his life, and many kept up a regular correspondence with the older artist. American artists began to seek out Whistler in London in the 1880s, in part due to the goodwill he had generated during the time in Venice with his countrymen.

William Merritt Chase was among the Americans who met Whistler in London in the mid-1880s. Chase had seen and admired Whistler's portrait of Cicely Alexander in the Grosvenor Gallery exhibition of May 1884, but was ambivalent about meeting the artist at that time.[36] The following year, on his way to Madrid, Chase summoned his courage and sought out Whistler in Chelsea, commencing a brief and volatile relationship. Many of the most entertaining tales about Whistler derive from the stories Chase later wrote about the summer of 1885, which the artists spent together in London and in the Netherlands. Chase described Whistler as having two distinct and separate personae—an artistic version of Dr. Jekyll and Mr. Hyde: *One was Whistler in public—the fop, the cynic, the brilliant,*

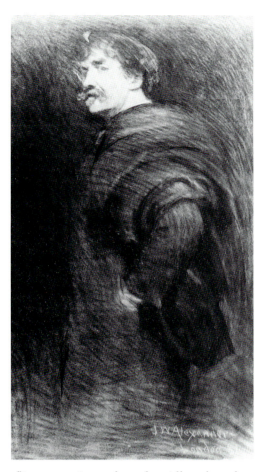

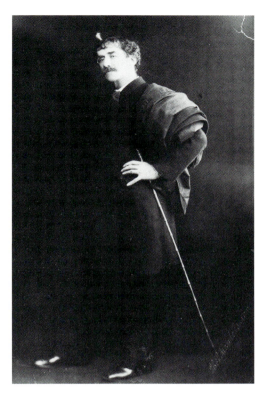

*flippant, vain, and careless idler; the other
was Whistler of the studio—the earnest,
tireless, somber worker, a very slave to his
art, a bitter foe to all pretense and sham,
an embodiment of simplicity almost to the
point of diffidence, an incarnation of
earnestness and sincerity of purpose.*[37]

At first the two artists were on the
most cordial terms, with Whistler treating
Chase as if he were an old friend or a
long-lost relative. After a time their rela-
tionship began to deteriorate, which was
characteristic of Whistler's friendships,
spoiled by his arrogance and egotism.
Chase noted, "at the end of a fortnight
he was quarreling with me. It was
impossible, I believe, for any man to live
long in harmony with him."[38] Chase
began preparations to go on to Madrid,
but Whistler persuaded him to delay his
trip. Despite his argumentative nature,
Whistler appears to have enjoyed Chase's

company, since they shared many views
on art. "'Don't go,' he urged. 'Stay, and
we'll paint portraits of each other.'"[39]
This suggestion led to one of the most fas-
cinating episodes in Whistler portraiture.

The artists agreed that whoever was in
the mood at a given moment was to work,
while the other posed. According to
Chase's later account, Whistler was the
one who was always in the mood to paint;
consequently, it was Chase who spent
most of his time sitting for the older artist.
Whistler, as usual, kept Chase posed for
painfully long sittings, castigating him for
moving or complaining, until he was dizzy
and stiff from the ordeal. Although the
portrait must have been close to comple-
tion, Whistler was not satisfied with the
result; he considered the work unfinished
when the two parted company shortly
afterward. Chase mentions little about
Whistler's sittings for the portrait he was

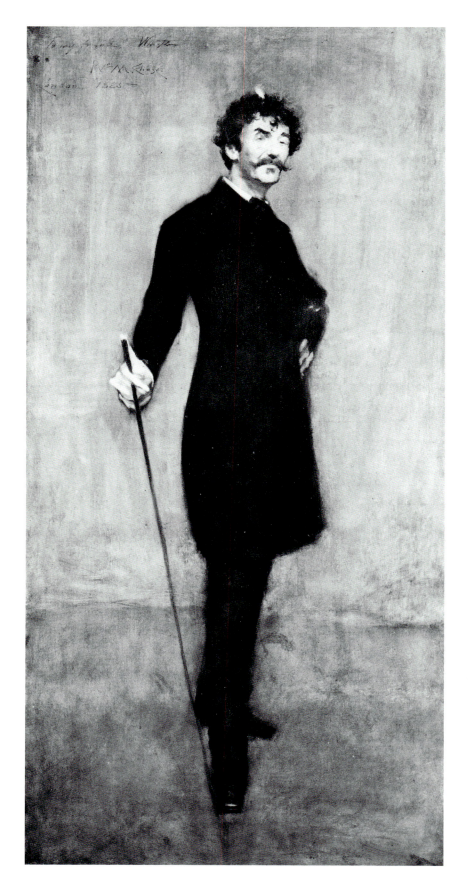

Fig. 4:25.
James McNeill Whistler by William Merritt Chase (1849–1916). Oil on canvas, 188.3 x 92.1 cm. (74 1/8 x 36 1/4 in.), 1885. The Metropolitan Museum of Art, New York City; bequest of William H. Walker, 1918 (18.22.2)

doing simultaneously, which is ironic considering that his painting was completed during the same time. When Chase had finished his portrait, having exhausted his last bit of patience, he determined to return to America after a short stay in Antwerp and Holland. Whistler accompanied the weary younger artist, tormenting him during travels through Belgium and into Holland: "A gadfly could not have been more persistently and maliciously annoying."[40] Eventually, Chase became sufficiently disgruntled to flee from Whistler's company by leaving their train in Haarlem. The two artists met only one more time, the following day in Amsterdam, when Chase was persuaded to introduce a group of admiring young artists to the famous American expatriate. Despite their brief time together, Chase benefited greatly from the experiences of the summer.

Chase's *James McNeill Whistler* [Fig. 4:25] is one of the most popular of all the portraits of Whistler. The artist included the characteristic attributes in this near life-size depiction, but added an epic quality to the image not apparent since Fantin's portrait in the *Hommage à Delacroix* [see Fig. 2:1]. Whistler strikes a familiar pose but is seen from a different angle, as if Chase had circled a quarter of the way around Ward's *Vanity Fair* caricature [see Fig. 3:1]. Whistler's index finger is placed on the tip of the cane, an innovation that lends a note of preciousness to the portrait. Chase endowed the artist with a somber, mildly bemused expression that is enhanced by the dark, restrained costume of this eloquently Whistleresque portrayal. In contrast to Chase's earlier, brightly painted portraits, the details of the clothes and setting are

sacrificed to an overall tonal harmony. The rich blacks of Whistler's outfit are placed against a neutral background, executed in broad brushstrokes of dilute wash. Chase consciously used the style of the older artist, communicating the likeness of his subject with Whistlerian means. The technique and the likeness meld to become an homage to Whistler. Both the brushwork and the pose are similar to Whistler's 1873 *Arrangement in Black: Portrait of Frederick Leyland*, now in the Freer Gallery of Art. Following his experience with Whistler, Chase employed a more subdued palette in his portraits, applying his paint in thin, broad washes adopted from Whistler's technique.[41]

The likeness captures one aspect of the Whistler whom Chase had known—the vain *poseur*, the sharp-tongued cynic. Chase described the appearance of the artist as designed for public view: *The Whistler of Cheyne Walk was a dainty, sprightly little man, immaculate in spotless linen and perfect-fitting broadcloth. He wore yellow gloves and carried his wand poised lightly in his hand. He seemed inordinately proud of his small feet and slender waist; his slight imperial and black mustache were carefully waxed; his monocle was indispensable.*[42] This was the side that Chase chose to represent, the proud Whistler gazing down on the viewer with slightly mocking condescension. Chase knew the "Dr. Jekyll" side of Whistler as well, the industrious artist who worked tirelessly to refine his skills as a painter. The genuine artist, as Chase christened this aspect of the painter, he described only in a written portrait: *This was merely Whistler at play. The real, genuine Whistler had been at work since early morning, working like a fiend—and, in truth, looking like a fiend as he worked. The monocle of the night before had been laid aside for an unsightly pair of iron spectacles, so heavy that they were clumsily wrapped with cloth where they rested on his nose. His hair was uncombed; he was carelessly dressed.*

Some student admirers from Venice called at the studio one day and found the real Whistler at work. They had seen him previously on the piazza, *carefully groomed for the occasion. Now they stood speechless with surprise. At length their spokesman exclaimed artlessly,*

"Why Mr. Whistler, whatever has happened to you?"

"What do you mean?" he demanded.

"You—seem so different," said the young man.

"Oh," said Whistler, "I leave all gimcracks outside the door."[43] Only a few artists had the courage to represent Whistler without the "gimcracks," and fewer depicted the artist at work. The visual evidence of Whistler in the studio is limited to the odd photograph and the work of occasional collaborators, such as Walter Greaves or Thomas Way, who had the requisite access to the artist at work.

A letter from Whistler to Chase at the end of the summer provides useful information about the relationship of the artists and their portraits.[44] Whistler began with a brief section of appreciation for Chase's kindness and consideration, and reproached himself for his own behavior. He proceeded to the portraits, saying that the world would have to wait a little longer to see them, since "neither master is really quite fit for public presentation as he stands on canvas at this moment." He suggested that Chase

should wait for him to come to New York that fall before showing his portrait of Whistler.[45] Whistler, probably having envisioned the impact the two portraits would have when displayed together, was attempting to dissuade the painter from preempting that exhibition.[46] In any event, Chase took the portrait of Whistler with him to the United States, although he never obtained his own likeness. Whistler apparently never completed his portrait of Chase, despite the amount of time spent on it in the studio, nor did his plans to travel to New York coalesce.[47]

Chase waited a year before displaying his portrait of Whistler in public. In October 1886 Whistler wrote a letter that was published in the *New York Herald*, in which he described the Chase portrait as "a monstrous lampoon" and framed the question: "How dared he—Chase—to do this wicked thing? . . . I, who was charming and made him beautiful on canvass, the master of the avenues."[48] Chase's *James McNeill Whistler* was exhibited in Boston in November 1886, and around the United States over the following decade.[49] Critical opinion of the painting varied, some regarding it as a caricature while others found it very accurate in capturing its subject.[50]

Chase developed a lecture about Whistler that was very popular and was the basis for a later article in *Century Magazine*. Whistler objected to Chase lecturing about him during the 1890s, complaining to mutual friends about the stories and descriptions of their friendship.[51] The Pennells criticized Chase for talking too much about Whistler's personality and not enough about his art, but the lectures were always laudatory about

Whistler as an artist and did much to enhance his reputation in the United States.[52] When Chase's portrait of Whistler was offered as a gift to the Metropolitan Museum in New York in 1917, the year after the artist's death, Joseph Pennell attacked the work in the press, protesting "the indiscriminate dumping of art and artless works on our galleries" and complaining that "the remarkable thing about the portrait is its badness from every point of view."[53] The museum trustees thought otherwise, accepting the painting as part of the bequest of William Hall Walker in 1918.

Several photographs record the appearance of the artists during their brief time together. A small photograph of Whistler and Chase [Fig. 4:26] is now in the Parrish Art Museum in Southampton, New York. Whistler stands on the right, in a favorite pose—one hand on his hip and holding the walking stick. To the left is Chase, with his jacket pulled back to his sides and his thumbs in his pockets. The top hat is a relatively new addition to the Whistler wardrobe; he soon adopted the flat-brimmed style that Chase wore, and later claimed that his fellow artist had stolen the style from him.[54] Another 1885 photograph shows Chase, Whistler, and one of his pupils, the Australian Mortimer Menpes [Fig. 4:27]. Except for the hat, Whistler is dressed in a costume similar to that depicted in the John White Alexander drawing [see Fig. 4:23]. Chase remembered, "Whistler always carried as a walking-stick a long, slender wand, a sort of a maulstick, nearly three-quarters his own height."[55] The artist rests his right index finger on the top of the wand, a detail that Chase had noted in his por-

Fig. 4:27 (below).*
An unidentified man, James McNeill Whistler, William Merritt Chase, and Mortimer Menpes (left to right) by an unidentified photographer. Gelatin printing-out paper, 8.9 x 11.4 cm. (3 1/2 x 4 1/2 in.), 1885. The William Merritt Chase Archives, The Parrish Art Museum, Southampton, New York; gift of Jackson Chase Storm

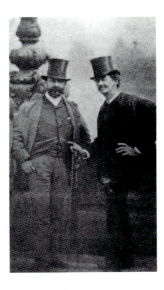

Fig. 4:26. (above).*
William Merritt Chase (left) and James McNeill Whistler by an unidentified photographer. Gelatin silver print, 8.3 x 4.8 cm. (3 1/4 x 1 7/8 in.), 1885. The William Merritt Chase Archives, The Parrish Art Museum, Southampton, New York; gift of Jackson Chase Storm

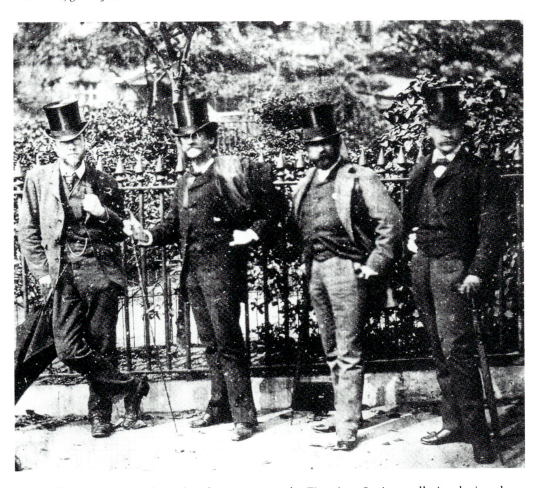

trait. Chase stands to the right of Whistler, and beyond him Menpes leans on his umbrella. Menpes was part of Whistler's entourage through much of the 1880s, and although not mentioned in Chase's later account, he was a member of the ill-fated trip to Holland at the end of the summer. A third photograph including Chase, Whistler, and Menpes [Fig. 4:28] is reproduced in Menpes's book *Whistler As I Knew Him*.[56]

Mortimer Menpes had been studying with Edward Poynter at the South Kensington School when he met Whistler at the Fine Arts Society galleries during the winter of 1880–1881. The Australian instantly idolized Whistler, who was working on the printing of the first Venetian plates at that time: "From that hour I was almost a slave in his service, ready and only too anxious to help, no matter in how small a way. I took off my coat there and then, and began to grind up ink for the Master."[57] Menpes was among the first of Whistler's followers in London in the decade following his return from Venice. The Pennells noted that Whistler attracted many younger artists during this

time who believed in his ideas and admired him as a role model. Their infatuation led them to take up the master's battles and to do his bidding. The disciples subordinated their own interests and personalities to him, in effect becoming caricatures of Whistler.[58] Although many initially profited from their exposure to Whistler's aesthetic theories, most eventually quarreled and broke with him. Only Menpes and Walter Sickert were pupils in the sense that Whistler occasionally

instructed them in their own work. Menpes worked with Whistler for most of the 1880s, often accompanying him around London and on other travels. His sympathetic account of his time with the artist was published the year after Whistler's death as a defense of his famous friend's reputation. Throughout the memoir he refers to Whistler as "the master," despite his having broken with the artist around 1890. Menpes's book also contains numerous illustrations of Whistler's work, and several of his own portraits of Whistler. After Walter Greaves, Menpes was the most prolific of the artist's portraitists, representing Whistler in various media more than twenty times. Some of those portrayals were executed during the time the artists worked together, while others date from after their separation.

The Menpes portraits fall into three distinct categories: bust-length studies emphasizing Whistler's range of expression, half- to three-quarter-length representations of the artist seated, and sheets containing multiple images of the artist. In each category, Menpes focused all of his attention on his sitter, eliminating any background detail. *Whistler with Monocle* [Fig. 4:29] is typical of Menpes's many studies of the artist's animated features. Drypoint is used to carefully render the lines of the subject's face, the curly hair, and the mustache, while the costume is barely suggested and the setting is ignored. Menpes included the standard Whistler trademarks, but they have been subordinated to concentrate attention upon the sitter's precisely delineated facial features. Most of the Menpes portraits are simple bust-length images, such as this one.

James M'Neill Whistler [Fig. 4:30], the frontispiece to Menpes's book, represents

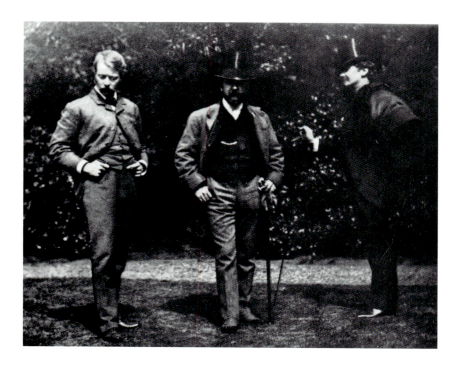

Fig. 4:28.
Mortimer Menpes, William Merritt Chase, and James McNeill Whistler *(left to right)* by an unidentified photographer. Photograph, 9 x 11.4 cm. (3 1/2 x 4 1/2 in.), 1885. Private collection

Fig. 4:29.*
Whistler with Monocle by
Mortimer Menpes (1860–1938).
Drypoint on laid paper,
21.3 x 20 cm. (8 3/8 x 7 7/8 in.),
1880s. Museum of Fine Arts,
Boston, Massachusetts; gift of Azita
Bina-Seibel and Elmar W. Seibel

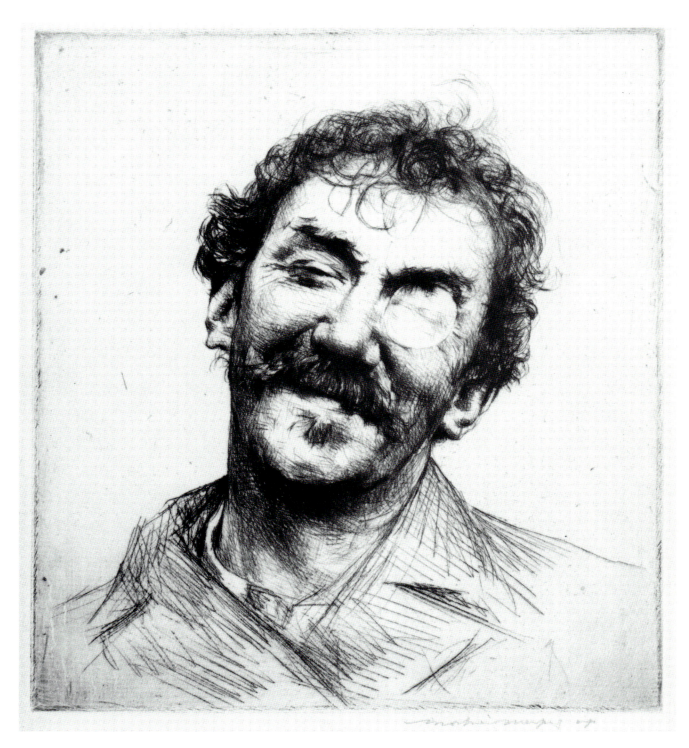

Fig. 4:30.
James M'Neill Whistler by
Mortimer Menpes
(1860–1938). Published as the
frontispiece to *Whistler As I
Knew Him*, 1904

Fig. 4:31.*
*White Ducks, or the Five Faces
of Whistler* by Mortimer
Menpes (1860–1938). Etching,
17.5 x 14.9 cm. (6 7/8 x 5 7/8
in.), not dated. The Metropoli-
tan Museum of Art, New York
City; gift of Paul F. Walter,
1985

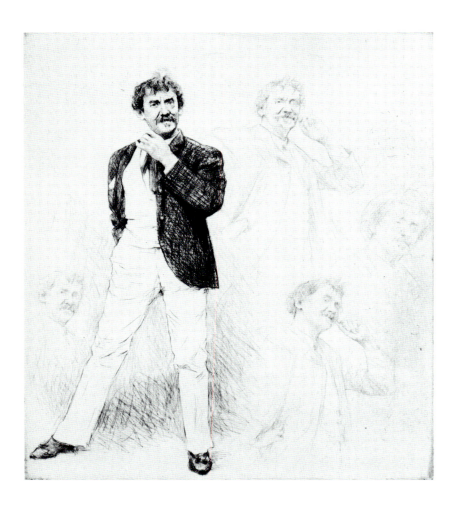

the second portrait type. Whistler is seat-
ed in an informal pose, leaning slightly
forward, his demeanor as relaxed as his
posture. The composition is based on
Whistler's own portrait style, which often
placed a dark figure against a lighter, neu-
tral background. The original painting is
now lost.

Menpes's most innovative approach to
capturing Whistler occurred in the multi-
ple-image drypoints that form the third
category of likenesses. *White Ducks, or
the Five Faces of Whistler* [Fig. 4:31] con-
tains five different sketches, with one
brought to a more finished stage than the
others. Whistler wears a dark jacket and
white-duck pants in an engaging represen-
tation devoid of the usual accessories, save
the ubiquitous white lock. Four surround-
ing vignettes capture the artist in various
attitudes, smiling and serious, tugging or
twirling the end of his mustache. Menpes
evoked the presence of the artist and his
personality through gentle descriptions of
Whistler's bemused arrogance. One
extant preparatory study for the three-
quarter-length portrait on the right side of
White Ducks—a charcoal drawing on blue
paper—reveals how closely Menpes fol-
lowed his initial studies for the print.
Despite the effect of spontaneity created
by the sketchiness of the drypoint lines,
the drawing is very similar in size to the
final drypoint portrait. Other Menpes
drypoints containing series of likenesses
include *Six Studies of Whistler* [Fig. 4:32]
and *Whistler Times Seven* [Fig. 4:33], a
rare print comprised of full-length por-
traits of the artist with his wand, top hat,
and overcoat.

Menpes's inclusion of several portraits
on the same copperplate was novel in

Fig. 4:32.*
Six Studies of Whistler by Mortimer
Menpes (1860–1938). Drypoint on
laid paper, 18.8 x 14.6 cm. (7 7/16 x
5 3/4 in.), 1880s. Museum of Fine
Arts, Boston, Massachusetts; gift of
Azita Bina-Seibel and Elmar W. Seibel

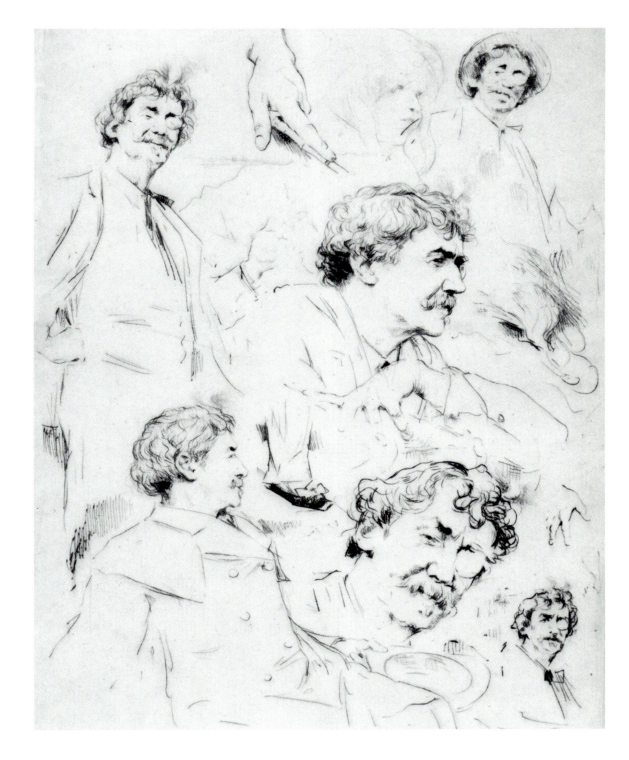

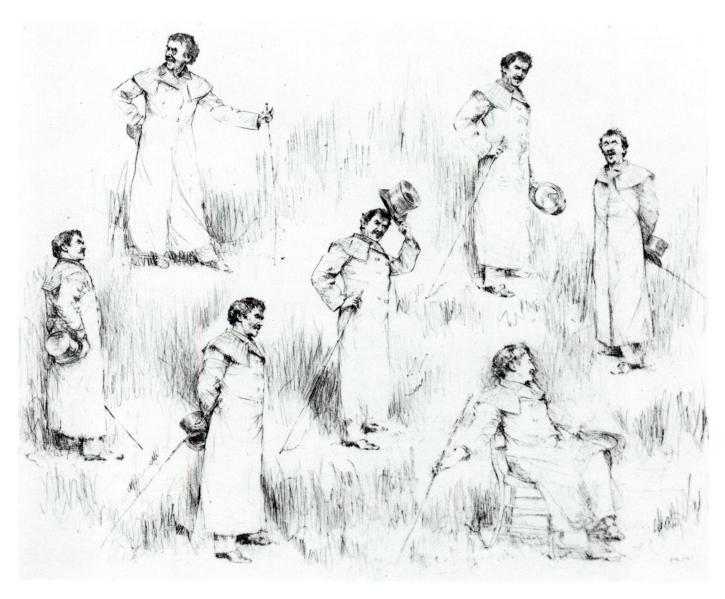

Fig. 4:33.*
Whistler Times Seven by
Mortimer Menpes
(1860–1938). Drypoint,
14 x 19 cm. (5 1/2 x 7 1/2 in.),
1880s. Michael Palmer, Esq.

nineteenth-century printmaking, although there was a notable historical precedent. Rembrandt, whom Whistler held up as an artistic model, created several etchings that included multiple images of the same figure without regard for unity in time or space. *Studies of the Head of Saskia and Others* [Fig. 4:34], or one of several similar prints by the Dutch master, may have served as Menpes's inspiration. The multiple images suggest that while there are many possible views of any subject, the condition of art is to select and elaborate only one. Plates that include a series of options allow the viewer a rare entry into the conceptual framework of the artist, a privileged view of the creative process. These Menpes portraits parallel the thoughtfulness with which Rembrandt drew his subjects, in contrast to the many contemporary images that seized upon only one aspect of Whistler.

T. R. Way was another young artist who assisted Whistler with the production of the Venetian etchings after his return to London. He was neither a follower nor a pupil, but the son of Whistler's longtime lithographic printer. He had initially seen the artist's work in the 1870s in his father's shop. On Whistler's return from Venice, the younger Way was employed as an assistant in the print studio.[59] His help in preparing materials for the *Venice Set* began a relationship that would last for fifteen years, during which he printed most of Whistler's lithographs and many of his brochures. Way published the first catalogue of Whistler's lithographs in 1896, and he also wrote two posthumous volumes on the artist. He was in a unique position to observe Whistler at

work, and much of what we know today about Whistler as a lithographer derives from his descriptions. In addition to the written commentary, Way recorded Whistler working, in several rare images.

The earliest of these, *The Room at Air Street* [Fig. 4:35], was painted shortly after Whistler's Venetian trip. The Fine Arts Society had rented a room at the northwest corner of Air and Regent Streets, and furnished it with the necessary equipment to produce the edition of the plates they had commissioned. Way later described the surroundings: *It was not an ideal room for the purpose, being poorly lit in daytime, notwithstanding its large bay window, for it was late in the year (1880). The Society had had it fitted up with a drugget to protect the carpet (of which more anon), a bench, with gas fittings for the hot plate, &c., and a printing press. In the spare time I made a little painting of the interior with Whistler at work, biting a plate, and my father by the window, which I have reproduced; in the foreground is a curious dog, which some very misguided friend had given him, I think in Venice.*[60] Whistler wears an apron as he leans forward, allowing the acid to flow over the exposed copper and bite into the etching plate. Way's 1880 canvas is the first documented record of another artist capturing the elusive butterfly at work. Fifteen years later, Way again depicted Whistler in a moment of creative isolation in *Sketch of Whistler, Whilst He Was Retouching a Stone* [Fig. 4:36].[61] According to the printer, Whistler often stood while retouching the lithographic image, even when it would have been convenient to sit. Way

Fig. 4:34.
Studies of the Head of Saskia and Others by Rembrandt van Rijn (1606–1699). Etching, 15.1 x 12.5 cm. (5 15/16 x 4 7/8 in.), 1636. Rosenwald Collection, National Gallery of Art. © 1994, Board of Trustees, National Gallery of Art, Washington, D.C.

rendered the artist in his thick greatcoat, hunched over his stone, concentrating on the corrections to the drawing. This lithograph accords with Chase's description of Whistler as a private, serious artist.

Way owned a self-portrait of Whistler at work that might have inspired him to portray a similar theme. Whistler, as described in Chapter 1, had begun to represent himself in the role of the artist in his earliest student work. In the 1870s he returned to the subject in his *Portrait of the Artist* [Fig. 4:37], the chalk drawing that belonged to Way and is now in the Freer Gallery of Art. The artist represented himself drawing his reflection in a mirror. The heavy black chalk used throughout the figure and the background

create the kind of tonal harmony that Whistler was seeking in the paintings at the time. The white chalk highlights the distinctive lock of hair, the collar, and the handkerchief.

Way once questioned the artist about the authenticity of a small drawing that he had of Whistler, which was probably this chalk study. The artist replied that at one time he had been in the habit of doing a self-portrait drawing each night before he went to bed, and that it was undoubtedly of this group.[62] The drawing may be related to Whistler's self-portrait drypoint *Whistler with a White Lock*.

Few portraits of the time show Whistler painting. *Lady Meux Triplex* [Fig. 4:38] by Charles Brookfield is a

Fig. 4:35.*
The Room at Air Street by T. R. Way (1861–1913). Oil on canvas, 25.7 x 30.6 cm. (10 1/8 x 12 1/4 in.), 1880. A. E. Gallatin Collection, The Miriam and Ira D. Wallach Division of Art, Prints, and Photographs, The New York Public Library, New York City, Astor, Lenox and Tilden Foundations

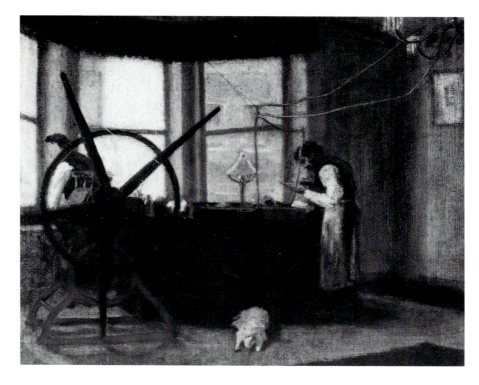

humorous caricature of 1881 that shows Whistler simultaneously painting three versions of the portrait. Sir Leslie Ward, the artist who had done the well-known *Vanity Fair* portrait of Whistler, recalled that it was Brookfield who had obtained the Lady Meux commission for Whistler in the first place.63 The amusing drawing suggests, as do Menpes's multiple portrait plates, that an artist has a variety of possible choices when constructing an image. The selection of a particular approach depends upon the artist's preference and intention, and is by no means an inevitable solution.

Brookfield depicted Whistler lunging forward as if fencing, with three exceptionally long brushes in his right hand and others in reserve in his left. Whistler's use of long-handled brushes is confirmed in contemporary accounts and also in a pencil drawing, *Whistler Painting Maud* [Fig. 4:39], which is contained in a small notebook by the artist's friend E. W. Godwin.

Although Whistler was photographed in his studio numerous times, most images show him carefully attired, formally posing for the camera. A photograph of Whistler in his Fulham Road studio [Fig. 4:40] is a rare case where he is apprehended in the act of painting. The unidentified photographer's choice of this subject gives the picture a sense of intimacy reminiscent of Chase's story of Whistler leaving the "gimcracks" outside the door. The viewer instinctively perceives this approach as privileged, a rare glimpse of the artist in the midst of creation. The empty chair in the foreground becomes an invitation to draw

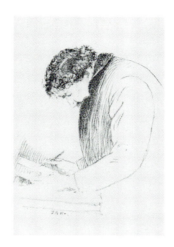

Fig. 4:36.
Sketch of Whistler, Whilst He Was Retouching a Stone by T. R. Way (1861–1913). Lithograph, 22.2 x 16.5 cm. (8 3/4 x 6 1/2 in.), circa 1895. Private collection

Fig. 4:37.
Portrait of the Artist by James McNeill Whistler. Chalk, 27.8 x 17.7 cm. (10 15/16 x 7 in.), circa 1878. Freer Gallery of Art, Smithsonian Institution, Washington, D.C.

Fig. 4:38.
Lady Meux Triplex by Charles Brookfield (lifedates unknown). Pen and ink, dimensions unknown, 1881. Unlocated

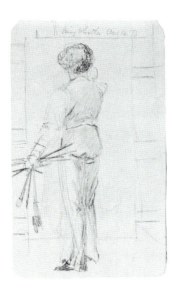

Fig. 4:39.
Whistler Painting Maud by E. W. Godwin (1833–1886). Pencil on paper, 14.6 x 8.3 cm. (5 3/4 x 3 1/4 in.), 1877. The Board of Trustees of the Victoria and Albert Museum, London

closer, sit down, and observe. The photographer has removed the distractions of the public personae in favor of a glimpse of the painter's workplace. Chase's appraisal of what he called the "real" Whistler provides an apt commentary on this photograph: *Yes, there were two distinct Whistlers, but there was only one genuine one—Whistler the tireless, slavish worker, ceaselessly puttering, endlessly striving to add to art the beautiful harmonies, the rare interpretations that his wonderful imagination pictured for him; Whistler the great artist, in other words, for that was his real self, which will live in all its glory when the man's eccentricities are utterly forgotten.*[64]

In the photograph, the artist applies pigment to a long-handled brush like those seen in the Brookfield caricature. Beyond the tabletop palette, previously seen in the Greaveses' portraits, is a now-lost portrait of Maud. By the end of the decade, Maud, too, would be gone, along with the many friends, pupils, and followers of the 1870s and 1880s. Whistler's marriage to Beatrice Godwin dramatically changed his life, and as we will see in the final chapter, the images of the artist changed as well.

5

From Beardsley to Beerbohm: The Final Decade

For Whistler, the five years following his marriage were a time of increasing stature in the art world and growing recognition from collectors. In 1889 an extensive display of his work was shown at the Wunderlich Gallery in New York, the most significant exhibition of his work in the United States since the 1883 "Arrangement in Yellow and White" touring show. During the same year, he won several prestigious awards in international exhibitions: a first-class medal in Munich, along with the Cross of St. Michael of Bavaria; a gold medal at the 1889 Paris Universal Exposition, along with election as a *chevalier* of the Légion d'Honneur; and a gold medal at the International Exhibition in Amsterdam. At the age of fifty-five he was finally receiving the accolades he had sought. Although Whistler was acknowledged as an accomplished master by the international community, official English recognition of his work was still to come.

Whistler spent the following year producing the most important publication of his career, *The Gentle Art of Making Enemies*. Published by William Heinemann, the carefully designed book contained Whistler's version of the Ruskin libel suit, the text of the Ten O'Clock Lecture, a miscellany of reviews, and other material. Artists and writers now had ready access to Whistler's aesthetic ideas, as well as new insights into his mischievous character, and the book's publication brought Whistler the fame he had sought throughout his career.

In 1891 Whistler achieved additional celebrity through one of the signal events of an artist's career—the purchase of his work for public institutions. In April, the Corporation of Glasgow purchased the *Arrangement in Grey and Black, No. 2: Portrait of Thomas Carlyle* [see Fig. 3:3], making it the first of Whistler's paintings to be bought for a museum collection. Later that year, the French government purchased Whistler's portrait of his mother [see Fig. 3:2] for the Musée du Luxembourg. These two purchases contributed to the artist's burgeoning fame. In July 1891, Whistler was invited to be on the selection committee of the autumn exhibition of the Liverpool Art Society at the Walker Art Gallery. The gallery was generally considered to be the most prestigious public collection in England outside of London, and Whistler regarded the opportunity as a distinguished honor. A photograph of the committee includes a rather diffident-looking Whistler gazing away from the camera, his top hat on his lap [Fig. 5:1].[1] Whistler's stature continued to rise during the following year with his elevation to *officier* in the

Fig. 5:1.*
The hanging committee of the Annual Exhibition of the Liverpool Art Society (Whistler is seated in the first row, to the left) by Robinson and Thompson. Photograph, 15.4 x 20.8 cm. (6 1/16 x 8 3/8 in.), 1894. Department of Special Collections, Glasgow University Library, University of Glasgow, Scotland (PH 1/174)

Fig. 5:2.*
James McNeill Whistler by
Sidney Starr (1857–1925) and
James McNeill Whistler.
Pen and ink on paper,
25.4 x 20.3 cm.
(10 x 8 in.) sight, 1890.
Mark Samuels Lasner

Fig. 5:3.*
Whistler in the Paris studio by
Dornac Studio. Albumen print,
19.3 x 26 cm. (7 5/8 x 10 1/4
in.), 1899. A. E. Gallatin Col-
lection, The Miriam and Ira D.
Wallach Division of Art, Prints
and Photographs, The New
York Public Library, New York
City, Astor, Lenox and Tilden
Foundations

Légion d'Honneur in France, and the
March opening of the Goupil Gallery's
retrospective exhibition in London. In
1893 he exhibited six paintings and
numerous prints at the World's
Columbian Exposition in Chicago, which
led to increased recognition of his work in
the United States. The international exhi-
bitions, awards, gallery shows, and muse-
um purchases contributed to Whistler's
widespread acceptance as a major living
artist, despite his continued neglect by
official Victorian England.

During the early years of their mar-
riage, Whistler and his wife spent more
time traveling on the Continent than
Whistler had done since his Venetian
sojourn. Although the couple stayed in
various locations around France and the
Low Countries, it was to Paris that they
were most drawn. Whistler had remained
fond of Paris since his student years, but

had considered London the better place to
promote his reputation and find a market
for his works. He traveled regularly
between the two capitals, and in 1892 he
and Trixie moved to Paris. In September
they took up residence in a house on the
rue du Bac on the Left Bank, and Whistler
acquired a studio nearby on the rue
Notre-Dame-des-Champs, a short walk
from the Luxembourg Gardens.

Relatively few portraits of Whistler date
from the early years of his marriage. A
few caricatures noting litigious events in
the artist's life appeared in Victorian peri-
odicals, but fewer depictions of Whistler
derive from this period than from any
time since the mid-1870s. Sidney Starr's
sketch of Whistler [Fig. 5:2] is one of the
few documenting this period in the artist's
life. The pen-and-ink drawing was begun
by Starr but completed with Whistler's
assistance, whose collaboration is record-
ed by the addition of his trademark but-
terfly signature.

The couple's relocation to Paris led to
interaction with a different group of
artists, who would portray their own
unique views of an older Whistler. Many
of the representations of this period are
photographs of Whistler in either the stu-
dio or the garden of his new house. The
portraits are an interesting mix of public
and private imagery, of formal occasions
and of informal personal moments.

Joseph Pennell described the studio at
86 rue Notre-Dame-des-Champs as it
appeared in the early 1890s: *The studio
was a big bare room, the biggest studio
Whistler ever had—a simple tone of rose
on the walls; a lounge, a few chairs, a
white-wood cabinet for the little drawings
and prints and pastels; the blue screen
with the river, the church, and the gold*

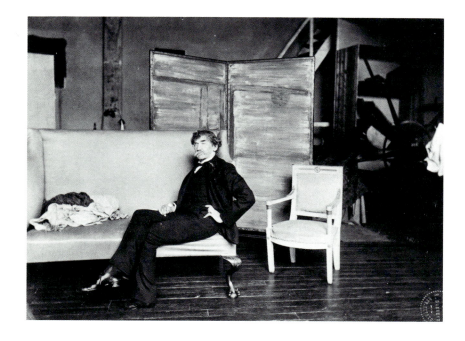

Fig. 5:5 (*below*).*
Whistler standing next to the press in his Paris
studio by Dornac Studio. Albumen print, 26.3 x
20.3 cm. (10 3/8 x 8 in.), 1899. A. E. Gallatin
Collection, The Miriam and Ira D. Wallach
Division of Art, Prints and Photographs,
The New York Public Library, New York City,
Astor, Lenox and Tilden Foundations

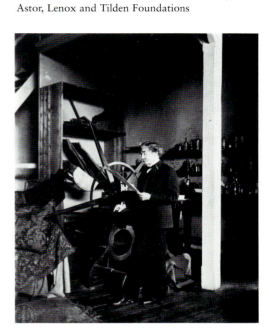

*moon; two or three easels, nothing on
them; rows and rows of canvases on the
floor, all with their faces to the wall; in
the further corner, a printing press—
rather, a printing shop, with inks and
papers on shelves; a little gallery above, a
room or two opening off; a model's dress-
ing room under it; and in front, when you
turned, the great studio window, with all
Paris toward the Panthéon over the Lux-
embourg gardens.*[2] Pennell's description
aptly records the setting of three large
photographs of Whistler produced by the
Dornac Studio in 1899.[3] No documen-
tary information exists about the specific
photographer or the commissioning of the
photographs. Whistler wears the same
suit in each image, suggesting that they
were all done in the same session. One
photograph of Whistler in the studio [Fig.
5:3] represents him posing, seated at the
end of a couch. His body is shown in
profile with his hand placed on his hip,
and his stern expression is focused on the
camera's lens. Behind him is *Nocturne in
Blue and Silver: Screen, with Old Bat-
tersea Bridge* [Fig. 5:4], a Japanese-
inspired nocturne of 1872. In the corner
of the room is the printing press with
shelving behind it. A second photograph
of Whistler in the studio [Fig. 5:5] shows
the artist standing next to the press,
examining an impression of an etching.
Here is the Pennells' "printing shop,"
with its bottles of ink and acid lined up in
the background. The vertical format of
the photograph uses the support beam of
the studio to exaggerate Whistler's size.

The third photograph in the set suggests
a number of connections to other like-
nesses. Here, the artist is seated on a
chair in profile [Fig. 5:6], in a pose remi-
niscent of the portraits of the artist's

Fig. 5:4 (*above*).*
*Nocturne in Blue and Silver:
Screen, with Old Battersea
Bridge* by James McNeill
Whistler. Distemper and gold
paint on brown paper, laid on
canvas, 195 x 182.2 cm.
(76 3/4 x 71 3/4 in.) open, 1872.
Hunterian Art Gallery,
University of Glasgow,
Scotland; Birnie Philip bequest

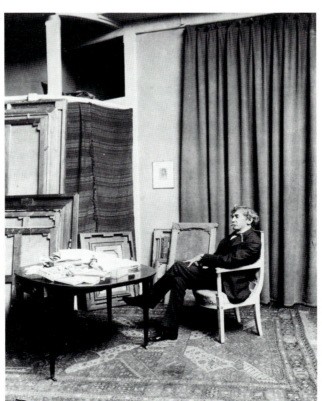

Fig. 5:6 (*left*).*
Whistler in his Paris
studio by Dornac
Studio. Albumen
print, 26 x 20.3 cm.
(10 1/4 x 8 in.),
1899. A. E. Gal-
latin Collection,
The Miriam and Ira
D. Wallach Division
of Art, Prints and
Photographs, The
New York Public
Library, New York
City, Astor, Lenox
and Tilden
Foundations

Fig. 5:7.
Whistler in the garden at 110 rue du Bac by an unidentified photographer. Photograph, 12.1 x 9 cm. (4 3/4 x 3 1/2 in.), circa 1895. Department of Special Collections, Glasgow University Library, University of Glasgow, Scotland (PH 1/126)

mother and Thomas Carlyle [see Figs. 3:2 and 3:3]. Whistler is placed before a backdrop of curtains, while a single framed work hangs on the wall above his knees—compositional elements also present in the earlier portraits. The subject of the picture on the wall cannot be discerned. As a set, the three photographs of the studio portray Whistler as an older, dignified master, worthy of the many honors that had been bestowed upon him.

Several other photographs from this same period portray Whistler in the garden of 110 rue du Bac, which Pennell also described: *On the far side, another big door and big windows opened on a large garden, a real bit of the country in Paris. It stretched away, in dense undergrowth, to several huge trees. Later, there was a trellis over the door, designed by Mrs. Whistler, and there were flowers everywhere.*[4] Whistler posed in the garden for an unidentified photographer at several times of the year, as may be judged from his changing attire and the surrounding flora. One photograph [Fig. 5:7] is a summer scene, with the artist smiling benignly at the camera, his straw hat clutched at his side. A photograph of Whistler in the garden in winter [Fig. 5:8] shows him wearing a heavy coat and striking a familiar pose, but with his back to the camera, creating a dramatic black silhouette against a sunlit wall. This image was the source for T. R. Way's 1896 lithograph, *James McNeill Whistler Seen from Behind* [Fig. 5:9]. Way designed the print as the frontispiece for his catalogue of Whistler's lithographs, but the artist was not happy with the results. Whistler himself worked on the second state of the print [Fig. 5:10], scraping down some of the darker high-

lights of the wall and trees to strengthen the silhouette of the winter coat. The artist added his signature below Way's to note their collaboration. Around this time, Way also made a more traditional portrait, *J. A. M. Whistler with White Lock* [Fig. 5:11]. In 1896 Whistler quarreled with his longtime printer over matters unrelated to lithography, and broke off a long and fruitful relationship with both Way and his father.

One photograph of the period is noteworthy as the only family portrait to include Whistler. Whistler at Mr. and Mrs. Whibley's wedding party [Fig. 5:12] dates to July 1895. The bride, Beatrice Whistler's younger sister, and groom, Charles Whibley, are to the artist's left, while an avuncular Whistler looks toward the other members of the wedding. The harsh glare of the older woman on the bench suggests that family members may have had mixed emotions about the artist.

In Paris, Whistler and his wife developed a circle of friends that included Joseph Pennell, Giovanni Boldini, Aubrey Beardsley, Frederick MacMonnies, Auguste Rodin, Paul Helleu, Alfred Stevens, and Pierre Puvis de Chavannes. During the 1890s, some of these artists did portraits of Whistler, adding to the pantheon of images created by English and American artists.

The precocious graphic artist Aubrey Beardsley met Whistler in Paris during the summer of 1893.[5] He had initially encountered Whistler's work two years earlier on a visit to the Peacock Room, which in its color and decorative scheme had an important influence on the young artist.[6] A short time later, Beardsley saw Whistler's paintings of Cicely Alexander and the portrait of the artist's mother,

recording his reaction to these works in a letter to a friend: *I herewith enclose a* REAL ART TREASURE, *for you. It is a hasty impression of Whistler's "Miss Alexander" which I saw a week or so back; a truly glorious, indescribable, mysterious & evasive picture. My impression almost amounts to an exact reproduction in black & white of Whistler's study in Grey and Green. By the side of it was W's por-*trait *of his mother, the curtain marvelously painted, the border shining with wonderful silver notes. The accompanying sketch is a vile libel.*[7]

Beardsley's admiration for Whistler during this time led him to spend a week's salary on one of his etchings.[8] In February 1893, Beardsley published a caricature of Whistler's butterfly signature as one of a series of four coins in a cartoon

Fig. 5:8.*
Whistler in the garden in winter at 110 rue du Bac by an unidentified photographer. Photograph, 10.6 x 8.3 cm. (4 1/8 x 3 1/4 in.), circa 1895. Department of Special Collections, Glasgow University Library, University of Glasgow, Scotland (PH 1/123)

Fig. 5:9.*
James McNeill Whistler Seen From Behind by T. R. Way (1861–1913). Lithograph (first state), 21.9 x 14.1 cm. (8 5/8 x 5 9/16 in.), 1896. Hunterian Art Gallery, University of Glasgow, Scotland

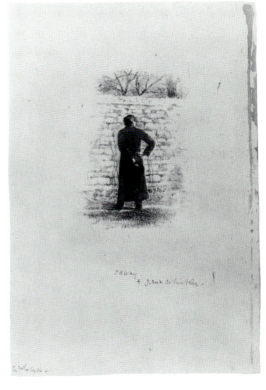

Fig. 5:10.*
James McNeill Whistler Seen From Behind by T. R. Way (1861–1913) and James McNeill Whistler. Lithograph (second state), 22.2 x 14.5 cm. (8 3/4 x 5 11/16 in.), 1896. Hunterian Art Gallery, University of Glasgow, Scotland

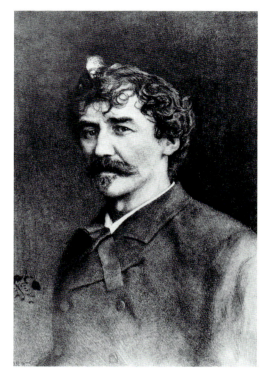

Fig. 5:11.*
J. A. M. Whistler with White Lock by T. R. Way (1861–1913). Lithograph, 20.5 x 14 cm. (8 1/16 x 5 1/2 in.), circa 1896. Boston Public Library, Massachusetts

Fig. 5:12.*
Whistler at the wedding of Mr. and Mrs. Whibley by E. Vallois Photography. Photograph, 17 x 22.7 cm. (6 11/16 x 8 15/16 in.), July 1895. Department of Special Collections, Glasgow University Library, University of Glasgow, Scotland (PH 1/167)

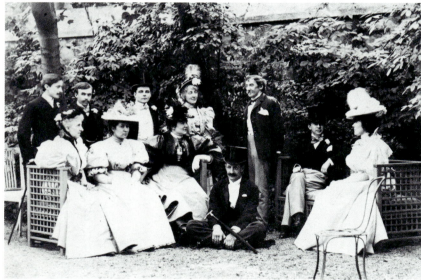

called *The New Coinage. Four designs which were not sent in for competition.*[9]

Joseph Pennell introduced Beardsley to Whistler later that year. Whistler was aloof at their first meeting, and Pennell reported Whistler's comments after he departed: *Why do you get mixed up with such things? Look at him!—he's just like his drawings—he's all hair and peacock plumes—hairs on his head—hairs on his finger ends—hairs in his ears—hairs on his toes. And what shoes he wears—hairs growing out of them!*[10] Pennell was an early admirer of Beardsley and defended his work. Attempting to persuade Whistler of his talent, Pennell brought Beardsley to Whistler's house the following day. The American proved to be no more cordial, and Beardsley left disenchanted. Over the next two years, Beardsley caricatured Whistler several times with varying degrees of enmity.

Beardsley's drawing, *Whistler as Pan* [Fig. 5:13], was used as the title page for Florence Farr's *The Dancing Faun* in 1894.[11] Whistler does not appear in the text of the lighthearted tale but is simply a convenient foil for Beardsley's creativity. The figure is seated on an elegant Regency couch, near an attenuated period lamp. Beardsley used conventional Whistler attributes to identify the faun: the large shock of curly hair, the monocle, the patent shoes with large bows. The white lock has been cleverly transformed into the two horns of the satyr. Whistler had a well-known reputation as a ladies' man throughout his life, and Beardsley's decision to represent him as a satyr may be a deliberate allusion to this.

Beardsley's *Caricature of James McNeill Whistler* [Fig. 5:14], from the same period, shows the artist as an aging aesthete,

Fig. 5:13.*
Whistler as Pan by Aubrey
Beardsley (1872–1898).
Lithograph, 17.6 x 5.3 cm.
(7 x 2 1/16 in.), 1892–1893.
Private collection

sitting primly on a wicker settee. His exaggerated hair extends wildly from under a petite straw hat, an accessory associated with the artist for forty years. The solid mass of black hair contrasts with Beardsley's spare linework elsewhere in the composition, and the subject is economically limited to the upper two-thirds of the sheet. The aging painter daintily points to his butterfly alter ego in this drawing that Beardsley called the "very malicious caricature of Whistler," which he and his sister Mabel hung on their Christmas tree in 1894.[12] There is no record of Whistler's opinion of the caricature, although he reacted strongly to another of Beardsley's drawings of the same time, *The Fat Woman* [Fig. 5:15]. This thinly veiled caricature of Whistler's wife Beatrice was drawn for the first issue of *The Yellow Book*, a new magazine devoted to the aesthetics of the 1890s. Whistler appealed to the publisher John Lane, who blocked its inclusion in the issue. Beardsley later published the drawing in *To-Day Magazine*.[13]

Whistler eventually developed an appreciation of Beardsley's talents as a draftsman. The Pennells relate that Beardsley came to show them his illustrations for *The Rape of the Lock* while Whistler was also visiting. Whistler was enthusiastic about the work, saying, "Aubrey, I have made a very great mistake—you are a very great artist."[14] Beardsley's response was to burst into tears of gratitude. Later, in 1896 Whistler visited Beardsley at Boscombe and was very distressed to see how ill he was.

Whistler's feelings were exacerbated by his own personal tragedy—the loss of his wife—from which he never fully recovered. Beatrice's health had begun to

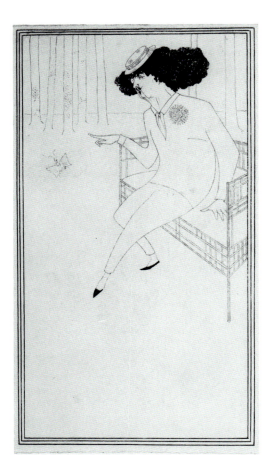

Fig. 5:14.*
Caricature of James McNeill Whistler by Aubrey Beardsley (1872–1898). Pen and ink on wove paper, 21.1 x 11.7 cm. (8 5/16 x 4 5/8 in.), circa 1894. Rosenwald Collection, National Gallery of Art. © 1994, Board of Trustees, National Gallery of Art, Washington, D.C.

Fig. 5:15.
The Fat Woman by Aubrey Beardsley (1872–1898). Pen and ink, 17.8 x 16.2 cm. (7 x 6 3/8 in.), 1894. Tate Gallery, London

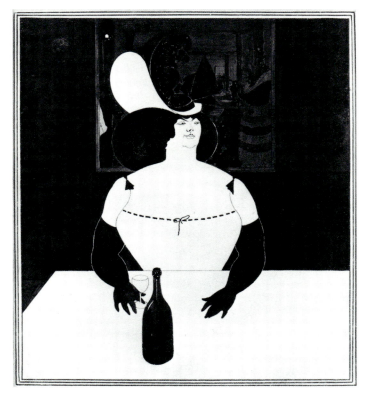

deteriorate in the fall of 1894, and the couple spent much of the next two years in hotels in London while she underwent medical treatment. Her death from cancer in May 1896 left Whistler distraught. During the next several years, he continued to travel frequently between London and Paris, but without the enthusiasm he had shown when accompanied by his devoted wife. The year following her death, he agreed to sit for a formal painted portrait by Giovanni Boldini, a circumstance he had long avoided.

The Italian expatriate Boldini settled in Paris in 1871, where he became a fashionable society portraitist.[15] He specialized in portrayals of the aristocratic and intellectual classes that employed a style of virtuoso brushwork that flattered without penetrating beneath the sitter's glittering facade.[16] Although friends with Manet and Degas early in his career, Boldini stayed aloof from developing artistic currents, preferring to emulate the painterly effects of older masters such as Hals, Velásquez, and Goya. His status as an expatriate and his affection for the masters of the past should have made Whistler a sympathetic sitter for Boldini, who painted the only formal portrait for which the artist sat after his experience with Chase [Fig. 5:16].

The Pennells related that the portrait was done in a few sessions, and that Whistler was impatient and in a bad temper during the sittings. Boldini positioned him in a relaxed pose, seated sideways on a chair, his elbow resting on the chair frame and his head leaning on his hand. The artist's vibrant brushwork captures Whistler's vivacious expression, while the reserved elegance of the formal evening wear and black silk hat are set off by the

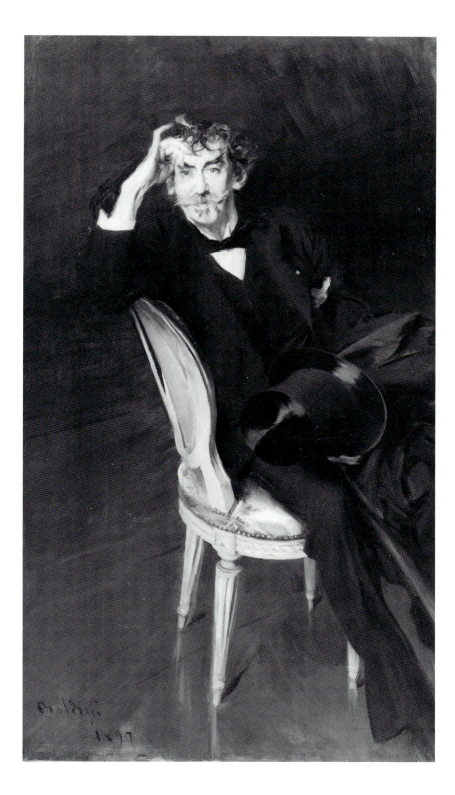

Fig. 5:16.*
James McNeill Whistler by Giovanni Boldini (1844–1931). Oil on canvas, 170.4 x 95.2 cm. (67 1/8 x 37 1/8 in.), 1897. The Brooklyn Museum, New York; gift of A. Augustus Healy (09.849)

lively treatment of the chair. The size of the figure within the composition gives Whistler a monumentality beyond his normal stature. Yet Boldini's rendering of Whistler shares the understated eloquence of the Nicholson woodcut of the same year [see Fig. 3:44], and it would not be surprising to discover that one of the artists knew the other's portrait. However, Boldini's work conveys a distinctly separate impression. Its imposing scale brings Whistler closer to the viewer, but the sitter's expression is simultaneously distancing. The stylish rendering of costume and props is a foil for the representation of Whistler as an aristocrat, a fashionable member of Parisian society. The painting is a contemporary example of late grand-manner portraiture.

Whistler himself disliked the Boldini, telling the Pennells, "They say that looks like me, but I hope I don't look like that!" The Pennells agreed with the artist's friend, Edward G. Kennedy, however, that it was a wonderful likeness of Whistler in his worst temper.[17] Collector Charles Freer, for similar reasons, was not fond of the painting; he felt that it was "unpleasantly realistic—it portrays too vividly, Whistler's external impressions and not enough the finer side of his character." Freer was offered the painting in 1909 but declined to buy it for his collection.[18] It was exhibited, along with five other portraits, in New York in 1897 at the Boussard, Valadon, and Company Gallery during Boldini's visit to the United States. The link between Whistler and Boldini conveyed by the portrait was of substantial benefit to the Italian portraitist. In 1900 Boldini's portrait was exhibited at the Universal Exhibition in Paris, where it won a medal in its section, and in 1901

Fig. 5:17.*
James McNeill Whistler
(*Whistler Asleep*) by Giovanni
Boldini (1844–1931).
Drypoint, 18.4 x 23 cm.
(7 1/4 x 9 1/16 in.), 1897.
National Portrait Gallery,
Smithsonian Institution,
Washington, D.C.

it was shown at the Venice Biennale.

Boldini executed a related drypoint [Fig. 5:17] at the same time he was painting the portrait. Kennedy, who was present during Whistler's sittings, provided additional information regarding the drypoint to A. E. Gallatin, when Gallatin was compiling his checklist of Whistler portraits: When Whistler "*settled back for slumber on Boldini's sofa, his back to the window, Boldini seized a 'point' and a plate, which were on the table among other things, and in fifteen minutes or so, the extraordinary drypoint was a result. It is remarkable that it is absolutely like Whistler as he reclined there, his back supported by cushions and his feet on the floor.*"[19] Boldini's drypoint is the third, and last, of the three portraits of Whistler asleep, which when taken together span forty years of the artist's career. Poynter's

drawing had captured the youthful Whistler asleep [see Fig. 1:18], with the future in front of him, while the Menpes print [Fig. 5:18] recorded the mature artist at the height of his powers. In the Boldini, Whistler's sleep is that of a weary, aging man resting between sessions of posing. The Italian did an additional drypoint of Whistler, a half-length image that uses the pose of the painting in reverse.[20]

The plate that Boldini found in the studio probably belonged to Paul Helleu, another artist who was present during the sittings. Helleu was also a fashionable portraitist of the era, and a friend of both Whistler and Boldini. He executed two bust-length drypoints of Whistler during Boldini's painting sessions, using essentially the same pose. The smaller of the two prints [Fig. 5:19] is a spontaneous sketch,

Fig. 5:18.
Double Portrait of Whistler Asleep by Mortimer Menpes (1860–1938). Etching, 25.5 x 24 cm. (10 1/16 x 9 7/16 in.), not dated. The Art Institute of Chicago, Illinois; Walter S. Brewster Collection of Whistleriana (1933.259). © 1994, The Art Institute of Chicago. All rights reserved

Boldini's portrait of Whistler was well received by critics in Europe and America. The Pennells record that *Century Magazine* had already obtained the right to have a print made after the painting by December 6, 1897.[23] Jacques Reich, an immigrant American printmaker, produced a large-scale reproductive etching of the Boldini portrait, which captures the detail and spirit of the painting with painstaking veracity.

Having neglected the subject for twenty

rendered in a drypoint technique that yielded a rich burr and dramatic contrasts of light and shadow. The linework of the larger plate [Fig. 5:20] is the graphic equivalent of Boldini's stylish brushwork on the canvas. While the poses in the drypoints and the oil are similar, the effects of the works are markedly different. In the prints, the scale and the medium bring the viewer close to the artist. The sketchy quality of the linework adds to this sense of immediacy, of direct confrontation. The technique is reminiscent of Whistler's early self-portrait prints, which in turn had been inspired by Rembrandt and Van Dyck.

Freer preferred Helleu's interpretation of the sitter to Boldini's, stating: "I have a very fine impression of Helleu's etching made from the Boldini portrait, which to me, conveys a closer subjective suggestion of Whistler the friend, than does the original in oil by Boldini."[21] One impression of Helleu's larger drypoint, on blue laid paper, is inscribed "12 mai, 1897," giving the only indication of when the painting was probably done.[22] Helleu was one of the earliest owners of the Boldini portrait, although no evidence exists that he commissioned the painting.

Fig. 5:19.
James McNeill Whistler by Paul Helleu (1850–1927). Drypoint, 15.2 x 10.2 cm. (6 x 4 in.), 1897. A. E. Gallatin Collection, The Miriam and Ira D. Wallach Division of Art, Prints and Photographs, The New York Public Library, New York City, Astor, Lenox and Tilden Foundations

Fig. 5:20.*
James McNeill Whistler by Paul
Helleu (1850–1927). Drypoint,
32.8 x 25.3 cm. (12 15/16 x
9 15/16 in.), 1897. National
Portrait Gallery, Smithsonian
Institution, Washington, D.C.;
transfer from the National
Museum of American Art; gift
of Olin Dows

Fig. 5:21.
Brown and Gold by James
McNeill Whistler.
Oil on canvas, 96 x 51.4 cm.
(37 3/4 x 20 1/4 in.), circa 1896.
Hunterian Art Gallery,
University of Glasgow, Scotland;
Birnie Philip bequest

years, Whistler revived his interest in self-portrait painting during the mid-1890s. The earliest of these later works is probably *Brown and Gold* [Fig. 5:21], a full-length portrait of the artist in the familiar stance of Velásquez's *Pablo de Valla-dolid*. Whistler owned a photograph of the Velásquez, and had used the pose in other paintings as well. The warm tonal harmony of *Brown and Gold* is also indebted to the Spanish master, with Whistler's lithe figure placed against the subtle, neutral background. The painter's

expression seems less confident than in any previous self-portrait; the weariness of age and the stress of Trixie's illness had taken their toll.

Brown and Gold is probably the work that Beatrice Whistler referred to in a June 1895 letter to Edward G. Kennedy, mentioning that Whistler was painting a self-portrait that he hoped to finish in the next week.[24] Whistler later wrote to Kennedy that Beatrice's grave illness over the following year had delayed the completion of the work.[25] According to the Pennells, Whistler had originally depicted himself in a white jacket, but substituted a black coat for the jacket after Trixie's death.[26] The portrait was shown in the Paris Universal Exposition of 1900, after which Whistler altered it, rubbing down the surface to its present condition.[27] The inclusion of Boldini's portrait and *Brown and Gold* in the same exhibition could only have emphasized the polar extremes of these two approaches to portraiture. The Italian artist focused on the appearance of his sitter, while Whistler sought to convey a sense of his psychological state.

Three other self-portraits from the period are half-length busts, reminiscent of the artist's pose in the circa 1872 *Arrangement in Grey: Portrait of the Painter* [see Fig. 2:10]. Whistler used the dark tonality of Rembrandt and Hals when he painted the *Self-Portrait* [Fig. 5:22], but dispensed with the harsh chiaroscuro of his early likenesses. One interesting aspect of this work is that the customary attributes of the artist are omitted, including the prominent white lock. This painting, and a similar self-portrait in the Hunterian Museum and Art Gallery, are related to the most

Fig. 5:22.
Self-Portrait by James McNeill
Whistler. Oil on canvas,
51.5 x 31.3 cm.
(20 1/4 x 12 1/4 in.),
circa 1896. Hunterian
Art Gallery, University of
Glasgow, Scotland; Birnie Philip
bequest

finished of the half-length renderings,
Gold and Brown: Self-Portrait [Fig. 5:23].
Here Whistler included the traditional
details of his self-portraits—the monocle
and the white lock—but proudly added
the red ribbon of the Légion d'Honneur.
He also included his hands in this por-
trayal; the open hand has the same awk-
ward quality as the rendering he had
produced twenty-five years before in
Arrangement in Grey. Rosalind Birnie
Philip, the artist's sister-in-law, told a
member of the Boston Memorial Exhibi-
tion Committee that this was the self-por-
trait that "Whistler wanted to be
remembered by."28

A pen-and-ink drawing in the Library
of Congress [Fig. 5:24] dates to the same

period. Whistler portrayed himself with
an overcoat thrown over his shoulders in
this freely drawn, quickly realized sketch.
The pose resembles Rembrandt's *Portrait
of Jan Six*, which Whistler could have
seen in Amsterdam or known in repro-
duction. From his student days in Paris
to the end of his career, Whistler had
Rembrandt's work and accomplishments
fixed in his mind as icons of artistic merit.

In the autumn of 1898, Whistler and the
sculptor Frederick MacMonnies opened
the Académie Carmen as a new atelier in
Paris. Announcements were sent to Amer-
ica, Britain, and Germany, in addition to
the widespread publicity given the school
in Paris. From the outset, Whistler stated
that he would have nothing to do with the
management of the venture, leaving this to
his former model, Carmen Rossi. The
artist visited the studio in the Passage
Stanislas on a weekly basis during the first
year of operations, but less frequently as
time passed. The school was closed in the
spring of 1901, when Whistler's health
seriously deteriorated. During these years
a number of portraits were done by stu-
dents at the Académie, including likenesses
by Clifford Addams, Cyrus Cuneo, and
Alice Pike Barney.

Alice Pike Barney has the distinction of
being the only woman among more than
one hundred artists who represented
Whistler. Her pastel likeness, *James
Abbott McNeill Whistler* [Fig. 5:25], is
on toned paperboard of the type that
Whistler often used in the latter part of
his career. In Barney's drawing, the aging
master is clearly recognizable, but a sinis-
ter new element has appeared. The
intense glare of the eyes, the pointed
beard, and the hornlike white lock lend
Whistler the appearance of a lustful Pan,

Fig. 5:24.
Self-Portrait by James McNeill
Whistler. Pen and ink, 11.2 x
8.8 cm. (4 7/16 x 3 7/16 in.),
1898–1900. Pennell
Collection, Library of
Congress, Washington, D.C.

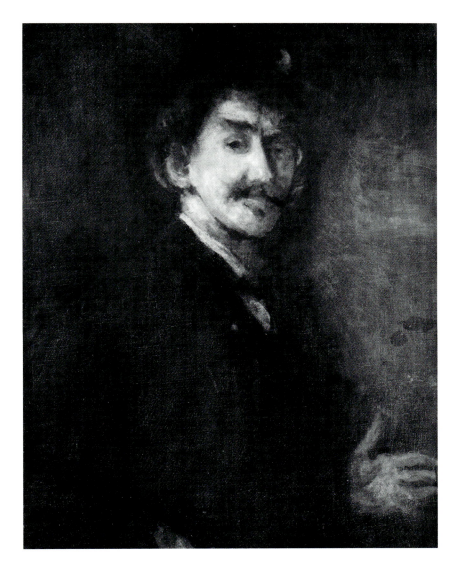

Fig. 5:23.
Gold and Brown: Self-Portrait by
James McNeill Whistler.
Oil on canvas, 62.2 x 46.4 cm.
(24 1/2 x 18 1/4 in.), circa 1896.
National Gallery of Art; gift of
Edith Stuyvesant Gerry.
© 1994, Board of Trustees,
National Gallery of Art,
Washington, D.C.

with overtones of sexuality previously
seen only in the work of Aubrey Beards-
ley [see Fig. 5:13]. Barney's later unpub-
lished writings indicate that at the
beginning of their acquaintance, Whistler
may have hinted at something more than
a teacher-student relationship.[29] Whis-
tler's suggestive remarks might have influ-
enced Barney to render the artist in the
guise of a satyr, since an observer might
not be surprised to find goat's hooves hid-
den inside the patent shoes of a figure
with this expression. Barney wrote that
the portrait was done in a single sitting of
about forty minutes, and that when it was
done, Whistler found it very amusing.[30]

Cyrus Cuneo was another of Whistler's
students at the short-lived atelier, later
becoming the monitor for the Académie's
male life class. He recorded his memories

Fig. 5:25.*
James Abbott McNeill Whistler
by Alice Pike Barney
(1857–1931). Pastel on
paperboard, 49 x 49 cm.
(19 1/4 x 19 1/4 in.), 1898.
National Museum of American
Art, Smithsonian Institution,
Washington, D.C.; gift of
Laura Dreyfus Barney

of the studio in an article in *Century Magazine* in November 1906, including four illustrations of Whistler with his text, the only representations of the artist instructing students.[31] According to Cuneo, the artist expended more effort instructing the women than the men, supporting Whistler's reputation as a bit of a rogue when it came to women. *Whistler Criticizing at His Paris School* [Fig. 5:26] illustrates one of Whistler's visits to the Académie. Other illustrations represented Whistler doing a painting demonstration for the men's class, reading from *The Gentle Art of Making Enemies*, and instructing a group of women students. Hiram C. Merrill translated Cuneo's original drawings into wood engravings for *Century Magazine*.

The Pennells saw Whistler regularly in Paris and recalled that he was always accessible to established artists, but was particularly cordial to English and American students. The American artist Ernest Haskell went to Paris to study at the Académie Julian in 1897, but quickly became disenchanted with the routine of the atelier. Instead, he pursued a course that paralleled Whistler's studies of forty years earlier—copying in the Louvre and studying contemporary art in the galleries. Manet and Degas were among his favorite painters, and Daumier's lithographs also attracted his attention. He became acquainted with Whistler in 1898, possibly at the American Art Association in Montparnasse, which Whistler frequented, or perhaps through a mutual friend.

Haskell may have attended the Académie Carmen, although no enrollment records have been preserved.

Haskell captured his student years in an early self-portrait [Fig. 5:27] that dates to late 1897 or early 1898. The pen-and-ink sketch shows him seated at a table studying. The scene is reminiscent of the youthful Whistler's self-portraits, but Haskell has incorporated an additional element, depicting himself with an enormously long pipe in his mouth. Pipes were stock properties of Dutch genre scenes. On the wall in the background are several pictures, including Nicholson's 1897 woodcut of Whistler [see Fig. 3:44], indicating Haskell's admiration for the American painter. This diminutive drawing was the first of a series of late portraits that refer to Whistler by placing his likeness in the background, in a fashion similar to the picture of Delacroix in

Fig. 5:26.
Whistler Criticizing at His Paris School by Hiram C. Merrill (1866–1958) after Cyrus Cuneo. Halftone published in *Century Magazine*, 1906

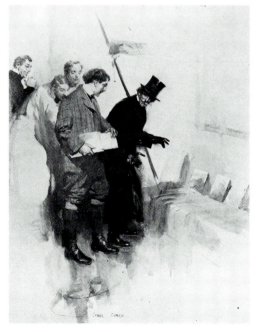

Fantin's 1864 *Hommage à Delacroix* [see Fig. 2:1]. However, the Haskell sketch is essentially a personal image, not intended for public display.

Haskell's gift for caricature led him to portray Whistler in some of his earliest published works. He produced the charcoal study of Whistler [Fig. 5:28] in 1898 for inclusion as a photogravure in the Christmas issue of *Life* magazine. The artist did the sketch from memory after a visit to the Louvre with Whistler.[32] In the drawing, Whistler is shown in three-quarter profile, glancing toward the viewer out of the corner of his narrowed eye. His skeptical expression suggests that while he is interested in the viewer's reaction, he is suspicious of our intent. The drawing literally records the view Haskell had as the two artists looked at art in the Louvre, Whistler peering sideways to see the young artist's response to a comment or a work. Haskell's selection of this vantage point effectively communicates the older master's mischievous nature.

Whistler's hair and mustache are vividly drawn, but Haskell eschewed the ubiquitous white lock in favor of a top hat. Much of the charm of the caricature derives from the unusual cropping of the hat and the bust, which is suggestive of Henri de Toulouse-Lautrec's lithographs of the time. According to Nathaniel Pousette-Dart, who later wrote an appreciation of Haskell's work, Whistler himself liked the portrait.[33]

In an article entitled "Portraits and Caricatures" in *Harper's Bazar*, Haskell wrote: "A caricature is an exaggerated portrait the characteristics of which are distorted to a grotesque degree—a parody on the features, as it were. There are kindly caricatures and cruel caricatures,

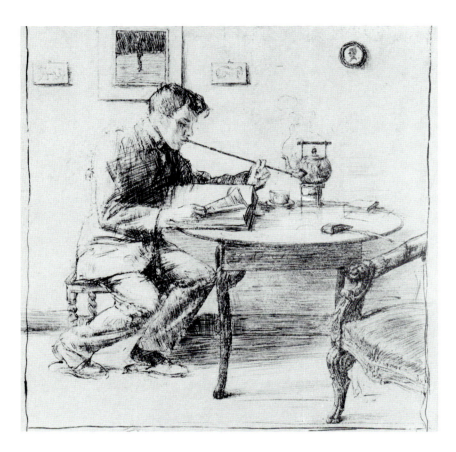

Fig. 5:27.*
Self-Portrait as a Student in Paris
by Ernest Haskell (1876–1925).
Pen and ink, 21 x 20.3 cm.
(8 1/4 x 8 in.), 1897–1898.
Philadelphia Museum of Art,
Pennsylvania; gift of Ernest
Haskell, Jr.

and both may be made of the same person, according to the artist's point of view or mission."[34] Haskell followed his 1898 caricature with several others, which were among the last likenesses of Whistler to appear in the press before the artist's death. While the first might have been interpreted as sympathetic, the others tended toward unkind exaggeration. His 1899 drawing *James Abbott McNeill Whistler* [Fig. 5:29], published in *The Critic* in January 1901, used expressive distortions of the monocle, face, hair, and hat for a satiric effect. The pose is a mirror image of that in Ward's caricature [see Fig. 3:1] or one of its progeny, but the result is closer to the 1894 Beardsley caricature [see Fig. 5:14]. Haskell knew the

Beardsley drawing, calling it a "'swell' thing of Jimmy" when he wrote to his sister Mabel after seeing it in Walter Sickert's collection.[35]

Several photographs captured the aging Whistler, frail and in deteriorating health. In their biography, the Pennells reproduced four late *Glimpses of Whistler* [Fig. 5:30], which have been attributed to the artist's publisher William Heinemann. The scene of Whistler sketching is from Corsica, where he went for his health in January 1901, and next to it is the artist posing in the garden at 110 rue du Bac. The two scenes below are in unidentified locations, but clearly the artist is also in his late sixties. Walter Sickert, who had earlier been one of Whistler's devoted pupils, struck a similar note in his 1900 sketch of the artist at Chelsea [Fig. 5:31].

One of the final photographs of Whistler, and one of the most melancholy, is *Mrs. Brown-Potter and the Late McNeill Whistler* [Fig. 5:32]. In the photograph, the fragile old figure leans stiffly forward in a carriage to look past his companion toward the camera. Even at a considerable distance, the camera records the decline of the once-energetic and sprightly Whistler.

The artist died on Friday, July 17, 1903. The funeral took place the following Wednesday, with a service in Chelsea Old Church and a procession to the graveyard in nearby Chiswick. Although not included in the funeral entourage, Walter and Henry Greaves watched from across the street, later recording the scene of their estranged master's final passing.[36]

The announcements of Whistler's death in newspapers and journals around the world were often accompanied by likenesses of the artist, mostly in the form of

Fig. 5:28.*
James McNeill Whistler by Ernest
Haskell (1876–1925). Ink, char-
coal, chalk, and watercolor,
24.7 x 15.1 cm. (9 3/4 x 5 15/16
in.), 1898. © Cleveland Museum
of Art, Ohio; gift of Mr. and
Mrs. Ralph King (24.72)

Fig. 5:29.
James Abbott McNeill Whistler
by Ernest Haskell (1876–1925).
Wood engraving published in
The Critic, January 1901

Fig. 5:33.
Memorial to Whistler by
Augustus Saint-Gaudens
(1848–1907). United States
Military Academy, West Point,
New York

Another drawing shows that the sculptor considered a relief of the artist for the stele, but these ideas were eventually put aside in favor of the austere tablet. Saint-Gaudens's choice of a classical grave monument is particularly fitting to contain Whistler's quotation on the Parthenon. The two artists shared an admiration for Greek and Japanese art, and the sculptor made appropriate reference to both in the memorial.

In March 1907 Homer Saint-Gaudens, corresponding for his ailing father, sent a photograph of the final designs for the memorial to Rosalind. She replied on June 3, precisely two months before Augustus Saint-Gaudens's death, saying, "It will be a most dignified and simple memorial of my brother-in-law's memory by the sculptor for whom he had such high admiration."[40]

Bruno Louis Zimm, a pupil of Saint-Gaudens, executed a bust of Whistler [Fig. 5:35] in 1905 for the facade of the Frederick Keppel and Company Print Gallery. A second bust on the facade by Zimm depicts Rembrandt, an appropriate pairing for a leading New York print dealer and one that would have certainly pleased Whistler. Gallatin stated that Zimm's portrait of Whistler was made from a photograph, although the sculptor may have seen the painter in Paris at the 1900 Universal Exposition, where Zimm was awarded a silver medal.[41]

Another sculpture memorial grew out of Whistler's involvement with the International Society of Sculptors, Painters & Gravers. Whistler had been president of the society from its founding in 1898 until his death. He had considerable influence over the society's first exhibition, which had included the work of Saint-Gaudens, MacMonnies, and Rodin. In 1905 the society sponsored the Whistler Memorial Exhibition in London, holding a banquet for the opening on February 22. The idea of commissioning a memorial monument to Whistler in London was first suggested at this time, and was considered again

Fig. 5:34.
Sketch for Whistler memorial
by Augustus Saint-Gaudens
(1848–1907). Charcoal on
paper, 25.4 x 20.3 cm.
(10 x 8 in.), 1904–1905.
Dartmouth College Library,
Hanover, New Hampshire

Fig. 5:35.
James McNeill Whistler by
Bruno Zimm (1876–1943).
Terra-cotta relief, 1905.
Unlocated

at a meeting of the society in May. Auguste Rodin had succeeded Whistler as president and was the first choice for the commission. If Rodin declined, a second possibility would be to purchase a cast of the Boehm bust [see Fig. 3:6].[42]

Rodin accepted the commission, and a committee was appointed to raise funds. The London City Council recommended a site in the gardens near Whistler's house on the Chelsea embankment, not far from Boehm's statue of Thomas Carlyle. The initial idea for the memorial was a "Winged Victory symbolizing Whistler's triumph—the triumph of Art over the Enemies."[43] Rodin was receptive to the idea of an allegory, since he had never done Whistler's portrait and preferred not to attempt one posthumously. The sculptor proceeded sporadically during the next dozen years, producing several small maquettes before his own death in 1917. A committee visited Rodin's studio in 1919 to see the statuette that had been the artist's final thoughts on the work, and found it inappropriate for the memorial.

A photograph of Rodin's preparatory model [Fig. 5:36] shows a muse with a small casket on her knee above a medallion with a crude drawing of Whistler. In light of Whistler's views concerning allegorical and symbolic art, the failure of the memorial probably would have pleased him. The Pennells reported that Whistler said that he never wanted to have a portrait in the gardens the way Rossetti did. As John Singer Sargent told the Pennells, "I also think Whistler would have hated the idea. He never was funnier or more sarcastic than on the subject of the monument to Rossetti on Cheyne Walk."[44]

An additional American memorial was

Fig. 5:36.
Preparatory model for Whistler
memorial by Auguste Rodin
(1840–1917). Rodin Museum,
Meudon, France

Fig. 5:37.
Whistler by Frederick William MacMonnies (1863–1937). Plaster, 89 cm. (35 in.) height, 1930. Private collection

done years later by a sculptor who had been a good friend of the artist. In 1930 Whistler was elected to the Hall of Fame for Great Americans in the Bronx, New York. Frederick MacMonnies, who had overseen the Académie Carmen with Whistler in Paris in the 1890s, was commissioned to do the memorial. MacMonnies did two plasters of the subject, one a lively, youthful Whistler, now lost, and the other a half-length bust with a more serious demeanor [Fig. 5:37].[45] The latter was chosen for the bronze cast that was installed in the hall on May 14, 1931. By the 1930s there was no controversy over Whistler's status as a major American artist; he was worthy of inclusion in the ranks of notable Americans.

A flurry of articles, memoirs, and

biographies had appeared in the aftermath of Whistler's death, and many contained previously unpublished portraits. The Pennells' *The Life of James McNeill Whistler* and Gallatin's *Portraits of Whistler* both illustrated many unknown or unpublished images of the artist. Drawings, prints, and paintings emerged from private collections, to be included in reminiscences or to be lent to exhibitions of what was dubbed "Whistleriana." Collections of art and books about Whistler were often accompanied by compendia of portraits of the artist. A. E. Gallatin in New York, Walter Brewster in Chicago, Elmer Adler in Rochester, and Ralph King in Cleveland were among the most prominent collectors. Whistler ephemera became popular, and his like-

Fig. 5:38.*
Cigar-box label, Leopold Powell and Company, Tampa, Florida. Chromolithograph, 15.5 x 21.5 cm. (6 1/8 x 8 1/2 in.), 1910. A. E. Gallatin Collection, The Miriam and Ira D. Wallach Division of Art, Prints and Photographs, The New York Public Library, New York City, Astor, Lenox and Tilden Foundations

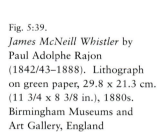

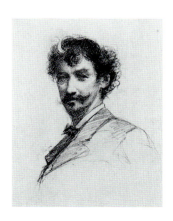

ness began to appear in advertisements for a wide variety of products. A portrait of the painter on the cover of a box of Whistler Cigars [Fig. 5:38] was based on a charcoal portrait by Paul Adolphe Rajon done in the 1880s [Fig. 5:39], which was itself after a photograph. The cigar-box likeness of the artist appears above a lower border containing six of Whistler's paintings, including the portraits of Carlyle and Cicely Alexander. F. Harriman Wright issued a statuette that was a child's bank—*Whistler Seated*, modeled after the Boldini portrait. Only a few original drawings and caricatures were still being produced by artists who knew Whistler in the later stages of his career. One such artist was Walter Crane, whose clever image, *Whistler as a Butterfly* [Fig. 5:40], appeared in his review of the Pennells' *The Life of James McNeill Whistler* in the *Evening News* and was republished in his book *William Morris to Whistler*.[46] The most important of all posthumous Whistler portraitists, however, was Sir Henry Maximilian Beerbohm, better known simply as "Max."

Beerbohm was one of the major caricaturists of English society from 1895 until 1930. He produced several drawings of Whistler during the painter's lifetime, and continued to include him in his work into the 1930s. Beerbohm had met Whistler in 1896 in London, and occasionally saw him later at the home of William Heinemann. Their first recorded public exchange appeared in the *Saturday Review* in November 1897, when Beerbohm wrote sarcastically about Whistler bringing out another edition of *The Gentle Art of Mak-*

ing Enemies. Despite the ensuing critical exchange, Beerbohm later admitted that he admired Whistler for his writing and his witticisms: *After an encounter with him* [his opponents] *never again were quite the same men in the eyes of their fellows. Whistler's insults stuck— stuck and spread round the insulted, who found themselves at length encased in them, like flies in amber. You may shed a tear over the flies, if you will. For myself, I am content to laud the amber.*[47] The year after Whistler's death, Beerbohm wrote an article for *Pall Mall Magazine* on Whistler's prose, in which he was the first to praise the artist's extraordinary talent as a writer: "You will find that for words as well as colour-tones he has the same reverent care, and for phrases as for forms the same caressing sense of beauty."[48]

In a letter to a friend dated May 31, 1897, Beerbohm wrote, "I have done a beautiful little caricature of Whistler." *Mr. Whistler* [Fig. 5:41] is typical of Beerbohm's work of the period, in that it represents the artist alone and matches the notes that Beerbohm made after their first meeting: "Tiny—Noah's Ark—flat-brimmed hat—band almost to top—coat just not touching the ground—button of the legion of honour—black gloves—Cuban belle—magnificent eyes—exquisite hands, long and lithe—short palms."[49] Whistler's oversized head and hat dominate the composition, with touches of Beerbohm's wit emerging in the way the eyebrows come up over the hat-brim and the white lock protrudes through the top hat. A similar figure inhabits *A Nocturne: Mr. Whistler Crossing the Channel,*

Fig. 5:41.
Mr. Whistler by Max Beerbohm (1872–1956). Pen and ink with wash, 26.3 x 19 cm. (10 3/8 x 7 1/2 in.), 1890s. Houghton Library, Harvard University, Cambridge, Massachusetts

a drawing that appeared in *The Idler* in February 1898.

Beerbohm commented upon the artist's role in various legal proceedings through a number of watercolors. In *Mr. Whistler Giving Evidence in the Case of Pennell v. The Saturday Review and Another* [Fig. 5:42], the caricaturist represented the painter testifying for his friend in a libel suit. The "Another" of the title was Whistler's former student Walter Sickert, who had allegedly slandered Joseph Pennell by claiming that a transfer lithograph was not an original print.

Sir William Eden and Mr. Whistler [Fig. 5:43] is another of Beerbohm's

works referring to litigation of this period. In Paris, Whistler had been engaged in a lengthy suit with Sir William Eden involving the price and manner of payment for a portrait of Eden's wife. The patron successfully brought action against the painter in March 1895, but Whistler appealed, and the verdict was reversed in December 1897. Beerbohm's caricature depicts Eden dressed as a lepidopterist, with net in hand, in pursuit of a butterfly that gracefully eludes his grasp. The Eiffel Tower, a symbol of Paris, is seen beyond a vaguely defined body of water. Beerbohm has summarized the situation with a few economical strokes of

Fig. 5:42.*
Mr. Whistler Giving Evidence in the Case of Pennell v. The Saturday Review and Another by Max Beerbohm (1872–1956). Pencil, black chalk, and watercolor, 30.4 x 27.2 cm. (12 x 10 3/4 in.), 1926. Birmingham Museums and Art Gallery, England

the pen. *Sir William Eden, Revisiting Paris, 1907* [Fig. 5:44] is a pendant watercolor that depicts Whistler's shadow hovering over the elegantly dressed Eden's return to the French capital.

Beerbohm created one of his most memorable caricatures, *Dante Gabriel Rossetti, in His Back Garden* [Fig. 5:45], in 1904, the same year he published his article on Whistler's writing.[50] The scene illustrates the author's fond view of the quickly receding world of Victorian arts and letters that had made a strong impression on him in his youth. In addition to Rossetti and his famous menagerie, Beerbohm included Ruskin,

Theodore Watts-Dunton, Ford Madox Brown, Edward Burne-Jones, Elizabeth Siddall, William Morris, Holman Hunt, and Algernon Swinburne, who is tugging on Whistler's white lock. The famous garden and its habitués represented a golden age for Beerbohm—one that he would evoke frequently in the years to come. The imaginative interaction of famous artists and writers imbues the drawing with the nostalgic charm that is at the core of Beerbohm's finest work. The clever combination of people and animals is reinforced by the wit of Beerbohm's drawing style. A few simple lines capture the exaggerated features of a

Fig. 5:43 (*left*).*
Sir William Eden and Mr. Whistler by Max Beerbohm (1872–1956). Pen and ink with watercolor, 32 x 20.4 cm. (12 5/8 x 8 3/4 in.), before 1907. Hunterian Art Gallery, University of Glasgow, Scotland

Fig. 5:44 (*right*).*
Sir William Eden, Revisiting Paris, 1907 by Max Beerbohm (1872–1956). Pencil, pen, ink, and watercolor, 33 x 21.5 cm. (13 x 8 1/2 in.), 1907. The Art Institute of Chicago, Illinois; gift of Emily Crane Chadbourne (1926.1549). © 1994, The Art Institute of Chicago. All rights reserved

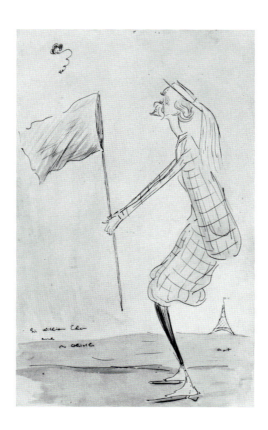

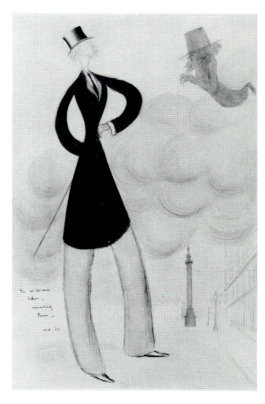

Fig. 5:45.*
Dante Gabriel Rossetti, in His Back Garden by Max Beerbohm (1872–1956). Published in *Rossetti and His Friends*, 1904. Mark Samuels Lasner

Ruskin or a Swinburne, the essential contours of a snake or kangaroo, or the shape and curly hair of an absurdly small Whistler. Beerbohm's gift was the result of an inspired selection of subjects rendered in an inimitably droll style.

In another of Beerbohm's evocations of Chelsea's past, he includes Whistler and Thomas Carlyle in *Blue China* [Fig. 5:46]. Whistler and Rossetti had both been early and avid collectors of Nankin china, vying for important pieces in the 1860s and 1870s. In *Blue China*, a diminutive Whistler espouses the virtues of an enormous Chinese vase to his laconic neighbor, Thomas Carlyle. The philosopher's dour expression contrasts with the painter's animated appreciation of this particular treasure. The austere room and the delicate watercolor tints resonate with Whistler's taste in room design and decoration. Beerbohm rendered Carlyle in profile, holding his hat, with a chair

rail and pictures on the wall, all prominent references to Whistler's 1872 portrait of the philosopher. The caricaturist was intrigued by Whistler's reuse of his mother's pose for the *Arrangement in Grey and Black, No. 2: Portrait of Thomas Carlyle* [see Fig. 3:3].[51] Beerbohm's continuing interest in the image is evident from his own pose in a 1916 photograph by Filson Young [Fig. 5:47]. An inscription identifies the image as "MAX BEERBOHM, ESQ; WITH APOLOGIES TO ALL CONCERNED FY, 1916," but whether the photograph was the author's conception or Young's, "the image is the perfect vehicle for Beerbohm, urbane, aesthetic and gently facetious, and shows the author of the ironical and fantastic *Zuleika Dobson*, in the guise of the self-absorbed and deadly serious 'sage of Chelsea.'"[52] Several years earlier, Beerbohm had done *Mr. Joseph Pennell Thinking of the Old 'Un* [Fig. 5:48], a caricature of Whistler's

Fig. 5:46.*
Blue China by
Max Beerbohm (1872–1956).
Watercolor, pen, and ink, 33.7
x 27.3 cm. (13 1/4 x
10 3/4 in.), 1916. Tate Gallery,
London; bequest of Sir Hugh
Walpole

Fig. 5:47.
Max Beerbohm by Filson
Young (1876–1938). Toned
bromide print, 29.7 x 22.4 cm.
(11 3/4 x 8 3/4 in.), 1916.
National Portrait Gallery,
London

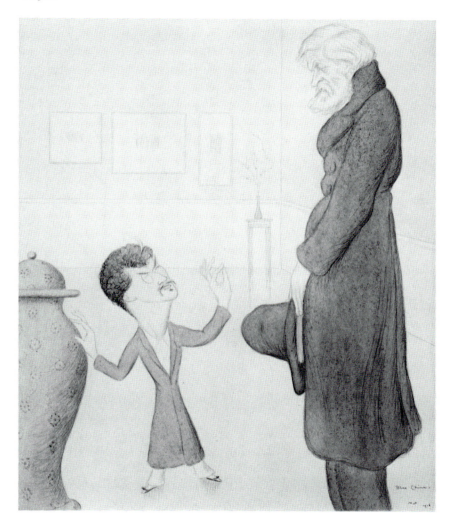

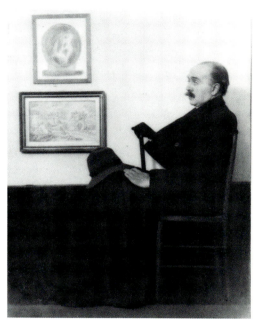

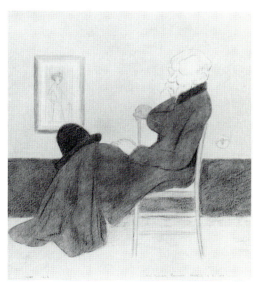

Fig. 5:48 (*right*).*
*Mr. Joseph Pennell Thinking of
the Old 'Un* by Max Beerbohm
(1872–1956). Pencil and wash,
27.9 x 24.1 cm. (11 x 9 1/2 in.),
1913. Robert H. Taylor Collec-
tion, Department of Rare Books
and Special Collections, Princeton
University Libraries, New Jersey

biographer in the guise of Carlyle. Pennell is placed in the sage's costume and pose, in a setting indebted to the *Arrangement in Grey and Black, No. 2.* However, an image of Whistler based on Ward's caricature [see Fig. 3:1] has replaced the undefined pictures in the background of the *Carlyle*, leaving no doubt as to the identity of the "Old 'Un." This caricature on the wall provides a key to understanding the image, as it had been in Ernest Haskell's drawing of his own student years in Paris [see Fig. 5:27]. The likenesses in the background of the portraits articulate the profound influence Whistler had on the artists. The portrait of Joseph Pennell was published in *Fifty Caricatures* in 1913.

Beerbohm used the same device again in a 1920 illustration, *The Mercilessness of Youth* [Fig. 5:49]. In the drawing, a figure in Bohemian dress is seen looking up

Fig. 5:49.*
The Mercilessness of Youth
by Max Beerbohm
(1872–1956). Pencil and
watercolor, 35.7 x 22 cm.
(14 1/16 x 8 5/8 in.), 1920.
Hunterian Art Gallery,
University of Glasgow,
Scotland

at a likeness of Whistler. The portrait in the background is signed W. Greaves, and is in Walter's usual half-length format and style. At the bottom of the drawing, below the title, is the inscription "*Post-Impressionist:* 'No one with any *real* talent could have behaved like that!'"[53] The caption probably refers to Whistler's notoriously bad behavior, or it may remark on Greaves's endless repetitions of Whistler portraits. Beerbohm took an interest in the exhibitions of Greaves's work in 1911 and in his sycophantic relationship to Whistler.[54]

Whistler continued to recur as a character in Beerbohm caricatures into the early 1930s, appearing finally and appropriately as an apparition in a drawing captioned "Shades of Rossetti, Ruskin, Swinburne, Pater and Whistler wondering that so much space has been devoted to this other later Romantic—and whether even he is the 'Last one.'" William Butler Yeats was the "later Romantic," a reference to the line "we were the last romantics" in his 1931 poem "Coole Park and Ballylee."[55] Beerbohm's drawing defends the honor of those idols of the late Victorian period; they had been part of his inspiration since his early days at Merton College at Oxford. By the fourth decade of the twentieth century, Whistler, Ruskin, and the others had become a part of history, their colorful personalities receding into a vague past, replaced by the scholarly study of their work. Victorian culture was held in low repute by the generation that had come of age during and after World War I. Beerbohm helped to keep the masters of the late nineteenth century alive well into a new era by including them in caricatures that affectionately celebrated the end of their own era.

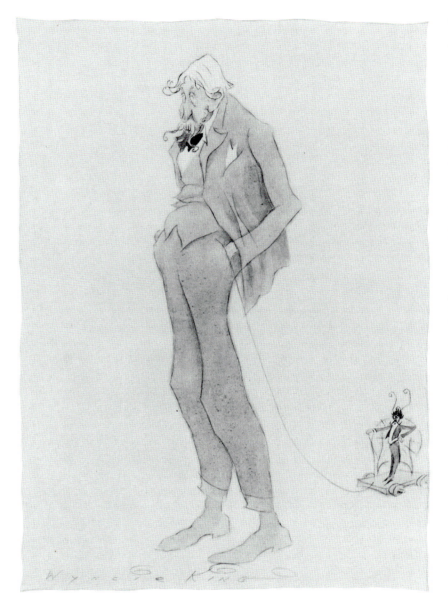

In many ways, the most significant twentieth-century portraits are the written descriptions of Whistler's life in memoirs and appreciations, and in the impressive biographical achievement of the Pennells' 1908 *Life of James McNeill Whistler*. Joseph Pennell was an accomplished artist who knew Whistler for the final twenty years of his life, but like another famous artist-biographer, Giorgio Vasari, he constructed the portrait of his master in words. Pennell's fame today is based in large part on his association with Whistler, much as Vasari is celebrated for his writings on Michelangelo and Renaissance art. Wynchie King's watercolor, *Joseph Pennell with Whistler* [Fig. 5:50], recognizes Pennell's efforts in promoting Whistler in the United States, as well as his debt to Whistler for his own notoriety.

Fig. 5:50.
Joseph Pennell with Whistler
by Wynchie King (born 1884).
Pencil and watercolor, 44 x
35.5 cm. (13 3/8 x 9 1/4 in.),
not dated. The Art Institute of
Chicago, Illinois; Walter S.
Brewster Collection of
Whistleriana (1933.260).
© 1994, The Art Institute of
Chicago. All rights reserved

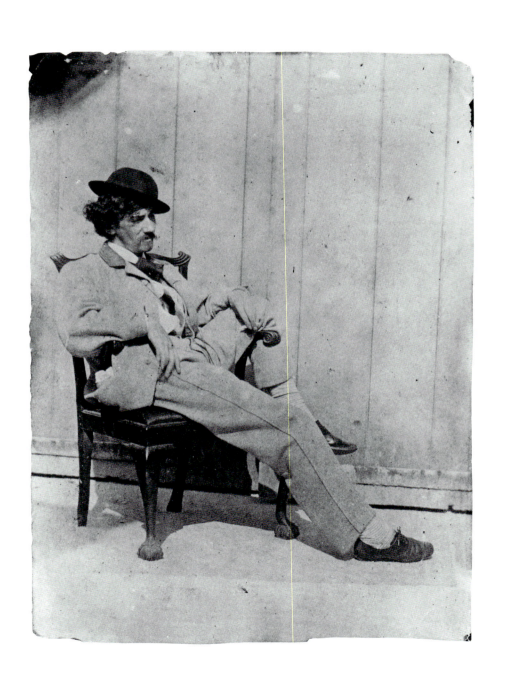

Conclusion

The hero was distinguished by his achievement; the celebrity by his image or trademark. The hero created himself; the celebrity is created by the media. The hero was a big man; the celebrity is a big name.

—DANIEL BOORSTIN[1]

Whistler is acknowledged today as one of the leading painters of his era and as one of the great personalities of Victorian England. Yet during his own lifetime, he was most notorious for his notoriety, with his art often accorded lesser status. Only in the final dozen years of his life was Whistler widely recognized for his artistic accomplishments and his pivotal contribution to the development of late-nineteenth-century aesthetics.

In the 1960s, Daniel Boorstin defined the difference between a celebrity and a hero in the modern age.[2] The evolution of Whistler's reputation illustrates Boorstin's distinctions with clarity, especially if the word "artist" is substituted for the word "hero" in the epigram above. Boorstin began by defining a hero as a human figure who has been recognized for greatness in some achievement. As an artist, Whistler's achievements during the first part of his career were notable, but not yet of the sustained quality that in retrospect would mark him as a significant artist-hero in the eyes of a substantial number of historians and collectors well versed in the period.

We have seen, however, how Whistler recognized the value of media attention, beginning with his letters to the press in the 1870s, and his courtship of reporters in the scandal surrounding the Peacock Room decorations.[3] What Whistler created at this time was a public posture, a constructed celebrity that he used to call attention to his art and to his redefinition of the artist's role and relationship with society.

Whistler attracted attention to himself as a way of marketing his work and his ideas. One of Boorstin's characteristics for a celebrity is that he is well-known for his well-knownness. Whistler's pugilism, well-advertised quarrels, and well-publicized litigation initially gave him notoriety, as distinct from the later fame that accompanied recognition of his artistic achievement. In Boorstin's words, "The celebrity is the creature of gossip, of public opinion, of magazines, newspapers, and the ephemeral images of movie and

*James McNeill Whistler by an unidentified photographer. Silver print, 16.2 x 11.6 cm. (6 3/8 x 4 9/16 in.), not dated. Charles Lang Freer Papers, Freer Gallery of Art Archives, Smithsonian Institution, Washington, D.C.

television screen."[4] Whistler lived before the age of "ephemeral" moving images; instead of attracting cameras, he attracted illustrators and portraitists in abundance.

One of the characteristics of the celebrity is contemporaneity—being newsworthy without actually making news. "The celebrity is born of the daily papers and never loses the mark of his fleeting origin."[5] For Whistler's strategy to be successful, he had to not only garner attention but also had to distinguish himself from the other artists of the day. He turned to the editorial pages of the press to create a pose of aesthetic independence. To construct a reliably recognizable artistic persona, Whistler developed a unique appearance by dressing flamboyantly and acting unconventionally. Again, as Boorstin suggested: *Celebrities are differentiated mainly by trivia of personality. To be known for your personality actually proves you are a celebrity. Thus, a synonym for a "celebrity" is a "personality." Entertainers, then, are best qualified to become celebrities because they are skilled in the marginal differentiation of their personalities. They succeed by skillfully distinguishing themselves from others essentially like them.*[6]

Whistler accessorized his appearance with a variety of eye-catching additions over the course of his life. His uncommon straw hat of the Paris years is followed by the addition of a monocle after his arrival in England. The fabled white lock of hair is added around 1870. Whistler's costume evolves as well, including at various times the ribbon tie, the white-duck outfit, a top hat, a wand or walking stick, shoes with large bows, and a cape with formal evening dress. All of these choices demonstrate the artist's

deliberate efforts to attract attention, particularly in the public arena, where illustrators could seize upon his peculiarly distinguished appearance. In his personal life, the artist's costume was more functional, as William Merritt Chase's anecdote illustrates. Out of the public eye, he could leave the "gimcracks" aside.

Characteristically, the gestation of Boorstin's hero required "'at least a generation. As the saying went, he had to prove that he 'stood the test of time'"— the opinion of succeeding generations of artists, historians, and collectors.[7] Beginning in the 1880s, Whistler's public recognition increased steadily, culminating in the general acknowledgment, in the early 1890s, that he was a master worthy of inclusion in important public collections. The requisite time had elapsed and the necessary sequence of events had unfolded since Whistler's first appearance for an acceptable evaluation of his accomplishments. However, as Boorstin pointed out, when a "man appears as hero and/or celebrity, his role as celebrity obscures and is apt to destroy his role as hero."[8] The point for our purposes is that Whistler deliberately created his media image as a means of self-advertisement. The strategy succeeded in attracting desirable attention at a time when his work, while often noted in exhibition reviews, was not receiving the publicity he desired. However, once Whistler's art had garnered widespread recognition, there was less need for the public posturing and the constructed self-image. The measure of the construction's potency is the length of time it has outlived its original purpose. Most of the biographies and studies of Whistler in the twentieth century have dwelled at disproportionate length on the

anecdotes surrounding the artist's life. A knowledgeable audience of our own time is more likely to know of Whistler's wit than his aesthetic intentions.

Although some of the blame for creating an obscuring aura of celebrity is Whistler's, we must share some of the responsibility for perpetuating it into the late twentieth century. Our own age is overwhelmingly attracted to personalities and celebrities. The tabloids and the glossy news magazines dote on the personal lives of entertainers, athletes, artists, criminals, politicians, and other merely bizarre individuals. As Boorstin stated in his prescient essay, "Most of our remaining heroes hold our attention by being recast in a celebrity mold."[9]

The earliest images of Whistler were mostly self-portraits, in which the artist sought to define himself in the context of contemporary art, or they were portraits by friends asserting his status as a significant young artist. Later, he consciously promoted an image of himself as a flamboyant, eccentric Bohemian, a belligerent stance calculated to attract the attention of the public. Yet he was never the indolent dandy he sometimes appeared to be. As recognition slowly emerged in the decades after the Ruskin trial, the image of Whistler as an unconventional but major figure of the time coalesced into the persona that is so familiar today—that of the Victorian outsider. Whistler bolstered this image by skillfully manipulating the press—writers as well as illustrators. The ascendant image of Whistler as a major artist eventually overtook the factitious construction during the

final years of his life, but it never entirely eradicated the popular depiction.

The best resolution to the dilemma posed by Whistler's image is perhaps that offered by Arthur Jerome Eddy: *Nearly every sketch, drawing, or portrait of Whistler gives some phase of his many-sided personality, but not one—not even those by himself—gives anything like an adequate conception.*

He was a man most difficult to place on canvas. He could not be grasped and held long enough. He himself tried it, but with only moderate success. Others have tried and failed completely—that is, failed to portray him at his best; for that matter, no one who has ever drawn or painted him did so when he was at his best, for those moments only came in the seclusion of his own studio, when, alone with model or sitter, he worked absolutely oblivious to everything but his art. No man is at his best when posing for photograph, sketch, or portrait, and Whistler was farther from being an exception to this rule than most others. He knew too well what a portrait should be to feel the indifference which is essential to a perfectly natural pose. Consequently, while few men were better known by sight in Paris and London, scarce anyone knew him as he was—the most profoundly serious, conscientious, and consistent artist of his day and generation.[10] What remains ninety years later is the curious amalgam of two images: the contemporary self-creation and our own time's assessment of James McNeill Whistler as a major Victorian artist and personality.

Notes

Introduction

1. G. S. Layard, "Whistler," *The Bookman* 43 (October 1912): 30.
2. Richard Brilliant, *Portraiture* (London: Reaktion Books, 1991).
3. Letter from Whistler to Rose, received November 21, 1878, R128, Glasgow University Library.
4. Daniel Boorstin, *The Image: A Guide to Pseudo-Events in America* (New York: Atheneum, 1962; revised ed., 1987), pp. 45–76.
5. Albert E. Gallatin, *Portraits and Caricatures of James McNeill Whistler, an Iconography* (London: John Lane, The Bodley Head, 1913), and Albert E. Gallatin *Portraits of Whistler: A Critical Study and an Iconography* (London: John Lane, The Bodley Head, 1918).
6. For a complete illustrated checklist of portraits of Whistler, see Eric Denker, "Whistler: Image and Icon . . . " (Ph.D. diss., University of Virginia, 1995).

Chapter 1

1. Elizabeth Robbins Pennell and Joseph Pennell, *The Life of James McNeill Whistler* (1st ed.; London: William Heinemann, 1908), vol. 1, p. 1. The Pennells' two-volume biography was the authorized life of the artist and will be the source of most of the general autobiographical material, except where noted. Whistler claimed at different times to have been born in Baltimore, Maryland, and St. Petersburg, Russia, among various other locations.
2. Nigel Thorp, *Studies in Black and White: Whistler's Photographs in Glasgow University Library,* vol. 19: *James McNeill Whistler: A Reexamination,* Studies in the History of Art (Washington, D.C.: National Gallery of Art, 1987), pp. 85–86, 99, n. 3.
3. David Curry, *Whistler in the Freer Gallery of Art* (Washington, D.C.: Smithsonian Institution Press, 1984), p. 73.
4. Margaret MacDonald, notes, curatorial files, Freer Gallery of Art, Smithsonian Institution, Washington, D.C.
5. Pennell and Pennell, *Life of Whistler,* vol. 1, p. xviii and facing p. 26, label of reproduction. The Pennells thought it was a miniature after a daguerreotype, neither of which appears to be the case.
6. *Ibid.,* facing p. 230.
7. *Ibid.,* p. 27. Palmer's description may have been influenced by the Dessain pastel image, which she owned until 1904.
8. *Ibid.,* p. 35.
9. *Ibid.,* pp. 52–53.
10. G. H. Fleming, *Whistler: A Life* (New York: St. Martin's Press, 1991), pp. 62–67.
11. Curry, *Whistler in the Freer,* p. 210.
12. *Ibid.*
13. Hélène Toussaint, "The Dossier on the 'Studio' by Courbet" in *Courbet, 1819–1877* (exhibition catalogue, London: Arts Council, 1978), pp. 278–79.
14. A similar self-portrait of the artist that may date to this time was revealed by X-rays beneath the surface of a landscape that Whistler painted in the early 1860s. Reproduced in Andrew MacLaren Young *et al., The Paintings of James McNeill Whistler* (New Haven, Conn.: Yale University Press, 1980), vol. 2, fig. 366.
15. Eric Denker, "The Influence of Dutch Seventeenth Century Art on the Work of James McNeill Whistler" (Master's thesis, University of Maryland, 1982), pp. 37–55.
16. *Ibid.,* pp. 33–35.
17. *Ibid.,* pp. 40–41, 50–51.
18. Pennell and Pennell, *Life of Whistler,* vol. 1, p. 51.
19. Gordon H. Fleming, *The Young Whistler* (New York: St. Martin's Press, 1978), p. 129.
20. *Ibid.*
21. Théodore Duret, *Histoire de J. McN. Whistler et son oeuvre,* (2d ed.; Paris: H. Fleury, 1904), pp. 10–11.
22. Pennell and Pennell, *Life of Whistler,* vol. 1, p. 74.
23. Curry, *Whistler in the Freer,* p. 231.
24. *Ibid.* David Curry noted that this sketch was traced onto a grounded plate, leaving a vague residue on the verso of the sheet.
25. Courbet made this statement in the manifesto of the catalogue for his 1855 exhibition. See Jack Lindsay, *Gustave Courbet: His Life and Art* (Bath: Adams and Dart, 1973), p. 138, n. 21.
26. A drawing in the Freer Gallery contains what is possibly a study for the view of the artist from behind. *Four Men on a Boat; Mr. Whistler at the Left,* appears to have three separate, unrelated vignettes, including a view of Whistler from the rear, but without the straw hat that appeared in the etching.
27. Pennell and Pennell, *Life of Whistler,* vol. 1, p. 62.
28. Leonée Ormond, *George Du Maurier* (Pittsburgh, Penn.: University of Pittsburgh Press, 1969), pp. 46–49.
29. *Ibid.,* p. 43.
30. Pennell and Pennell, *Life of Whistler,* vol. 1, pp. 50–51.
31. Graham Reynolds, *Victorian Painting* (New York: MacMillan, 1967), pp. 123–24.
32. L. M. Lamont, ed., *Thomas Armstrong C. B., a Memoir* (London: M. Secker, 1912); Daphne Du Maurier, ed., *The Young George Du Maurier, a Selection of His Letters, 1860–67* (New York: Doubleday and Co., 1951).
33. Pennell and Pennell, *Life of Whistler,* vol. 1, p. 52.
34. Lamont, *Thomas Armstrong,* p. 183.
35. Pennell and Pennell, *Life of Whistler,* vol. 1, p. 51.
36. Reproduced in Ormond, *Du Maurier,* p. 57.
37. Lamont, *Thomas Armstrong,* p. 14.
38. Pennell and Pennell, *Life of Whistler,* vol. 1, p. 52.
39. Reproduced in Margaret MacDonald, ed.,*Whistler's Mother's Cookbook* (New York: G. P. Putnam's Sons, 1979), p. 30.
40. Marie-Thérèse de Forges, *Autoportraits de Courbet* (exhibition catalogue, Paris: Musée du Louvre, 1973), p. 10. Courbet's painting was originally based on a drawing, *The Country Siesta,* dated to the 1840s. This early romantic charcoal sketch shows two lovers, a young woman with her head resting upon her paramour's chest, his eyes closed in dreamy contentment. An X-ray shows that Courbet's painting also originally had the second figure. Exactly when the painting was modified remains unknown.
41. *Tradition and Revolution in French Art, 1700–1880: Paintings and Drawings from Lille* (exhibition catalogue, London: National Gallery of Art, 1993), p. 95.
42. Katherine A. Lochnan, *The Etchings of James McNeill Whistler* (New Haven, Conn., and London: Yale University Press, 1984), pp. 65–66.
43. F. G. Stephens, "Mr. Edward John Poynter," in *Artists at Home* (London: Sampson, Low, Marston, Searle, and Rivington, 1884), p. 78.
44. Compare *The Music Room,* an 1858 etching by Whistler, and the artist's paintings *At the Piano* (Taft Museum, Cincinnati) and *In the Music Room* (Freer Gallery of Art), from the same time period.
45. A thorough biography of Burges that illuminates the world of design in nineteenth-century England is J.

Mordant Crook, *William Burges and the High Victorian Dream* (Chicago: The University of Chicago Press, 1981).

46. *Ibid.*, p. 86, n. 26.

47. *Ibid.*, p. 87, n. 38.

48. Mary Axon and Virginia Glenn, *The Strange Genius of William Burges "Art-Architect," 1827–1881* (exhibition catalogue, Cardiff: National Museum of Wales, 1981), p. 73.

49. Du Maurier, *Young Du Maurier*, p. 4.

50. *Ibid.*

51. Ormond, *Du Maurier*, p. 93.

52. *Punch* was founded in 1841 and became the most widely read of the satirical political magazines. It was issued weekly and during this time generally included in each issue one full-page illustration and many smaller drawings. *Once a Week* began publication in 1859 and maintained a notably high level of quality among its illustrators. During the early 1860s, the two magazines employed many of the best artists in England, including John Everett Millais, Dante Gabriel Rossetti, Charles Keene, Edward Poynter, Edward Burne-Jones, and Whistler.

53. The humor is clearer in the preparatory drawing, where the door is clearly labeled "Photographers studio." Du Maurier was not happy with the engraving, telling his mother that the likenesses were not preserved from his drawing (Du Maurier, *Young Du Maurier*, p. 14).

54. Arthur Prager, "The Artists Amuse Themselves: Victorian Painters and *Punch*," *Source* 1 (spring 1982): 27. Ornamental letters were an important source of income for the illustrators of *Punch* and other periodicals.

55. Ormond, *Du Maurier*, pp. 28–30, reproduction on page 29.

56. *Ibid.*; reproduced on p. 101. The Ionides family members were among Whistler's major patrons from the Paris years to the last decade of his life. Alexander Constantine Ionides, the father, owned paintings by Whistler, as did his sons Luke and Alecco, and his daughter Aglaia. In 1860 Whistler did a portrait of Luke Ionides, whom he had known since 1855. In 1877 Whistler's younger brother William married Helen Ionides, another of the siblings (Young *et al.*, *Paintings of Whistler*, pp. 12, 26–27, 38, 44–45, 58, 74, 87–88, 91–92, 104, 157).

57. Ormond, *Du Maurier*, pp. 101–2, and Pennell and Pennell, *Life of Whistler*, vol. 1, p. 79.

58. Du Maurier, *Young Du Maurier*, p. 29.

59. *Ibid.*, facing p. 240.

60. *Ibid.*, p. 66.

61. *Ibid.*, p. 216.

62. *Ibid.*, p. 235.

63. Ormond, *Du Maurier*, p. 91.

64. Du Maurier, *Young Du Maurier*, pp. 265–66.

65. Ormond, *Du Maurier*, p. 91.

66. Sylviane Heftler, *Étienne Carjat, photographe* (exhibition catalogue, Paris: Musée Carnavalet, 1982), p. 11.

67. Margaret MacDonald and Joy Newton, eds., "Letters from the Whistler Collection," *Gazette des beaux arts* 108 (December 1986): 201–2.

68. Thorp, *Studies in Black and White*, p. 89.

69. *Ibid.*, pp. 89–90.

70. Pennell and Pennell, *Life of Whistler*, vol. 1, p. 68.

71. "Dutch" and "Flemish" were often incorrectly applied or arbitrarily used in mid-nineteenth-century art literature.

72. Pennell and Pennell, *Life of Whistler*, vol. 1, p. 75. *One day, Whistler brought back from London the Piano Picture, representing his sister and niece. He was refused with Legros, Ribot and myself at the Salon. Bonvin, who I knew, interested himself in our rejected pictures, and exhibited them in his studio, and invited his friends, of whom Courbet was one, to see them. I recall very well that Courbet was struck with Whistler's picture.*

73. Marcel Guérin, ed., *Degas' Letters*, trans. M. Kay (Oxford: Oxford University Press, 1947), p. 235.

74. Curry, *Whistler in the Freer*, p. 232.

Chapter 2

1. Léonce Bénédite, "Artistes Contemporains: Whistler," *Gazette des beaux-arts* 33 (1905): 505, and 34 (1905): 232–33.

2. Douglas Druick and Michel Hoog, *Fantin-Latour* (exhibition catalogue, Paris: Éditions de la Réunion des musées nationaux, 1982), p. 165.

3. *Ibid.*

4. Adolphe Jullien, *Fantin-Latour: Sa vie et ses amitiés* (Paris: Lucien Lavour, 1909), p. 63.

5. Pennell Collection, Library of Congress, frames 797–802.

6. Druick and Hoog, *Fantin-Latour*, p. 174, fig. 19.

7. John Rewald, *The History of Impressionism* (New York: The Museum of Modern Art, 1946), pp. 44–46. Manet was at the core of a group of young artists who gathered regularly at the Café Tortoni in the early 1860s to discuss the latest developments in art. In 1861 his *Spanish Guitar Player* was exhibited at the Salon and attracted considerable attention. The painting received an honorable mention, perhaps due to Delacroix's influence. Writing in 1863, Fernand Desnoyers related a story of how the *Spanish Guitar Player* was admired by a group of painters at the Salon, including Legros, Carolus-Duran, Bracquemond, and Fantin. These artists then sought out Manet to express their esteem, and visited later with critics and poets. John Rewald suggests that the critics who visited Manet were those who also supported Courbet, including Castagnary, Astruc, Champfleury, and Edmund Duranty. Possibly six of the ten individuals grouped around Delacroix were also in the company of admirers who had called on Manet.

8. The cartoonist André Gill's caricature of the *Hommage à Delacroix* makes the white-shirted Fantin even more prominent, and he begins the caption with "Moi et Delacroix avec mes amis autour" to emphasize the point (Druick and Hoog, *Fantin-Latour*, pp. 176–77).

9. Albert de Balleroy was an old friend of Manet's and had accompanied Fantin on a visit to the *Salon des refusés* along with Legros, Manet, and Bracquemond. He was included in the Manet painting *Concert* of 1862, and he had bought Legros's painting, *l'Ex Voto*, which had been in the Salon of 1861 (Druick and Hoog, *Fantin-Latour*, pp. 174–75).

10. Jonathan Mayne, ed. and trans., *Painters and Etchers Art in Paris, 1845–1862: Salons and Other Exhibitions Reviewed by Charles Baudelaire* (London: Phaidon, Inc., 1965), pp. 217–22.

11. These two critics had appeared together nine years earlier in Courbet's *Allegory*, and they now appeared with Duranty in Fantin's tribute. Champfleury and Duranty had been ardent supporters of the realist style and subject matter in the visual arts, and were sympathetic toward the artistic progeny of Courbet. Their inclusion supports the legitimacy of the young artists represented here honoring the memory of Delacroix.

12. Joseph C. Sloane, *French Painting Between the Past and Present* (Princeton, N.J.: Princeton University Press, 1951), p. 117. Sloane summarized the regard for Delacroix at this time: "To his contemporaries Delacroix stood not for the new, but for a marvelous, belated, unforgettable, final sunset of that greatness in art whose last days they knew were upon them."

13. Druick and Hoog, *Fantin-Latour*, pp. 175–80. In this section, the authors provide the fullest discussion of the critical reception of the painting, which serves as the basis for much of this examination.

14. *Ibid.*, pp. 175–76.

15. *Ibid.*, p. 177.

16. Pennell Collection, Library of Congress, frames 797–802.

17. *Ibid.*, frames 806–8, 814–15.

18. Druick and Hoog offer the most extensive analysis of the painting, and the documentary information in the following section is based on their essay (*Fantin-Latour*, pp. 179–90).

19. *Ibid.*, p. 191, fig. 25.

20. Henri Fantin-Latour to Edwin Edwards, February 3, 1865, in Druick and Hoog, *Fantin-Latour*, p. 191.

21. Jullien, *Sa vie et ses amitiés*, p. 66.

22. Pennell and Pennell, *Life of Whistler*, vol. 1, p. 131.
23. Luce Abélès, *Fantin-Latour: Coin de table* in *Les Dossiers du Musée D'Orsay* (Paris: Éditions de la Réunion des Musées Nationaux, 1987), p. 11. The quotation is from the same letter cited in n. 20.
24. Pennell and Pennell, *Life of Whistler*, vol. 1, p. 131.
25. Henri Fantin-Latour to Edwin Edwards, March 21, 1865, in Jullien, *Sa vie et ses amitiés*, p. 67.
26. Henri Fantin-Latour to Edwin Edwards, April 14 and 29, 1865, in Druick and Hoog, *Fantin-Latour*, p. 192.
27. The portrait of Whistler is now in the Freer Gallery of Art. The Chinese robe cannot be discerned below the features of the thirty-one-year-old artist.
28. Pennell Collection, Library of Congress, frames 816–17.
29. Jullien, *Sa vie et ses amitiés*, p. 69.
30. Pennell Collection, Library of Congress, frames 833–35.
31. Beginning in spring 1865, the artist Albert Moore (1841–1893) was a close friend of Whistler. His work consists largely of groups of female models draped in flowing, antique clothes. He and Whistler were closest during the five years after they first met, influencing one another in a series of harmonious, decorative canvases inhabited by languorous figures in classically inspired garb.
32. Gallatin, *Portraits of Whistler* (1918), pp. 8–9.
33. Thorp, *Studies in Black and White*, p. 89. Whistler owned nine photographs of eight paintings by Velásquez.
34. Pennell and Pennell, *Life of Whistler*, vol. 1, facing p. 104.
35. Pennell Collection, Library of Congress, frames 777–79.
36. Pennell and Pennell, *Life of Whistler*, vol. 1, pp. 189, 222, and vol. 2, p. 177; Alan S. Cole diary, January 6, 1876: "Whistler considered art had reached a climax with Japanese and Velásquez."
37. James McNeill Whistler, *The Gentle Art of Making Enemies* (2d ed.; New York: G. P. Putnam and Sons, 1892), pp. 137, 158.
38. *Ibid.*, p. 136.
39. Denker, "Influence of Dutch Art," pp. 48–51.
40. Young, *et al.*, *Paintings of Whistler*, vol. 1, p. 74.
41. Otto Bacher, *With Whistler in Venice* (New York: The Century Company, 1908), p. 250.
42. Pennell and Pennell, *Life of Whistler*, pp. 80–81.
43. Mortimer Menpes, *Whistler as I Knew Him* (New York: MacMillan Company, 1904), pp. 33–35.
44. Bacher, *Whistler in Venice*, p. 250.
45. *Ibid.*, p. 249.
46. *Ibid.*, p. 244.

Chapter 3

1. Lochnan, *Etchings of Whistler*, pp. 168–70.
2. Young *et al.*, *Paintings of Whistler*, vol. 1, p. 62.
3. Anna McNeill Whistler to Gamble, March 13, 1872, Additional Manuscripts, 1962, W/57, Glasgow University Library.
4. The terra-cotta bust is inscribed "J. E. Boehm fecit 1872" on the left shoulder. A reduced terra-cotta version in the Toledo Museum of Art is inscribed 1875. These are the only sculptural likenesses of Whistler made during the artist's lifetime.
5. Mark Stocker, *Royalist and Realist: The Life and Work of Sir Joseph Edgar Boehm* (New York: Garland Publishing, Inc., 1988). The background material is indebted to this study.
6. Whistler to George Lucas, May 3, 1869, Baltimore Museum of Art, as cited in Linda Merrill, *A Pot of Paint: Aesthetics on Trial in Whistler v. Ruskin* (Washington, D.C.: Smithsonian Institution Press, 1992), pp. 87, 348–60.
7. *Architect* 9 (London, 1873): 298, as cited in Stocker, *Royalist and Realist*, p. 69.
8. *Saturday Review* 34 (London, 1873): 51, as cited in Stocker, *Royalist and Realist*, p. 69.
9. Thomas Robert Way, *Memories of James McNeill Whistler, the Artist* (London and New York: John Lane Company, 1912), p. 26.
10. A smaller version of 1875 was shown at the

Grosvenor Gallery exhibition in 1877, and again at the Exposition Universelle in Paris in 1878.
11. Discussions of the circumstances surrounding the creation of the Peacock Room are contained in Pennell and Pennell, *Life of Whistler*, vol. 1, pp. 202–9 and in Linda Merrill, "Whistler's Peacock Room Revisited," *Magazine of Antiques* 143 (June 1993): 894–901.
12. Merrill, *Pot of Paint*, has the most detailed account of the events leading up to the Whistler-Ruskin libel trial.
13. "The Palace of Art (New Version)," *Punch* 72 (July 7, 1877): 307.
14. John Ruskin, "Letter 79: Life Guards of New Life," *Fors Clavigera* 7 (July 1877), as collected in E. T. Cook and Alexander Wedderburn, eds., *The Works of John Ruskin* (London: George Allen, 1903–1912), vol. 29, p. 160.
15. Merrill, *Pot of Paint*, pp. 59–71.
16. Hilary Taylor, *James McNeill Whistler* (New York: G. P. Putnam's Sons, 1978), pp. 94–95.
17. John Hollingshead, *The Grasshopper. A Drama in Three Acts. Adapted from "La Cigale" by M. M. Meilhac and Halévy* (London, 1877), as cited in *ibid.*
18. Merrill, *Pot of Paint*, p. 105.
19. *Ibid.*
20. Leslie Ward, *Forty Years of "Spy"* (New York: Brentano's, 1915), p. 112.
21. Jerold Savory, *The Vanity Fair Lithographs: An Illustrated Checklist* (New York and London: Garland Publishing Company, 1978), pp. xi–xvi.
22. His friend Manet had used the Velásquez as his inspiration for an 1866 portrait of Philibert Rouvière, and Whistler would refer to the painting in the 1890s for a late self-portrait. Whistler may have suggested this pose to Ward for the lithograph as a conscious connection to one of his artistic heroes.
23. Ward, *Forty Years of "Spy,"* p. 298.
24. *Ibid.*
25. See Whistler Letterbook 11, p. 7, Glasgow University Library, for one given to Charles Augustus Howell signed with a butterfly and dated May 25, 1881.
26. Linda Merrill's exhaustive research and documentation of the facts and issues surrounding the trial have allowed for a far clearer and more precise understanding of the case than has been previously possible, and I am indebted to her for my interpretation of the events summarized here (Merrill, *Pot of Paint*, pp. 183–97).
27. Linley Sambourne, "Whistler Versus Ruskin," *Punch* 76 (December 7, 1878): 254.
28. Psalm 102, verse 6, King James version. My appreciation to Donald Vogler for tracking down this obscure reference.
29. Merrill, *Pot of Paint*, pp. 252–53.
30. Sambourne to Whistler, December 1, 1878, Whistler S. 11, Glasgow University Library.
31. James Abbott McNeill Whistler, *The Gentle Art of Making Enemies* (London: William Heinemann, 1890), p. 20.
32. *Pick-Me-Up* magazine, London, January 9, 1892, as cited in Gallatin, *Portraits and Caricatures*, p. 64.
33. James Thorpe, *Phil May: Master-Draughtsman and Humorist* (London: George G. Harrap & Co. Ltd., 1932), p. 97.
34. Nina Darnton, "An American Artist Displeases the English Cousins," in *New York Times*, October 24, 1994, pp. 11–12.
35. London Stereoscopic Company (A. H. Burchatt), 110, 106, 108, Regent Street, to James Whistler, December 28, 1878, Pennell Collection, Library of Congress, as cited in Thorp, *Studies in Black and White*, p. 86, n. 12.
36. Otto Bacher, *With Whistler in Venice* (New York: The Century Company, 1908), p. 213.
37. Thorp, *Studies in Black and White*, p. 86, n. 12.
38. *Ibid.*, p. 87.
39. Cope's was a tobacco concern in nineteenth-century London that commissioned various artists for seasonal advertisements. The original watercolor was formerly in the collection of Allan Cuthbertson.
40. Identifications are derived from Richard Godfrey and Lionel Lambourne, *English Caricature: 1620 to the Present* (exhibition catalogue, London: Victoria and Albert Museum, 1984), pp. 115–16.

41. See Charles Léger, ed., *Courbet: Salon Les Caricatures et Les Images* (Paris: Paul Rosenberg, 1920), where roughly half of the 190 images refer to specific paintings.

42. Published November 27, 1884.

43. *Ibid.*, p. 8.

44. *Ibid.*

45. *Ibid.*, p. 34. The narrative is extensive and complex, deserving a full citation: *As I took my place among the staff I gradually learnt the names of the rebels we were to subdue or disperse. It seems that certain sects had defied the Mahdi's authority, and retired in wrath and revolt. The Gay Dogs had betaken themselves to mountain fastnesses; obscure poets had fled to the wilderness; and a tiny band of Impressionists had entrenched themselves on an Embankment, and were rapidly lashing themselves into paroxysms of pictorial incomprehensibility.*

"Let us bring these truant daubers back to the fold," said our leader, as he ordered a general advance of the Royal Academicians, who were naturally all in the first line.

The camp of the Impressionists was an insignificant place, and it was quite a Tite (Street) fit to get the little band inside of it. Once established there, however, their position seemed impregnable. They laughed at us; they told us "we roared like bears;" they caught the sharpest critical arrows in their hands and hurled them back upon their foes. Finally, the brigades of the Realistic Regulars advanced against them, one led by Sir Valentine's Day Princep Pasha (whose helmet I noticed was bound with orange blossoms), and the other commanded by Sir Derby Day Firth. Sir Valentine, bearded and beaming, flung piles of painted loaves at the rebels' heads, and threatened to paint the lot of them, as if they were Indian Rajahs, if they refused to submit. General Firth menaced them with the Road to Ruin on his own railway-station lines; and Captain 'Arry, an Officer of distinction in the Realistic Regulars, advanced with reckless audacity to the very foot of the embankment, got possession of a White outpost house, and thence shouted indignantly that all their photo-gravures were really etchings. Mr. Frederick Wedmore annoyed them most of all by insisting on explaining the position of the little band. Many Examiners, and not a few Spectators, harassed them in the rear. Even Mr. Ruskin, who was busy conducting a revolt of his own, flung his last farthing in their faces. But a certain rebel "Jemmy," the leader of the band, caught the coin, and tossed it up in scornful triumph.

"I am the Master!

Who can paint faster?"

he sang as he rushed about with a wand encouraging his devoted followers. The fight was a long and obdurate one, and much ink and paint were shed on both sides. At last the Veiled One could stand it no longer. Accompanied by his staff, he galloped up to the very walls of the Embankment, which were papered with patent brown paper critic-crushing catalogues, and dashing bravely through fluttering flocks of brilliant butterflies that flew out and surrounded him, boldly faced the most terrific pictures that the garrison had in their possession, and which they had hung on their battlements to intimidate the foe.

Long and earnestly he looked at the nearest nocturne. To the evident surprise of the insurgents, he neither quivered, nor trembled, nor fainted, but, gazing earnestly at the moonlight monotone in question, said solemnly, "Very like a whale!"

It was a terrible blow, and it had an immediate effect. The dejected, melancholy, dispirited Impressionists threw down their paint brushes and surrendered themselves.

"Had he even called it a 'sensitive caricature,'" they murmured, "we might still have prolonged the fight. It is of course, as a matter of fact, not a whale at all; it is a cloud, specially painted for the ceiling of the Princess's Theatre. Still, it seems that the picture over which we lavished such tender nonsense, and over which we have laboured so long and so lovingly to render it absolutely incomprehensible, bears a distinct resemblence to some object in nature. We are lost!

We surrender!"

46. The now-lost portrait of Maud is reproduced in an unidentified press clipping in BP III, P/C, p. 116, Glasgow University Library, cited in Young *et al.*, *Paintings of Whistler*, vol. 1, p. 166, and illustrated in vol. 2, plate 423.

47. The connection between the white feather and the Victorian perception of cowardice is most notably expounded in A. E. W. Mason's novel *The Four Feathers*, set in Africa in the last quarter of the nineteenth century. My appreciation to Donald Vogler for this citation.

48. The drawing for this illustration is in the Grenville L. Winthrop Collection of the Fogg Art Museum, Harvard University.

49. Robert H. Getscher and Paul G. Marks, *James McNeill Whistler and John Singer Sargent: Two Annotated Bibliographies* (New York and London: Garland Publishing Inc., 1986), pp. 8–13.

50. A comparison with a contemporary drawing by Harper Pennington demonstrates the accuracy of the costume and setting. Pennington had met Whistler five years before in Venice and was in the master's circle in London beginning in 1883. *Whistler Delivering His "Ten O'Clock" Lecture* appears to have been sketched during the artist's performance, since it is dated "Feb. 1885," although it was not published for more than thirty years. Reproduced in Albert E. Gallatin, "Note on an Exhibition of Whistleriana," *American Magazine of Art* 10 (March 1919): 201–4.

51. *Lady's Pictorial*, February 28, 1885, p. 191.

52. Pennell and Pennell, *Life of Whistler*, vol. 2, pp. 55–61.

53. *Ibid.*

54. Nicolai Cikovsky, Jr., with Charles Brock, "Whistler and America," in Richard Dorment and Margaret F. MacDonald, *James McNeill Whistler* (London: Tate Gallery Publications, 1994), pp. 34–35.

55. *Ibid.*, pp. 35–36.

56. *Ibid.* In a letter to the *New York Tribune* on October 12, 1886, Whistler gave several reasons for his reluctance to return to America: the poor reception for other speaking tours; the unsympathetic treatment he had received in the American press; and the monstrous portrait of him done by Chase, which had not yet been publicly exhibited (see Chapter 4). My appreciation goes to Nicolai Cikovsky, Jr., and Charles Brock for their generous assistance in this section.

57. Getscher and Marks, *Whistler and Sargent*, p. 206, items J. 172–74.

58. George Du Maurier, *Trilby*, in *Harper's New Monthly Magazine* 88 (March 1894): 577–78.

59. *Ibid.*, p. 578.

60. *Ibid.*

61. *Ibid.*

62. A balanced consideration of the *Trilby* episode is contained in Ormond, *Du Maurier*, pp. 431–79.

63. *Life* 24 (November 8, 1894): 293, as cited in Sarah Burns, "Old Maverick to Old Master: Whistler in the Public Eye in Turn-of-the-Century America," *American Art Journal* 22, no. 1 (spring 1990): 34, n. 15.

64. Colin Campbell, *William Nicholson: The Graphic Work* (London: Barrie and Jenkins, 1992), pp. 60–62.

65. *Ibid.*, p. 62.

66. Whistler's introductory note in the "Company of the Butterfly" exhibition catalogue of Nicholson's work, as cited in Colin Campbell, *William Nicholson*, pp. 245–46.

Chapter 4

1. Pennell and Pennell, *Life of Whistler*, vol. 2, p. 10.

2. Whistler to David Croal Thompson, October 24, 1895, Library of Congress, frames 1828–29.

3. Tom Pocock, *Chelsea Reach: The Brutal Friendship of Whistler and Walter Greaves* (London: Houghton and Stoughton, 1970), pp. 1–2, 41–43. Pocock's book is the most thorough examination of the Whistler-Greaves relationship, and is the basis for the biographical details regarding the relationship between the brothers and Whistler included in this work.

4. *Ibid.*, p. 56.

5. *Ibid.*, p. 66.
6. Pennell and Pennell, *Life of Whistler*, vol. 1, p. 108.
7. *Ibid.*, pp. 107, 126, 164.
8. *Ibid.*, p. 164.
9. *Ibid.*, pp. 168, 171, 175–77.
10. Pocock, *Chelsea Reach*, pp. 107–11.
11. *Ibid.*, pp. 115–17.
12. None of the single-figure portrait drawings are dated.
13. Pocock, *Chelsea Reach*, p. 105.
14. Michael Bryan, *Old Chelsea and the Thames* (exhibition catalogue, London: Michael Bryan, 1989), pp. 11–15.
15. *Ibid.*, p. 12.
16. Pennell and Pennell, *Life of Whistler*, vol. 1, p. 168.
17. *Ibid.*, p. 164.
18. Merrill, *Pot of Paint*, p. 62.
19. "What the World Says," *The World* (London), September 17, 1879, p. 10.
20. *Illustrated London News* 79 (1880): 361.
21. Bacher, *Whistler in Venice*, pp. 24–25.
22. Pennell and Pennell, *Life of Whistler*, vol. 1, p. 267.
23. Hugh Honour and John Fleming, *The Venetian Hours of Henry James, Whistler and Sargent* (Boston: Bulfinch Press, 1991), p. 42.
24. Letter by Ralph Curtis, quoted in Pennell and Pennell, *Life of Whistler*, vol. 1, p. 273.
25. Pocock, *Chelsea Reach*, p. 120. "He had asked Walter Greaves to go with him, but neither had money and Walter refused, foreseeing the inevitable trail of unpaid bills, saying later, 'I refused because I knew we should have trouble.'"
26. Bacher, *Whistler in Venice*, pp. 4–8.
27. *Ibid.*, p. 13.
28. Whistler did not want his prints to be collected for their topographic accuracy in depicting a known site, but preferred them to be admired for their artistic merit.
29. *Ibid.*, pp. 117–18.
30. Letter from Ralph Curtis, quoted in Pennell and Pennell, *Life of Whistler*, vol. 1, pp. 273–74.
31. Bacher, *Whistler in Venice*, p. 39.
32. *Ibid.*, pp. 4, 7.
33. Mary Anne Goley, *John White Alexander (1856–1915)* (Washington, D.C.: Smithsonian Institution Press, 1976), unpaginated.
34. Anonymous, "How Whistler Posed for John W. Alexander," *The World's Work* 9, no. 5 (March 1905): 5993–94.
35. *Ibid.*, p. 5994.
36. "The Two Whistlers: Recollections of a Summer with the Great Etcher," *Century Magazine* 57 (June 1910): 219–26. This article by Chase provides the basic source of information on his relationship with Whistler.
37. *Ibid.*, p. 222.
38. *Ibid.*, p. 219.
39. *Ibid.*, p. 220.
40. *Ibid.*, p. 225.
41. Carolyn Kinder Carr, *William Merritt Chase: Portraits* (exhibition catalogue, Akron, Ohio: Akron Art Museum, 1982), pp. 16, 18.
42. Chase, "The Two Whistlers," p. 222.
43. *Ibid.*, pp. 222–23.
44. Katherine Metcalf Roof, *The Life and Art of William Merritt Chase* (New York: Charles Scribner's Sons, 1917), pp. 140–41.
45. Whistler had been considering a visit to New York to deliver his Ten O'Clock Lecture, a plan he would nurture for several years before abandoning it.
46. Ronald G. Pisano, *William Merritt Chase: A Leading Spirit in American Art* (Seattle: University of Washington Press, 1989), p. 80.
47. Roof, *Life and Art of Chase*, pp. 140–41.
48. *New York Tribune*, October 12, 1886, p. 1, as cited in Doreen Bolger Burke, *American Paintings in the Metropolitan Museum of Art* (New York: Metropolitan Museum of Art, 1980), vol. 3, p. 83. Whistler included an extract of the letter in the 1890 edition of *The Gentle Art of Making Enemies*, pp. 184–85, but he changed his description of Chase to "the Masher of the Avenues."
49. Burke, *American Paintings in the Metropolitan*, pp.

83–84.
50. Pisano, *William Merritt Chase*, pp. 81–82, describes the critical reaction to the exhibition of the portrait of Whistler in different venues.
51. Keith L. Bryant, Jr., *William Merritt Chase: A Gentle Bohemian* (Columbia and London: University of Missouri Press, 1991), p. 225.
52. Pennell and Pennell, *Life of Whistler*, vol. 2, pp. 30–32.
53. Pisano, *William Merritt Chase*, p. 82.
54. Roof, *Life and Art of Chase*, p. 144.
55. Chase, "The Two Whistlers," p. 221.
56. Mortimer Menpes, *Whistler As I Knew Him* (New York: The MacMillan Company, 1904), p. 152.
57. *Ibid.*, p. 89.
58. Pennell and Pennell, *Life of Whistler*, vol. 2, p. 18.
59. Thomas Robert Way, *Memories of James McNeill Whistler, the Artist* (New York: John Lane Company, 1912), pp. 41–42. Curiously, although both Way and Menpes went to the South Kensington School, and both worked for Whistler at this time, neither mentions the other in his written account of the period. Their accounts of where the plates were printed differ markedly.
60. *Ibid.*, p. 42. Way includes a lithograph from the painting after p. 40.
61. *Ibid.*, after p. 126.
62. *Ibid.*, p. 26.
63. Ward, *Forty Years of Spy*, pp. 172–73.
64. Chase, "The Two Whistlers," p. 226.

Chapter 5

1. Ronald Anderson and Anne Koval, *James McNeill Whistler: Beyond the Myth* (London: John Murray, 1994), p. 335.
2. Pennell and Pennell, *Life of Whistler*, vol. 2, pp. 137–38.
3. Two of the Dornac photographs in the Lucas Collection at the Baltimore Museum of Art bear George Lucas's inscription, "Photographed in Whistler's atelier, 23 June 1899."
4. Pennell and Pennell, *Life of Whistler*, vol. 2, p. 139.
5. *Ibid.*
6. Miriam J. Benkovitz, *Aubrey Beardsley: An Account of His Life and Work* (New York: G. P. Putnam's Sons, 1981), p. 38.
7. Reproduction of letter to George Frederick Scotson-Clark, *The Uncollected Works of Aubrey Beardsley*, introduction by C. Lewis Hind (London: John Lane, The Bodley Head Ltd., 1925), p. 69.
8. Benkovitz, *Aubrey Beardsley*, p. 73.
9. *The Pall Mall Budget*, February 9, 1893, as cited in Brian Reade, *Aubrey Beardsley* (New York: Bonanza Books, 1967), p. 314, plate 39, nn. 38–40.
10. Pennell and Pennell, *Life of Whistler*, vol. 2, p. 140.
11. Florence Farr, *The Dancing Faun* (London: E. Mathews and J. Lane, 1894), cover. The Beardsley caricature was reproduced separately as a lithograph.
12. Reade, *Aubrey Beardsley*, p. 343, n. 336.
13. Brigid Brophy, *Beardsley and His World* (New York: Harmony Books, 1976), p. 44 (caption). The Beardsley caricature was published in May 1894.
14. Pennell and Pennell, *Life of Whistler*, vol. 2, p. 140.
15. Roberta J. M. Olson, *Ottocento: Romanticism and Revolution in 19th-Century Italian Painting* (exhibition catalogue, New York: American Federation of the Arts, and Florence: Centro Di Della Edifimi srl, 1992), pp. 215–16, 260–61.
16. When Sir Max Beerbohm, in his 1911 novel *Zuleika Dobson*, wrote that "Boldini did a portrait of her," he established the stature and allure of his heroine for his sophisticated audience.
17. Pennell and Pennell, *Life of Whistler*, vol. 2, p. 193.
18. Freer to Whitney Warren, of Warren and Wetmore, New York, March 13, 1909, Freer Papers, Letterbook 27, Freer Gallery of Art, Smithsonian Institution, Washington, D.C.
19. Gallatin, *Portraits of Whistler*, p. 18.
20. *Ibid.*, reproduction following p. 58.
21. Freer to Whitney Warren, New York, March 13, 1909, Freer Papers, Freer Gallery of Art.

22. In the collection of the Art Institute of Chicago.
23. Elizabeth Robbins Pennell and Joseph Pennell, *The Whistler Journal* (Philadelphia: J. B. Lippincott Company, 1921), p. 18.
24. Letter in New York Public Library, cited in Young *et al.*, *Paintings of Whistler*, vol. 1, p. 195, entry 440.
25. *Ibid.*
26. Pennell and Pennell, *Life of Whistler*, vol. 2, p. 158.
27. Young *et al.*, *Paintings of Whistler*, vol. 1, pp. 195–96.
28. Pennell and Pennell, *Life of Whistler*, vol. 1, p. 202, entry 462.
29. Jean L. Kling, *Alice Pike Barney: Her Life and Art* (Washington, D.C., and London: Smithsonian Institution Press, 1994), p. 123. Kling's chapter on the Barney-Whistler relationship is based on an unpublished third-person autobiography that Barney wrote close to thirty years after the incidents occurred, and a play, *Jimmy*, written around the same time.
30. *Ibid.*, p. 126.
31. Cyrus Cuneo, "Whistler's Academy of Painting," in *Century Magazine* (New York), 73, no. 1 (November 1906): 19–28.
32. Gallatin, *Portraits of Whistler*, p. 18.
33. Nathaniel Pousette-Dart, *Ernest Haskell: His Life and Work* (New York: T. Spencer Hutson, 1931), p. 14.
34. Ernest Haskell, "Portraits and Caricatures," *Harper's Bazar*. Clipping preserved in A. E. Gallatin Collection, New York Public Library.
35. Ernest Haskell to his sister Mabel, n.d., Haskell file, Catalog of American Portraits, National Portrait Gallery, Smithsonian Institution, Washington, D.C.
36. Pocock, *Chelsea Reach*, reproduction opposite p. 145.
37. Joy Newton and Margaret MacDonald, "Rodin: The Whistler Monument," *Gazette des beaux arts* 92, no. 1319 (December 1978): 221. The authors correctly attribute the commission to Freer, but letters in the Special Collections Department of the Dartmouth College Library, Hanover, New Hampshire, indicate that the conception of the memorial occurred prior to their date of 1905.
38. Burke Wilkinson, *Uncommon Clay: The Life and Works of Augustus Saint-Gaudens* (New York: Harcourt Brace Jovanovich, 1985), p. 303.
39. Rosalind Birnie Philip to Homer Saint-Gaudens, February 22, 1907, Special Collections Department, Dartmouth College Library.
40. Rosalind Birnie Philip to Homer Saint-Gaudens, June 3, 1907, Special Collections Department, Dartmouth College Library.
41. Gallatin, *Portraits of Whistler*, p. 59.
42. Newton and MacDonald, "Rodin," p. 221.
43. Pennell and Pennell, *Whistler Journal*, p. 307.
44. *Ibid.*, pp. 308, 313.
45. Ethelyn Adina Gordon, "Sculpture by Frederick William MacMonnies," entry 99, in Mary Smart, *A Flight with Fame: The Life and Art of Frederick William MacMonnies (1863–1937)* (Madison, Conn.: Sound View Press, 1994). My appreciation to Ms. Gordon for this and other information on MacMonnies
46. Walter Crane, *William Morris to Whistler: Papers and Addresses on Art and Craft and the Commonweal* (1911; reprint ed.: Folcroft Library Editions, 1973).
47. N. John Hall, *A Peep into the Past: Max Beerbohm Caricatures* (exhibition catalogue, New York: Hunter College, 1987), unpaginated introduction (9).
48. Max Beerbohm, "Whistler's Writing," *Pall Mall Magazine* (May 1904): 139.
49. Hall, *A Peep into the Past*, unpaginated introduction (8).
50. Max Beerbohm, *The Poets' Corner* (London: William Heinemann, 1904).
51. Hall, *A Peep into the Past*, unpaginated introduction (8).
52. Malcolm Rogers, *Camera Portraits: Photographs from the National Portrait Gallery, 1839–1989* (exhibition catalogue, London: National Portrait Gallery Publications, 1989), p. 180.
53. A blot covers part of the inscription, which led Beerbohm to write "spoilt" across the drawing and create a second, now unlocated, picture that was reproduced in Max Beerbohm, *A Survey* (London: William Heinemann, 1921).
54. Rupert Hart-Davis, ed., *Max Beerbohm: Letters to Reggie Turner* (London: Rupert Hart-Davis, 1964), p. 200, letter of May 10, 1911, nn. 1, 2.
55. Rupert Hart-Davis, *A Catalogue of the Caricatures of Max Beerbohm* (London: MacMillan London Ltd., 1972), p. 161, entry 1829.

Conclusion

1. Daniel Boorstin, *The Image*, p. 61.
2. *Ibid.*, pp. 45–76.
3. Catherine Carter Goebel, "Arrangement in Black and White: The Making of a Whistler Legend" (Ph.D. diss., Northwestern University, 1988) provides a thorough account of Whistler's use of contemporary media to construct his image as an outsider and Bohemian in Victorian England. She examines Whistler's role in manipulating opinion in the press between 1859 and 1879, ending with an analysis of the published material on the Whistler-Ruskin trial.
4. Boorstin, *The Image*, p. 63.
5. *Ibid.*
6. *Ibid.*, p. 65.
7. *Ibid.*, p. 62.
8. *Ibid.*, p. 74.
9. *Ibid.*, p. 74.
10. Arthur Jerome Eddy, *Recollections and Impressions of James McNeill Whistler* (Philadelphia and London: J. B. Lipppincott, 1903), pp. 225–26.

Selected Bibliography

In 1986 Robert Getscher and Paul Marks published an exhaustive bibliography of Whistler scholarship, cited below. The recent exhibition catalogue by Richard Dorment and Margaret MacDonald, *Whistler*, contains citations of more recent work, as does Margaret MacDonald's catalogue raisonné of Whistler's works on paper, published in January 1995. The works listed below were specifically relevant to the study of portraits of Whistler.

General Works

Beerbohm, Max. *The Poets' Corner*. London, 1904.

Benkovitz, Miriam J. *Aubrey Beardsley: An Account of His Life and Work*. New York, 1981.

Boorstin, Daniel J. *The Image: A Guide to Pseudo-Events in America*. 1962. Revised edition, New York, 1987.

Brilliant, Richard. *Portraiture*. London, 1991.

Bryan, Michael. *In Cheyne Walk and Thereabout*. London, 1984.

———. *Old Chelsea and the Thames*. London, 1989.

Campbell, Colin. *William Nicholson: The Graphic Work*. London, 1992.

Carr, Carolyn Kinder. *William Merritt Chase: Portraits*. Akron, Ohio, 1982.

Crook, J. Mordant. *William Burges and the High Victorian Dream*. Chicago, Ill., 1981.

Druick, Douglas, and Michel Hoog. *Fantin-Latour*. Paris and Ottawa, 1982.

Du Maurier, Daphne, ed. *The Young George Du Maurier, a Selection of His Letters, 1860–67*. New York, 1951.

Hall, N. John. *A Peep into the Past: Max Beerbohm Caricatures*. New York, 1987.

Jullien, Adolphe. *Fantin-Latour: Sa vie et ses amitiés*. Paris, 1909.

Lamont, L. M., ed. *Thomas Armstrong C. B., a Memoir*. London, 1912.

Lasner, Mark Samuels, and Margaret D. Stetz. *The Yellow Book: A Centenary Exhibition*. Cambridge, 1994.

Ormond, Leonée. *George Du Maurier*. Pittsburgh, Penn., 1969.

Pisano, Ronald G. *William Merritt Chase: A Leading Spirit in American Art*. Seattle, Wash., 1989.

Randall, Lillian M. C., ed. *The Diary of George A. Lucas: An American Art Agent in Paris, 1857–1909*. 2 vols. Princeton, N.J., 1979.

Rogers, Malcolm. *Camera Portraits: Photographs from the National Portrait Gallery, 1839–1989*. London, 1989.

Roof, Katherine Metcalf. *The Life and Art of William Merritt Chase*. New York, 1917.

Stocker, Mark. *Royalist and Realist: The Life and Work of Sir Joseph Edgar Boehm*. New York, 1988.

Ward, Leslie. *Forty Years of "Spy."* New York, 1915.

Wilkinson, Burke. *Uncommon Clay: The Life and Works of Augustus Saint-Gaudens*. New York, 1985.

Books on Whistler

Anderson, Ronald, and Anne Koval. *James McNeill Whistler: Beyond the Myth*. London, 1994.

Bacher, Otto. *With Whistler in Venice*. New York, 1908.

Brewster, Walter S. *Catalogue of a Collection of Whistleriana from the Collection of Walter S. Brewster*. Chicago, Ill., 1917.

Crane, William. *William Morris to Whistler: Papers and Addresses on Art and Craft and the Commonweal*. London, 1911.

Curry, David. *Whistler in the Freer Gallery of Art*. Washington, D.C., 1984.

Denker, Eric. "The Influence of Dutch Seventeenth-Century Painting on the Work of James McNeill Whistler." Master's thesis, University of Maryland, College Park, 1982.

Dorment, Richard, and Margaret MacDonald, with essays by Nicolai Cikovsky, Jr., and Charles Brock, Geneviève Lacambre, and entries by Ruth E. Fine. *James McNeill Whistler*. London, 1994.

Duret, Théodore. *Histoire de J. McN. Whistler et son oeuvre*. Paris, 1904.

Eddy, Arthur Jerome. *Recollections and Impressions of James A. McNeill Whistler*. Philadelphia and London, 1903.

Fleming, Gordon H. *The Young Whistler*. New York, 1978.

—. *Whistler: A Life*. New York, 1991.

Fine, Ruth E., ed. *James McNeill Whistler: A Reexamination*. Thorp, Nigel. "Studies in Black and White: Whistler's Photographs in Glasgow University Library." Vol. 19, *Studies in the History of Art*. Washington, D.C., 1987.

Gallatin, Albert E. *Portraits and Caricatures of James McNeill Whistler, an Iconography*. London, 1913.

—. *Portraits of Whistler: A Critical Study and an Iconography*. London, 1918.

Getscher, Robert H., and Paul G. Marks. *James McNeill Whistler and John Singer Sargent: Two Annotated Bibliographies*. New York and London, 1986.

Goebel, Catherine Carter. "Arrangement in Black and White: The Making of a Whistler Legend." Ph.D. dissertation, Northwestern University, Chicago, Ill., 1988.

Honour, Hugh, and John Fleming. *The Venetian Hours of Henry James, Whistler and Sargent*. Boston, 1991.

Hopkinson, Martin. *Catalogue of Whistler Exhibition in Japan*. Tokyo, 1987.

Kennedy, Edward G. *The Etched Work of Whistler*. New York, 1910.

Koval, Anne. *Whistler in His Time*. London, 1994.

Lochnan, Katherine A. *The Etchings of James McNeill Whistler*. New Haven, Conn., and London, 1984.

MacDonald, Margaret. *James McNeill Whistler—Drawings, Pastels, and Watercolors: A Catalogue Raisonné*. New Haven, Conn., 1995.

—, ed. *Whistler's Mother's Cookbook*. New York, 1979.

Menpes, Mortimer. *Whistler as I Knew Him*. New York, 1904.

Merrill, Linda. *A Pot of Paint: Aesthetics on Trial in Whistler v. Ruskin*. Washington, D.C., 1992.

Parkin, Michael. *Artists and Writers*. London, 1976.

—. *Round and About Whistler*. London, 1994.

Pennell, Elizabeth Robbins, and Joseph Pennell. *The Life of James McNeill Whistler*. 2 vols. New York and London, 1908.

—. *The Whistler Journal*. Philadelphia, Penn., 1921.

Pocock, Tom. *Chelsea Reach: The Brutal Friendship of Whistler and Walter Greaves*. London, 1970.

Spencer, Robin. *Whistler: A Retrospective*. New York, 1989.

Sweet, Frederick Arnold. *James McNeill Whistler*. Chicago, Ill., 1968.

Taylor, Hilary. *James McNeill Whistler*. New York, 1978.

Way, Thomas Robert. *Memories of James McNeill Whistler, the Artist*. London and New York, 1912.

Whistler, James McNeill. *The Gentle Art of Making Enemies*. London, 1890.

Young, Andrew McLaren, and Margaret MacDonald, Robin Spencer, and Hamish Miles. *The Paintings of James McNeill Whistler*. New Haven, Conn., and London, 1980.

Articles on Whistler

Bénédite, Léonce. "Artistes contemporains: Whistler." *Gazette des beaux arts* 33 (1905): 496–511, and 34 (1905): 231–46.

Burns, Sarah. "Old Maverick to Old Master: Whistler in the Public Eye in Turn-of-the-Century America." *American Art Journal* 22 (spring 1990): 29–49.

Chase, William Merritt. "The Two Whistlers: Recollections of a Summer with the Great Etcher." *Century Magazine* 57 (June 1910): 219–26.

Cuneo, Cyrus. "Whistler's Academy of Painting." *Century Magazine* 73 (November 1906): 19–28.

MacDonald, Margaret, and Joy Newton, eds. "Letters from the Whistler Collection." *Gazette des beaux arts* 108 (December 1986): 201–14.

Newton, Joy, and Margaret MacDonald. "Rodin: The Whistler Monument." *Gazette des beaux arts* 92 (December 1978): 221–32.

Index

Photography Credits

Edited by Frances K. Stevenson, Dru Dowdy, and Katherine Gibney
Designed by the Watermark Design Office, Alexandria, Virginia

The book was typeset in Adobe Sabon on a Macintosh Quadra 950. It was printed on eighty-pound Warren's Lustro Offset Enamel Dull by Schneidereith and Sons, Baltimore, Maryland